THE
ENCYCLOPEDIA
OF
DRAWING
TECHNIQUES

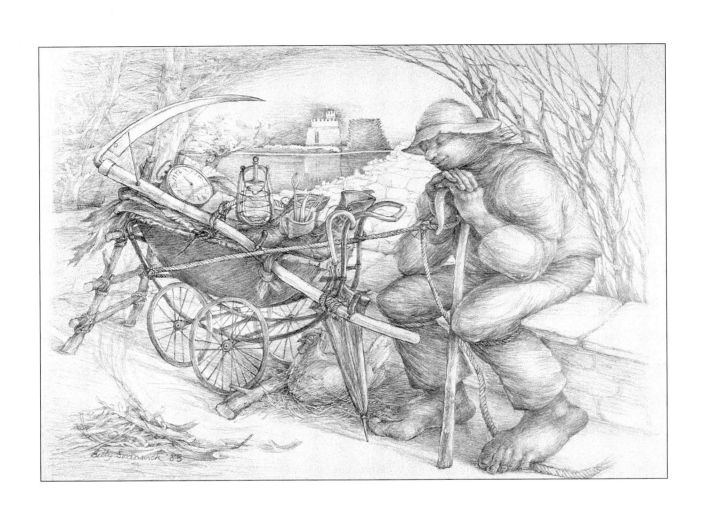

THE
ENCYCLOPEDIA
OF
DRAWING
TECHNIQUES

IAN SIMPSON

Contributing Editor Lawrence Wood

BCA

LONDON · NEW YORK · SYDNEY · TORONTO

A QUARTO BOOK

This edition published 1991
by BCA by arrangement with
Headline Book Publishing plc

Copyright © 1987 Quarto Publishing plc

Reprinted 1992

CN 1744

First published in Great Britain in 1987 by
HEADLINE BOOK PUBLISHING PLC

This book was designed and produced by
Quarto Publishing plc
The Old Brewery
6 Blundell Street
London N7 9BH

Senior Editor Maria Pal
Art Editor Hazel Edington

Editors Patricia Seligman, Eleanor Van Zandt
Designer Thomas Graham

Art Director Moira Clinch
Editorial Director Carolyn King

Typeset by Central Southern Typesetters Ltd, Eastbourne
Manufactured in Hong Kong by
Regent Publishing Services Ltd
Printed by Leefung-Asco Printers Ltd, Hong Kong

CONTENTS

PART ONE

TECHNIQUES

The greatest art is produced when originality of vision is fused with a high degree of technical skill. Technical excellence, however, has to be the handmaiden of vision because all the skill in the world, on its own, will not produce a great work of art. Perhaps surprisingly, this is a lesson we are having to re-learn. In the last twenty-five years or so technique has taken something of a back seat: art students have been required to channel their energy into 'creativity' – to develop a vision, the idea being that once they have something to say they will automatically find the means of saying it.

In fact, the opposite is quite often the case. Knowledge of a particular technique gives us a frame of reference with which to gauge the pictorial possibilities of what we see; and the discovery of new techniques enables us to see things in new ways.

This book is timely because it coincides with the rediscovery both of the importance of technique and of the fundamental role played by drawing in the artist's repertoire. It is structured so that the first section lists, in alphabetical order, the drawing techniques that are, or have been, most widely used. As well as showing what is technically possible, this method of organization enables the meaning of individual techniques – 'scraperboard' or 'sfumato', for example – to be looked up in just the same way as any reference book would be used.

I hope that you will experiment with the various techniques described and find out for yourself how these can develop and extend your approach to drawing. Students often say that although they can see what they want to draw, they can't actually do it. They feel that what is holding them up is some failure of method, and it is all too easy at this point for them to believe that drawing is a special gift possessed by the very few. My experience suggests that when this happens the failure lies in their inability to truly see and analyze the subject, rather than not being able to make use of a particular technique.

This intimate relationship between seeing, technique and drawing cannot be overemphasized. Whatever you decide to draw has to be translated into marks on paper. These marks are constrained by the media at your disposal and your technical skill. The first section of this book is, therefore, more than just a reference section; it is a means by which you can enlarge your visual vocabulary.

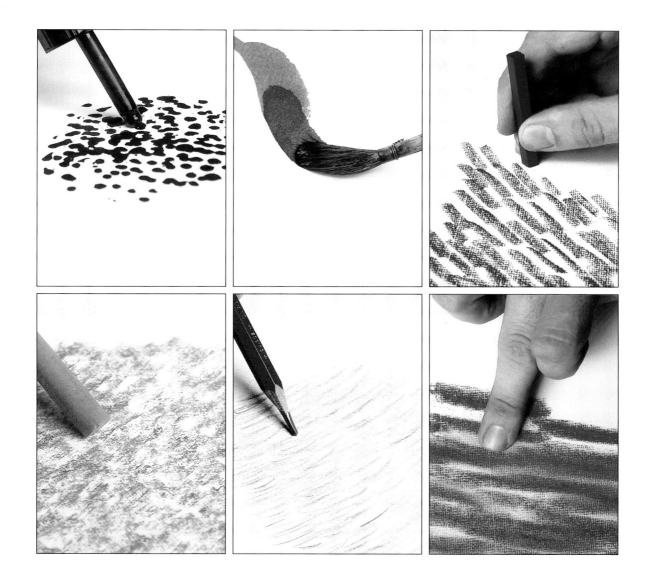

ACCIDENTAL DRAWING

Unusual visual effects can often come about by chance. Depending upon the nature of your imagination, a few marks aimlessly put on the paper may well contain rich images, evoking the suggestion of a face, a bird perhaps, or a plant. While drawing, many artists respond to such accidents and develop them as they occur, enriching the picture. A few casual strokes with a stick of charcoal over a textured paper, for example, may instantly create an illusion of the surface of a stony wall or the texture of a meadow.

It is also possible that such an effect might be noticed in a drawing in which it is inappropriate (for example, the texture of a stone wall cropping up while sketching the face of one's beloved!). In this case, where the accident cannot be exploited immediately, it needs to be filed in the memory as a technique that can be used to create a particular effect when it is required.

Some artists have taken this use of the accidental much further. For them, it becomes a fundamental part of the drawing process and is used not only to stimulate invention but also to actually initiate new work. The Surrealists of the 1930s used chance and accident to generate new ideas and images. One interesting technique they explored was to hold a sheet of paper in the smoke of a burning candle. The carbon in the smoke produced random patterns over the paper that the artist could then modify to produce unusual images.

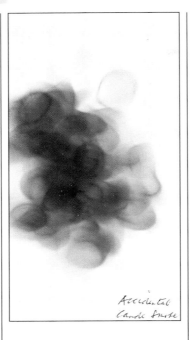

Accidental Candle Smoke

Accidental Drawing
1 An image made by repeatedly bringing the paper down horizontally over a lighted candle. Care must, of course, be taken not to set the paper alight. The smoke produces beautiful soft oval forms from which a drawing can be made. Before they are worked on, the fragile smoke marks should be carefully fixed with charcoal fixative.

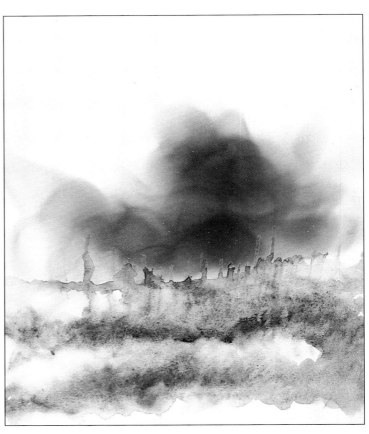

2 After studying this arrangement of smoke marks from all angles the vapourous forms appeared to the artist as billowing clouds, so he quickly used a wash to develop them into a misty landscape, full of atmosphere.

AUTOMATIC DRAWING

The practice of automatic drawing developed from the theories of automatism and is usually associated with the Surrealists and artists such as André Masson (b. 1896). Forgoing any attempt at conscious planning, marks are drawn over the paper or canvas. The pencil is allowed to record the free movements of the arm, the gestures of the artist guided by, and revealing, his subconscious. This technique was explored by the American Abstract-Expressionist artists of the 1940s, most notably Gorky (1904–48), De Kooning (b. 1904) and Pollock (1912–1956).

However, some degree of automatic mark-making is evident in the drawings of most artists. The particular way that an artist holds his pen or habitually moves his hand or arm when he draws can produce involuntary and characteristic marks. These automatic marks can identify an artist's work just as handwriting reveals its writer; and in the same way as handwriting, they give an insight into the artist's personality. The carefully placed horizontal marks made with a brush in Cézanne's watercolour drawings tell us much about the careful analytical way he attempted to record space. The more nervous, agitated marks of a quill pen in van Gogh's landscape drawings betray a more emotional response to the subject. Even if a deliberate attempt is made to eliminate automatism from drawings, it is probably impossible to achieve unless drawings are made entirely using automatic drawing instruments.

As with ACCIDENTAL DRAWING, automatism can be profitably exploited by the artist, but it needs to be used with discretion. The danger can be that the automatic marks go further than merely revealing the artist's personal imprint and instead make the drawing 'mannered', obscuring the information that the drawing is intended to convey.

Dots and squiggles drawn quickly in the centre of a sheet of paper and guided largely by impulse suggested to the artist the idea of foliage. By adding a few simple vertical strokes the automatic marks were transformed into the base of a tree.

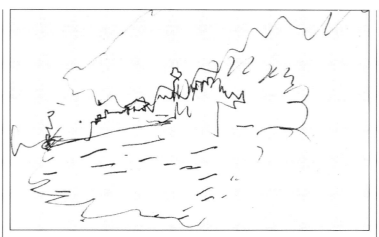

In this drawing the artist drew rapidly keeping his eyes open. The subject was again a townscape and the medium a ballpoint pen. Visual control has produced a more familiar image but the impulsive way it was drawn has resulted in vigorous and inventive marks.

The artist chose a ballpoint pen for this drawing, because it runs easily over the paper in any direction and produces an unbroken line. With eyes tightly closed the artist imagined an urban scene and allowed hand and pen to wander over the paper guided only by thought or physical impulse. The result is a lively image, clearly a townscape yet also open to imaginative interpretation.

BLENDING

To achieve a gradual transition from light to dark or from one colour to another various blending techniques can be used. The rich tones of a charcoal drawing can be merged together by rubbing them lightly with the fingertip. This smudging technique is also suited to pencil, conté and pastel drawings.

A tortillon (literally 'a twist of paper') made of tightly wound paper can be shaped with sandpaper to a point and is effective for delicate or detailed blending, especially with pastel. Try using a soft rubber eraser to blend coloured pencils.

When drawing with watercolour or ink, different techniques are needed. Washes can be blended together by laying a wet dark tone against a wet light one and letting the water do the work. This merging of wet tones or colours can be difficult to control. The secret is to have just the right degree of wetness so that only the edges of the appropriate areas blend, without the sudden flooding of one area into another. A useful tip is to damp the area with clean water before blending. If the tones are then laid in with a fairly dry brush there is less chance of flooding.

Blending can create the subtle effects that depict the softness of folds in velvet or the hard forms of a machine. In a landscape it can produce misty, atmospheric effects. But don't overdo it. Not all tonal or colour transitions need to be blended and too much use of the technique can drain the vitality and contrast from a subject.

There are two basic ways of blending together different colours or tones. One is to shade areas carefully to merge them together. The other is to shade them together roughly and complete the blending by rubbing over the areas to be joined. The artist here rubs over pencil shading with a tortillon – a piece of paper tightly rolled to make a point. This method can be particularly useful for blending small areas.

The artist blends areas of conté crayon with a tortillon. Blending using this method has the advantage, over rubbing with a finger, of keeping the drawing hand clean; the artist has more control and there is less risk of a messy end result. When blended in this way, an area of SHADING produced with hatched conté lines becomes much darker.

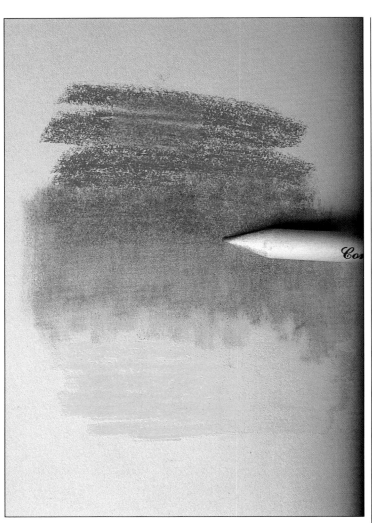

Two areas of blue and yellow pastel are laid down side by side and merged using a tortillon to produce green. The technique enables a smooth transition to be made from one hue to another.

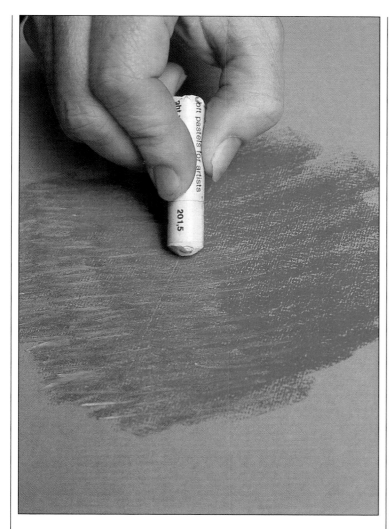

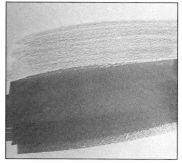

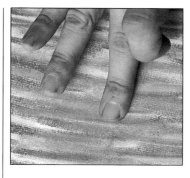

Blending • Aquarelle, Watercolour
1 A yellow aquarelle pencil is used to produce a solid patch of colour before a red watercolour wash is placed alongside.

A finger is a useful tool for blending pastel strokes together, because the pressure can be controlled very precisely. Very delicate SFUMATO effects are possible, as well as quite robust smudging and colour blending. Here red and yellow strokes are blended to produce orange.

2 Before the red wash has dried the yellow pencil is used to draw into it, producing an orange area where the colours and media merge together.

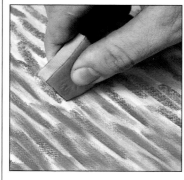

Some artists prefer to keep rubbing-in to a minimum. When pastel is rubbed in excessively, it loses its fresh appearance and looks too smooth and mechanically produced. Here the artist has completely avoided rubbing-in. The two coloured areas have been laid in with bold long strokes, and where they come together short strokes are used to roughly blend the colours while preserving the vitality of the medium.

A soft blue pastel is used to create an area of broad and broken strokes that are smudged together with a soft eraser. This method does not damage the paper and allows a delicate overall tone to be created, merging but not obliterating the original strokes.

BLOT DRAWING

Many of us will remember as children the then novel practice of putting some blobs of coloured paint onto one half of a sheet of paper and then folding the other half over the top of them. The layer of paint was squeezed in all directions and when the sheet was unfolded incredible patterns would emerge. The painter Max Ernst (1891–1976) used a similar technique, known as decalcomania, to produce some of his most famous paintings.

In fact, the use of the blot and its unpredictable nature as a means of making art has a long and erudite history. In 1786 the English painter Alexander Cozens, prompted by the writings of no less a figure than Leonardo da Vinci, devoted a whole book to it. Called *A New Method for Assisting the Invention in Drawing Original Compositions of Landscapes*, the book demonstrated how the ink-blot could be used by artists to improve and enliven the usual formulae by which they composed their paintings. A group of blots scattered onto paper could, wrote Cozens, produce an 'assemblage of accidental shapes from which a drawing may be made'.

The blots can be dropped onto the paper from a brush, a pen or stick; and the effects can be varied by dropping onto dry or wet paper. It is possible to build up a complete drawing using this technique, but it is more usual to use the technique for creating a particular effect in one section: for example, to represent foliage in a landscape drawing.

Absorbent kitchen paper comes into its own in blot drawing. First, it should be crumpled into a large ball and pressed onto an inky surface. Then, while still damp, this inked paper can be used to print a number of impressions on clean paper. The resulting blots provide interesting raw material for further development as images in their own right. They can also suggest textures that might be useful in another drawing at some later stage. In this series of images, the dendritic patterns of the first print might easily be transformed into a landscape. The second and third prints unearthed interesting textures that could be incorporated into future drawings of heavy clouds or textured rocks.

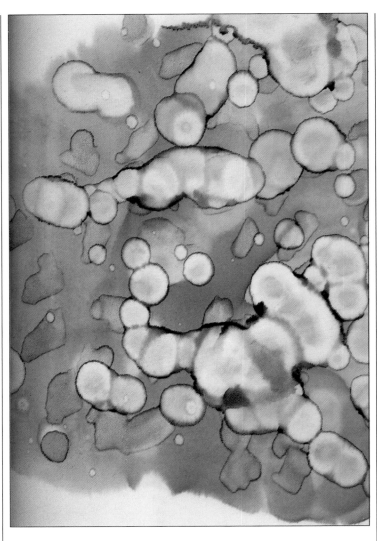

A peep through a microscope might reveal an image similar to this one. It was made by dripping solvent (lighter fuel) onto a pattern drawn with felt-tipped pens. A similar technique might be used to texture an area of foliage or water in a landscape drawing. Such a technique could also be adapted to pattern clothes or drapery for a figure drawing or still-life work.

Chinese ink diluted with water was dripped onto paper from the end of a paintbrush. This random collection of blots was then studied from different angles to see if anything came to mind. The artist realized that by adding a few brushstrokes here and there he could contrive a rocky coastal landscape. The inclusion of a boat on the left-hand side of the drawing successfully completes the blot-inspired picture.

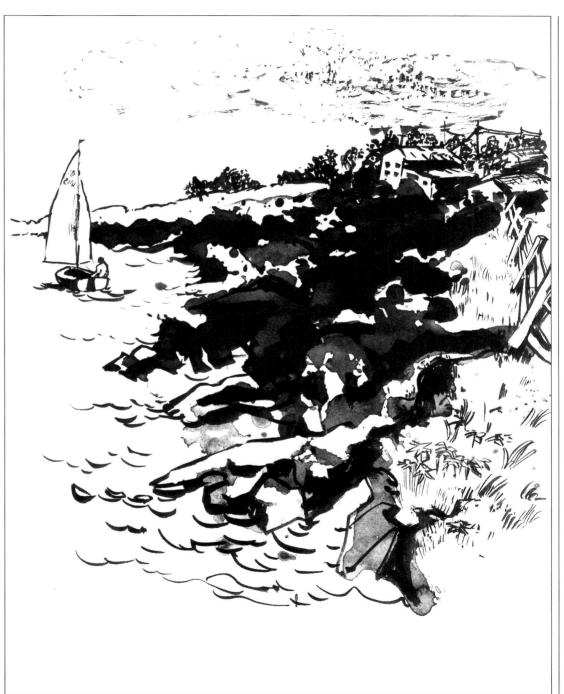

BRACELET SHADING

This method of SHADING uses parallel lines like HATCHING but the lines follow the contours of the form being drawn. To make a line drawing of an object by just copying its silhouette can easily produce a cardboard cut-out effect. To avoid this, it is necessary to use line to describe the volume of the form, which can be done by bracelet shading. The great German draughtsman Dürer (1471–1528) was one of the first to exploit this technique, although many artists since, especially engravers, have used line in this way. The shading is produced by a series of parallel lines that follow the bumps and hollows of the form being drawn. The technique is well suited to pencil, or pen and ink, but is used sometimes with pastels or charcoal.

Many sculptors have favoured this technique when examining or exploring their ideas for three-dimensional work. But its name reveals its weakness. Bracelet shading can easily make the object look as if it is contained in bracelets or cut into diagrammatical cross-sections. The bracelets don't have to be this mechanical, however: the lines can swell or thin out and they can round the form at different angles, as in the expressive drawings of Henry Moore (1898–1985).

This section of a branch was rendered in charcoal. The bracelets guide the eye around the cylindrical form and also create SHADING to convey the effect of light — enhancing the illusion of a three-dimensional form.

Pen and ink were used to draw this branch. The underlying tubular forms and the way that they intersect are clearly described with bracelet shading. The flexible pen line also shades the forms.

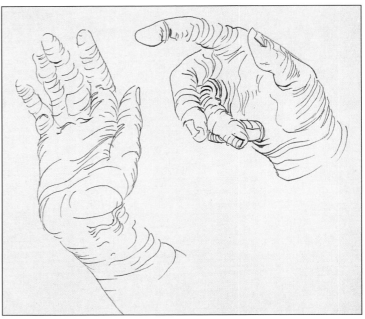

Drawing the complex forms found in the human body presents particular difficulties. Here bracelet shading conveys the three-dimensional qualities of the form, while the sepia lines suggest texture and movement.

BROKEN COLOUR

Broken colour is an effective technique when drawing with pastels. Dots and strokes of different colours can be juxtaposed or an area of solid flat colour can be brought to life by adding flecks of another. This colour effect can be further enhanced by using a tinted paper and allowing it to show through the covering of pastel.

In a monochromatic drawing a large area of uniform tone can be enlivened by being 'broken' with another tone or by making use of the texture of the paper.

Don't always obliterate the whole surface of the paper. Allowing it to be seen in places can help to unify a drawing. If white or light in tone, the light reflected from its surface can imbue the work with its own luminosity and freshness.

Broken Colour • Short Strokes

1 Short strokes of blue pastel have been applied very freely. Sometimes the stroke is a straight stroke; sometimes it is a couple of loops like a figure 3. These marks are interspersed with similar marks in yellow that will be gradually extended to produce an area of broken colour. In this kind of free drawing the marks can be of any kind; they are merely small marks the artist's hand makes naturally.

2 Using free marks similar to **1**, a third colour is introduced and the broken colour area almost completed. The aim is to achieve a sense of immediacy, and the colours are therefore applied confidently and then left with no attempt being made to blend different colours together. Overworking will make the area dull and lifeless and ruin its spontaneity.

3 The completed area of broken colour. The variety of marks and juxtaposed hues creates an impression of great vibrancy.

Broken Colour • Frottage

1 Creating texture so that breaks in one colour allow another to show through can be achieved in a number of ways. One of these is to use the frottage technique and apply the chosen medium with the paper pressed against a textured surface. Here the artist has used a yellow pastel with the paper pressed against a textured metal surface to produce an area of dots and diamonds.

2 Here the paper has been moved slightly and a red pastel used to add a second colour. This results in a pattern similar to the first colour, but the dots and diamonds are out of register.

3 The artist has repeated the process and added green. More colours could be added, but the vibrancy of the effect would be lost. The texture chosen was sufficiently open to allow each colour to break through readily.

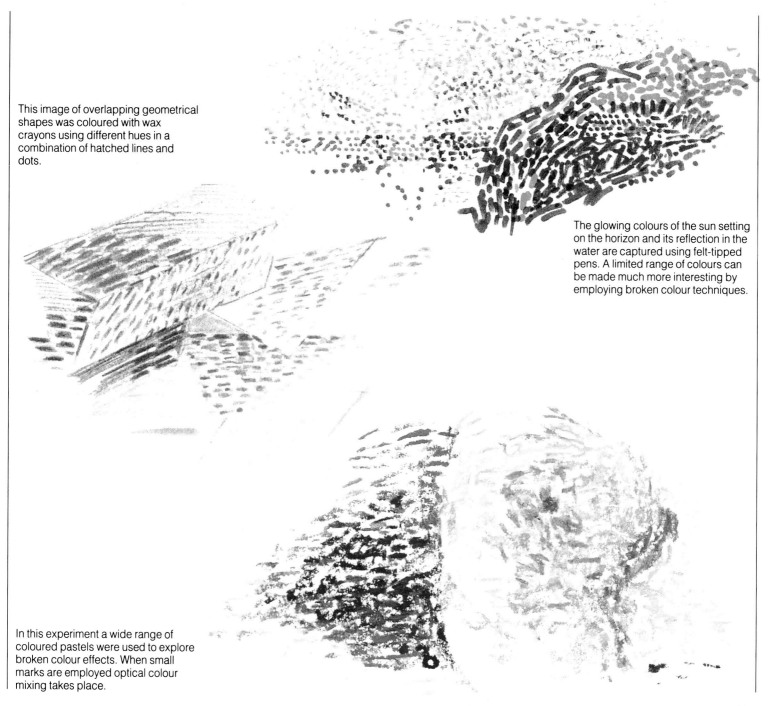

This image of overlapping geometrical shapes was coloured with wax crayons using different hues in a combination of hatched lines and dots.

The glowing colours of the sun setting on the horizon and its reflection in the water are captured using felt-tipped pens. A limited range of colours can be made much more interesting by employing broken colour techniques.

In this experiment a wide range of coloured pastels were used to explore broken colour effects. When small marks are employed optical colour mixing takes place.

BRUSH DRAWING

Working on crisp white paper with a good springy brush dipped in ink is one of the most sensual and expressive drawing techniques. The flowing lines, varied marks and capacity for rendering tone quickly and easily, all contribute to its appeal. The boldest brush drawings are made entirely with a brush, without first mapping out the forms in pencil or pen. Fluid and decisive marks are the essence of a good brush drawing. For centuries, Chinese and Japanese artists have exploited the simplicity and power of this approach. They combine tradition, spontaneity and gesture with a love of mark-making to produce beautiful and dynamic ink drawings.

Another approach to brush drawing is to sketch in the forms first with a brush and diluted ink or watercolour, so thinly that the marks can only just be seen. These guidelines can then be strengthened and built up more carefully by adding lines and washes of more concentrated ink where necessary.

By using only the tip of the brush, very fine lines can be drawn; and by increasing the pressure so that the belly of the brush makes contact with the paper, thicker lines are produced. Dragging an almost dry brush on its side across dry, textured paper produces an area of mottled tone. Known as dry brush technique, it is very useful for creating luminosity or broken colour effects in a drawing. Stipple and flecks are also part of the brush's repertoire and good examples of this can be seen in Chinese paintings of trees and foliage.

Brushes are made of different materials, such as sable hair, bristle or nylon and come in all manner of shapes and sizes. The marks that can be made with these are of almost equal variety.

For work using the dry brush technique the brush should be dipped in the paint or ink and then either shaken dry (with care, as the paint may fly a long distance) or blotted dry on absorbent paper or rag. Some slight moisture must of course be retained or no mark will be produced. The kind of mark depends on the brush used and the degree of moisture contained in it. In this example the artist has produced dry brush lines that range from the almost imperceptible through to two strong bold lines, with the surface of the paper showing through the strokes to give a textured finish.

A round no. 8 sable brush dipped in brown ink has been used to produce a variety of straight and curved marks by adjusting the amount of pressure applied. Some interesting accidents have occurred, as in the 'pen-nib' shapes on the right-hand side, where the brush was swiftly swept across the paper barely touching it.

Using a no. 9 round sable brush, the artist has experimented with a number of different techniques: varying the pressure on the brush produces lines that can be thick or thin in one continuous stroke, or blots and dots of different shape and weight; and an almost dry brush gives a broken effect, as in the curved strokes at the bottom of the drawing. A range of marks like these might be used to produce linear drawings with a strong emphasis placed on the textures of the objects.

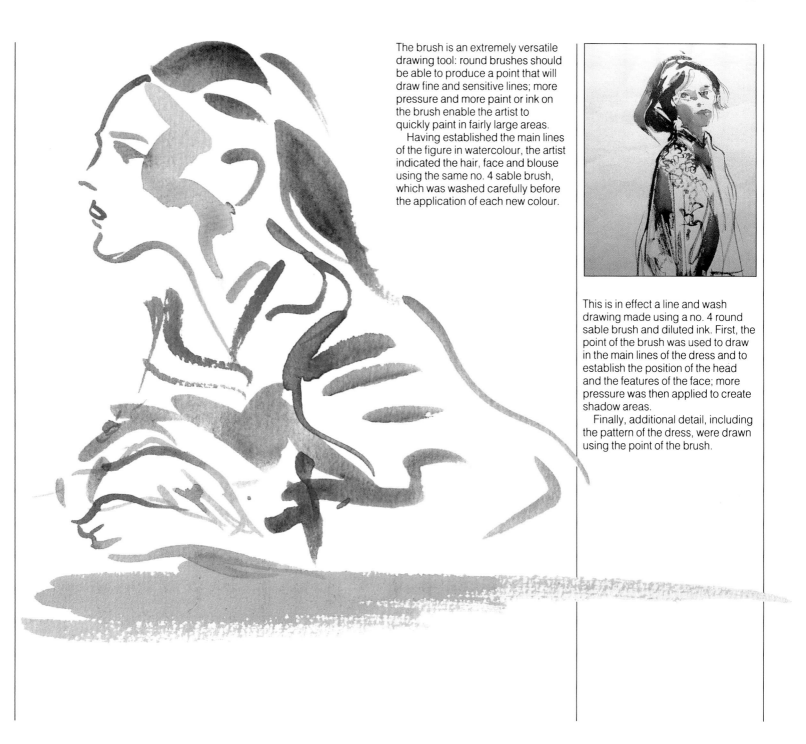

The brush is an extremely versatile drawing tool: round brushes should be able to produce a point that will draw fine and sensitive lines; more pressure and more paint or ink on the brush enable the artist to quickly paint in fairly large areas.

Having established the main lines of the figure in watercolour, the artist indicated the hair, face and blouse using the same no. 4 sable brush, which was washed carefully before the application of each new colour.

This is in effect a line and wash drawing made using a no. 4 round sable brush and diluted ink. First, the point of the brush was used to draw in the main lines of the dress and to establish the position of the head and the features of the face; more pressure was then applied to create shadow areas.

Finally, additional detail, including the pattern of the dress, were drawn using the point of the brush.

BUILDING UP

Drawings often need to be 'built up' in stages. To an extent, all but the quickest sketches have to be developed in this way, but it is particularly so with pastels, crayons, charcoal and chalk, where the medium itself usually requires that several layers are applied one on top of the other with the drawing being fixed at each stage.

This building up serves two purposes. It stops 'soft' media from being smudged by your hand. It also enables richer tones and (in the case of pastels and chalks) colours to be built up. Building up preserves the vitality of hastily scribbled areas of tone and allows the effects of HATCHING and BROKEN COLOUR to be exploited. Wash drawings can be built up by diluting the initial wash. When dry, more concentrated watercolour or ink is applied, building up the tone where necessary.

A description of the method of building up a pastel drawing will also serve as a description for using crayons, charcoal and chalk. Following an initial blotting in of the shapes and directions, the main colour areas of the drawing should be laid in. This process can be carried out either by scribbling with the pastel stick or, if a more uniform effect is required, using the pastel stick on its side. When the layer of pastel begins to be thick enough on the paper for there to be a fine dust on the paper surface, carefully blow off the dust and fix the drawing, either by using a mouth diffuser and blowing colourless fixative (a thin varnish) onto the drawing or by spraying direct from a fixative aerosol can. The application of fixative usually makes the pastel (or other soft media) appear slightly darker. If applied too generously, the fixative will make the surface of the drawing greasy, and it will lose its freshness. Fixative is only needed for soft pastels and crayons. Oil pastels and similar crayons that do not 'powder' or smudge easily can be built up merely by putting layer over layer.

Building Up • Pastel
1 With some drawing media, particularly chalks, pastel and crayons, it is often necessary to build up areas of colour by applying several layers to obtain a required density or tone. With the media mentioned it is often best to apply at least the first layer by using the stick on its side, as the artist is seen doing here to lay a series of broad stripes of colour.

2 In the next stage the pastel is applied in broad stripes at right angles to the first ones. Gradually the striped effect is lost and a more uniform area of colour results.

3 In the final stage stripes are applied in the same direction as in the first stage. Care is taken to eliminate the joins between stripes produced in the first two stages so that a completely flat, uniform area of colour is produced. In this series of drawings the pastel was not fixed between each stage, but with a more complex drawing it would be usual for fixative to be sponged or sprayed on after each stage to ensure that the medium is not smudged or partly removed by the building up process itself.

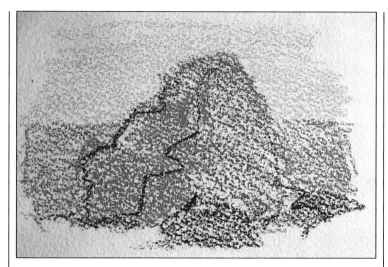

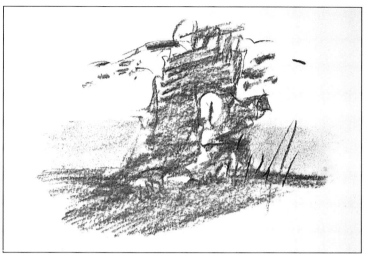

Building Up • Oil Pastel
1 The main colour areas of this oil pastel drawing have been blocked in and then fixed (although fixative is not usually associated with this medium).

The artist chose a grainy watercolour paper to work on, which accepts the pastel more readily than smooth paper when layer is placed upon layer.

Building Up • Charcoal
1 To achieve really intense darks in charcoal usually requires at least two stages of building up, with fixative applied after each stage. In

the first stage of this drawing the artist has freely drawn all the main elements and established the basic tonal areas.

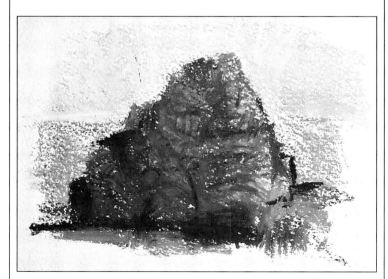

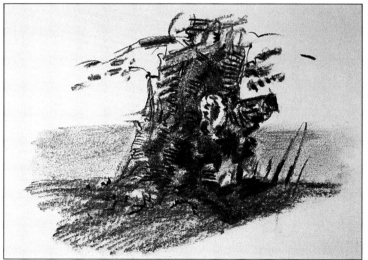

2 More colour is added to the drawing, building up the intensity and density of the pastel. In some parts of the drawing the oil pastel is

quite thick, in others the paper breaks through. This variety stops the drawing from becoming too dense and overworked.

2 In this stage some of the original drawing has been left untouched but the dark areas have been drawn over to give greater depth and

intensity. Building up a drawing in this way also assists the artist in creating a unified image.

BURNISHING

This technique is normally used with coloured pencils. After the colours have been put down on the paper they are rubbed with a tortillon. Apart from blending the colours together, this actually makes the pigment particles even finer and produces a smooth polished appearance. By layering colours one over another, and burnishing each in succession, a very smooth marble-like surface can be produced. White pencil is often burnished over an underlying colour to produce a more muted hue.

Pastels can also be burnished but need fixing after each layer has been completed. Try using an eraser or the back of a spoon to blend and polish the pigment.

Remember to take care when burnishing because it is quite easy to rip the paper when applying the firm pressure that is needed.

A tortillon made of stiff paper enables firm pressure to be applied. The sharpened point also allows sensitive control when burnishing small areas. Here blue pencil is burnished to a smoother, paler tone.

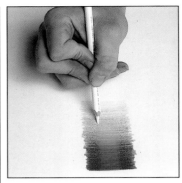

A patch of magenta coloured pencil is burnished with white. A thin strip of paler tone results, optically affecting the original colour, which appears softer and less saturated.

A firm plastic eraser makes a useful burnishing tool. Here, strokes of green, yellow and orange coloured pencil are blended together and softened.

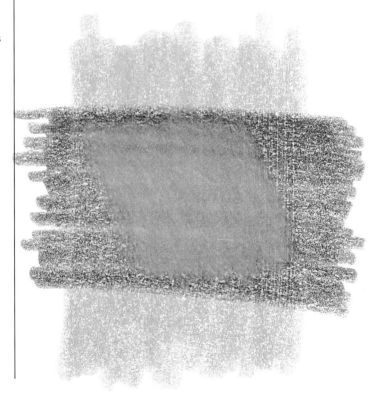

Red pencil shaded over yellow has been burnished with a white pencil. The pressure blends the colours, producing a soft hazy orange.

CONTOUR DRAWING

This method involves using line to describe the three-dimensional qualities of an object. The line must indicate the thickness of the form it surrounds and not simply the length and width.

Take a drawing of a head, for example. An inexperienced artist will often use line to do two things: firstly, to describe the extreme edge or outline of the head, known as the silhouette; secondly, to outline the major features within that silhouette, such as the eyes and lips. In a drawing approached like this, although all the features are indicated, to the viewer the face and head appear flat. There is no information in the drawing to tell us that a head is actually rounded, and we therefore use our own knowledge to make up the deficiency.

This is where the contour line is needed. Imagine moving your finger over the surface of a face, across the

bumps and hollows. Now use a line to track the movement of this finger. The line does not just keep to the edges but goes across the forms, indicating where the surface of the object is closer to you or further away, where it is curved and where it is flat, following the sense of touch.

If you drape a piece of striped fabric and then draw it by copying the stripes and not the edges, you will see how the stripes become contour lines and create a sense of three-dimensional form; but don't put stripes around everything you draw. Contour drawings by artists such as Ingres (1780–1867) or Picasso (1881–1973) make very subtle changes in the width and weight of line so that the fullness of the forms contained within are indicated. With a subtle outline only a few contour lines are needed to suggest the third dimension.

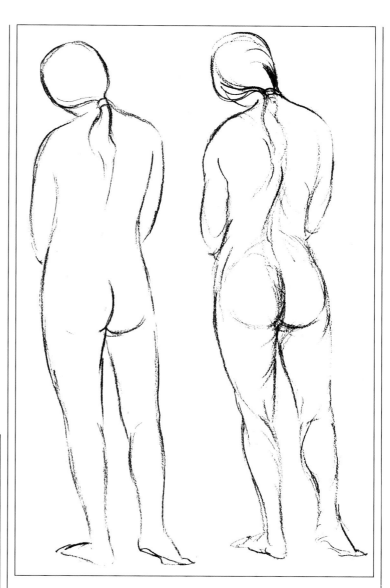

Here contour line is added to the charcoal outline of the figure. Contour line is particularly useful when drawing the human form because it is able to describe the three-dimensional construction of the body, indicating the way in which forms turn and twist into one another.

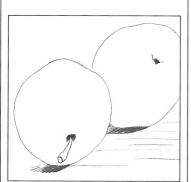

Contour Drawing • Felt-tipped Pens
1 Felt-tipped pens were used to record only the outlines of the two apples. A basic drawing like this conveys very little information about the three-dimensional qualities of the forms, and the fruit looks flat.

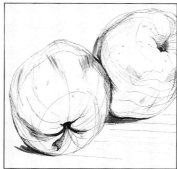

2 Again using coloured felt-tipped pens, the artist has redrawn the apples and introduced contour lines to map out the curvature of the fruit, explaining its form.

CORRECTIONS

Drawings do not have to have all the 'errors' removed. There are many line drawings, by artists such as Ingres, Degas (1834–1917) or Matisse (1869–1954), where several attempts at, for example, positioning the leg of a figure have been left in the final drawing. These are known as *pentimenti* and, curiously, they enhance the end result, rather than detracting from it.

There are times, nevertheless, when necessary corrections cannot be made without removing or obliterating what is on the paper. The most usual way is by using an eraser (there are several kinds with different degrees of hardness). Sometimes a hard eraser is sufficient to remove ink, but more usually a sharp knife or razor blade is necessary to scratch off the ink. Opaque white paint (gouache or acrylic) will obliterate most forms of drawing; and when all else fails the relevant piece of paper can be cut from the drawing and an identical piece inserted in its place. The new piece is attached by sticking gumstrip on the back of the drawing.

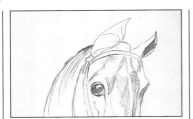

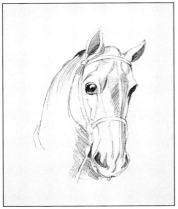

The artist was halfway through this pencil drawing of a horse's head when he decided that one ear was in the wrong position. Using a kneadable eraser, he completely removed that part of the drawing before re-drawing the ear in the correct position.

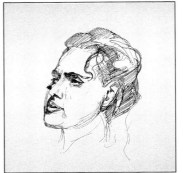

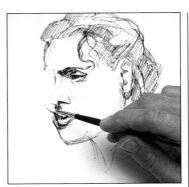

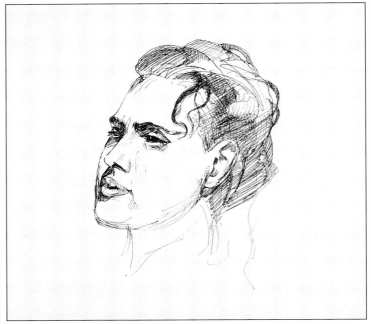

While the artist was making a bold pen and ink drawing a blot of ink disfigured one side of the face. He decided to correct this and the position of the eye above it. Using an opaque white paint called process white he paints out the area to be corrected. Once the paint has dried thoroughly the lines are redrawn and the portrait completed.

CROSSHATCHING

This form of SHADING is a development of HATCHING and combines two or more sets of parallel lines, one set crossing the other at an angle. It is a technique employed extensively in engraving and etching when tone is produced through linear means as opposed to stipple or aquatint. It is commonly used in pen and ink drawings.

At one time artists were taught to crosshatch their lines at a regulation 45° angle and in black ink only. There is no need now to adhere to such strict practices, which were really conventions related to commercial engraving. All kinds of linear media can be used to crosshatch, including ballpoint pens, felt-tipped pens and fine brushes. Lines don't have to be straight. For example, try cross-hatching curved, zig-zagged or dotted lines with coloured ink or felt pens.

When using black Indian ink and a nib pen, very dense tones can be built up by crosshatching in multiple directions. Because the white of the paper is not completely obliterated, the tone retains a luminosity that is one of the assets of this technique.

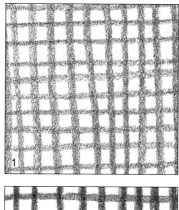

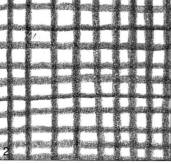

The effects produced by crosshatching can be varied by changing the angle of the intersecting lines. In example 1 crosshatching has been applied vertically over horizontal hatching. Note the difference in example 2, where the same effect has been executed with heavier strokes.

Example 3 shows crosshatching laid at a 45-degree angle to vertical hatching. The angle can, of course, be altered, as in example 4 where a more acute angle is used.

Examples 5 and 6 demonstrate hatching and crosshatching involving the three primary colours. Apart from creating an intriguing texture, the overlaid strokes produce secondary colours where they mix on intersection.

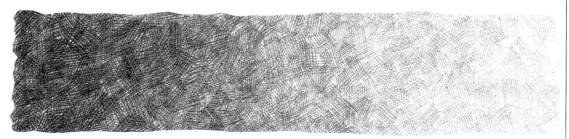

This crosshatched tonal scale indicates the degree of nuance that can be achieved with the technique. Despite the fact that the only medium used was a black pen, variety and gradations in tone were accomplished by varying the line density and the amount of pressure applied.

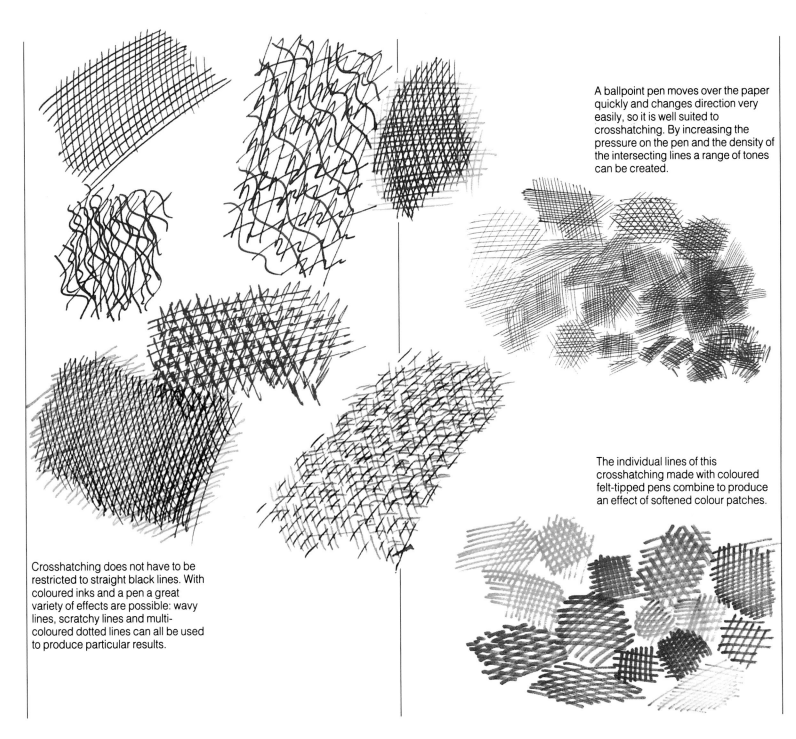

A ballpoint pen moves over the paper quickly and changes direction very easily, so it is well suited to crosshatching. By increasing the pressure on the pen and the density of the intersecting lines a range of tones can be created.

The individual lines of this crosshatching made with coloured felt-tipped pens combine to produce an effect of softened colour patches.

Crosshatching does not have to be restricted to straight black lines. With coloured inks and a pen a great variety of effects are possible: wavy lines, scratchy lines and multi-coloured dotted lines can all be used to produce particular results.

DOODLES

These are scribbles made while your mind is at least partly on something else. The word is derived from the French for simpleton. Many people doodle while they are on the telephone, during a meeting or lecture, or when listening to a boring speech. Doodles can border on the random, but there is usually a degree of control in doodles that distinguishes them from pure accidents.

Doodles often take the form of quite elaborate patterns or wandering lines. Sometimes something already on the paper starts off the doodle, perhaps a letterhead or a stain from a coffee cup. This is then modified into a recognizable object or merely decorated. Doodles can range from abstract patterns to rude drawings and humorous sketches.

However, there is a serious side to doodles, in that they may contain unusual and remarkable combinations of images, rather like dreams or thought patterns made visible. For this reason, they are sometimes used in psychoanalysis to reveal aspects of a patient's subconscious world. The AUTOMATIC DRAWINGS of the Surrealist artists are related to doodling. The Chilean artist Matta (b. 1911) has produced enormous canvases full of gigantic doodle-like images and gestural washes of colour.

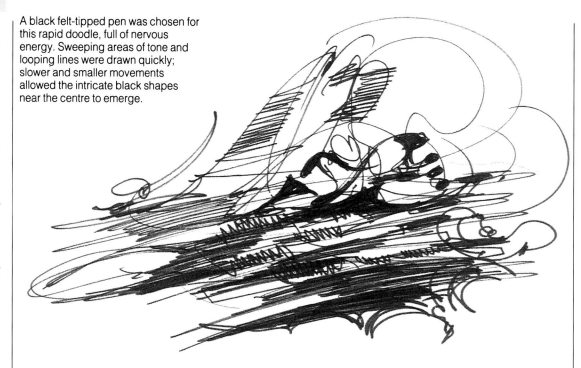

A black felt-tipped pen was chosen for this rapid doodle, full of nervous energy. Sweeping areas of tone and looping lines were drawn quickly; slower and smaller movements allowed the intricate black shapes near the centre to emerge.

The ubiquitous ballpoint pen is often the medium used for drawing doodles. This doodle is full of swirling, wandering lines, produced as the red ballpoint literally rolled around on the paper.

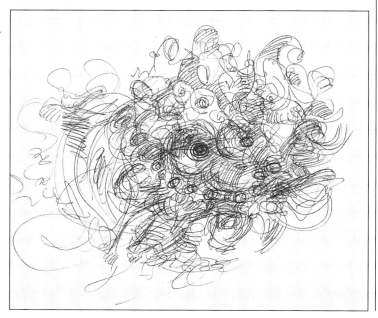

FEATHERING

Feathering is a technique whereby an area of tone or colour is lightly drawn over with the same or another medium so that the original area shows through. The technique involves making delicate diagonal hatched strokes over the underlying colour, keeping the wrist loose and using the lightest touch.

It might be used to enrich a rather flat and dead passage in pastel or crayon. In a black and white drawing, white conté can be feathered over a dark area to lighten it slightly and produce a more subdued effect. Feathering is good for softening hard edges or for making transitions from light to dark. The name is derived from the fact that the overlaid colour looks as if it has been brushed on with, and actually resembles, the barbs of a feather.

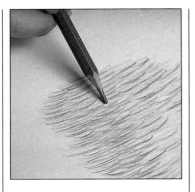

An area of short and delicate HATCHED strokes has been drawn with a green coloured pencil. A purple pencil is then used to feather short contrasting strokes across it.

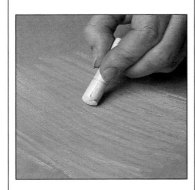

On tinted paper a delicate layer of yellow pastel strokes has been overlaid with a bright pink pastel. The artist is adding further yellow to the area by feathering across it.

An elaborate form of feathering has been successfully employed for this pastel drawing of a nude (right). Broad areas of pale colour were blocked in to indicate the main shapes. Once the correct proportions had been established, the artist then began to develop the colour. Small vertical strokes were feathered and HATCHED onto the underdrawing. The detail (below) shows how the accumulation of strokes has modified the basic colours, producing subtle and subdued mixtures. Apart from the colour effect, the vertical strokes provide an interesting contrast to the horizontal emphasis of the subject herself.

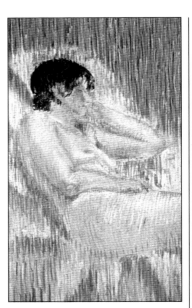

FINGER DRAWING

For many people, drawing or painting with the fingertips in place of a pen or brush has associations with childhood and infant school art lessons. It normally involved getting more paint on hands, face and clothing than on the paper. But consider some cave paintings or Chinese ink drawings where fingers have been used to create beautiful works of art. It is possible to make some very sensitive finger drawings with the right medium, or to use finger marks in conjunction with other techniques.

Powdered graphite or pastel can be applied and blended very delicately with the fingers. While making charcoal drawings artists often smudge tones together or dust off heavy tones with their fingers.

An inky finger dragged lightly over a rough textured paper creates a drybrush effect. On a large drawing the tip of the little finger can be used for stipple and flecking. Turner (1775–1851) is reputed to have grown one finger nail exceptionally long so that he could use it to scratch out highlights in his watercolour sketches.

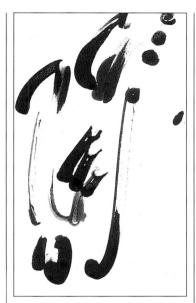

These calligraphic marks were produced by dabbing a finger in a saucer of ink and drawing with it swiftly and surely. Note the soft breaks in the line produced where the finger scarcely touched the paper.

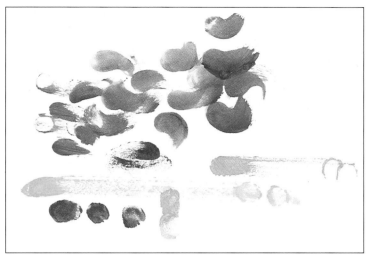

Oil paint can be thinned out with white spirit to produce a colourful and transparent medium that is well suited to the bold and decisive marks produced by finger drawing. The paint is absorbed quickly and does not flow across the paper as readily as ink.

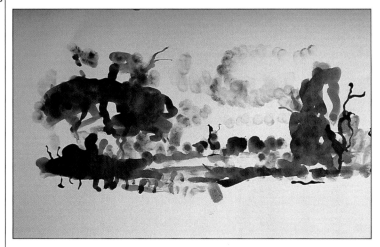

Brown Indian ink has been poured onto a sheet of paper and a finger used to spread it out and draw into it. Prints from the inky finger are also incorporated into the drawing.

The sensitive way fingers can spread ink or paint is particularly suitable for describing soft clouds and the rounded forms of foliage in a landscape.

FROTTAGE

This technique is used in drawing to obtain textured effects. Its origin as a technique for making art is normally attributed to the German Surrealist Max Ernst. He is reputed to have had the idea while staring at some scrubbed wooden floorboards. The prominent grain stood out like the lines in a drawing, and when he made a rubbing the inherent shapes within it inspired all kinds of images. By means of frottage, he transformed commonplace textures into drawings full of fantastic creatures, unusual forms and foliage.

A frottage can be produced from almost any firm surface on which you can place your paper. Wooden boards, textured metal, meshes and fabrics like hessian give good results. Most dry media are suitable for making the rubbing and soft pencils or conté crayons are particularly effective. Frottage techniques can also be used in conjunction with coloured pastels to produce broken colour effects.

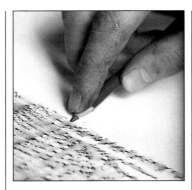

Frottage ● Woodgrain
1 Paper has been laid on the rough end-grain of a sawn tree trunk and shaded with a soft pencil to produce a textured area.

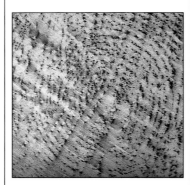

2 The growth rings of the tree are clearly visible in the completed pencil rubbing when viewed from a distance.

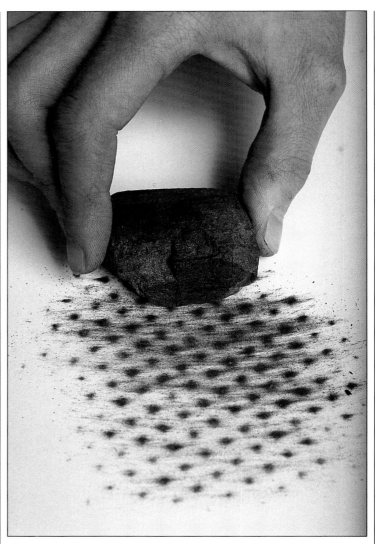

The artist produces a texture of dots and diagonals by using a large piece of charcoal to draw over paper placed on textured metal. An area of BROKEN COLOUR was produced by the same technique, using coloured pastels.

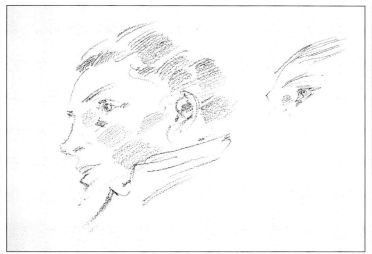

Before starting this portrait a sheet of coarse glass paper was placed beneath the drawing paper. Using a 4B pencil and firm pressure a grainy texture was imparted to the lines and patches of tone.

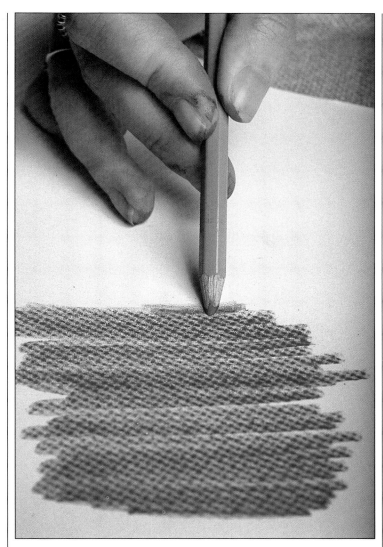

A piece of hessian has been placed underneath the sheet of paper. As the artist draws across the paper with a coloured pencil the texture of the fabric is revealed.

All sorts of surface are worth exploring to find interesting textures. Conté crayon and frottage on the back of a sheet of lino produced this example.

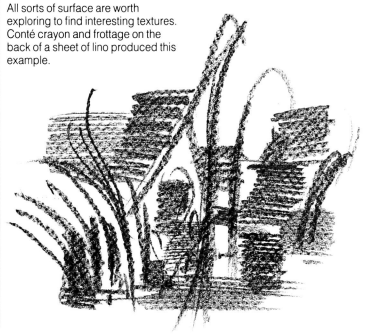

GESTURAL DRAWINGS

These are drawings made with speed and spontaneity. The marks on the paper are a record of the artist's physical gestures, emotions and personality in response to his subject. A gestural drawing does not set out to describe the subject in a detailed way but uses sweeping strokes and dashes to convey its essence. The vitality in such drawings stems from the bold movements of the artist's wrist or arm, as the subject matter is translated into rhythmical lines.

Fast drawings like these can be used to interpret the sense of movement of a skater, athlete or dancer. The gestural brush drawings of the artist Constable (1776–1837), on the other hand, convey the fleeting patterns of light and shadow in the landscape.

When making a gestural drawing, don't bother to correct it if it does not seem quite right. Start again on another sheet and be even more decisive and spontaneous. Choose a soft medium such as charcoal or use a Chinese brush with which you can draw freely and quickly.

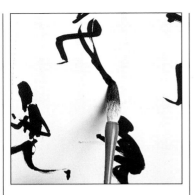

Gestural Drawings • Ink
1 The free movement of the hand produces great vitality and a feeling of movement in figures rendered using a Chinese brush and ink.

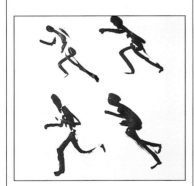

2 The completed sheet of brush drawings. The artist allowed his hand to express the movement of the athletes, rather than being overly concerned with accurate descriptions of them.

Gestural drawing is frequently used to describe figures in action. The rhythmical brushstrokes in this drawing not only capture the movement of the cellist but also express the pulse of the music.

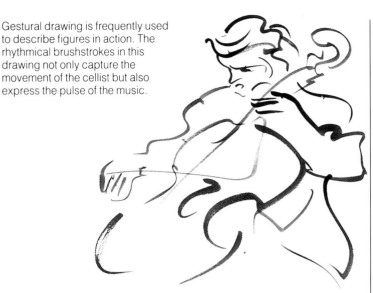

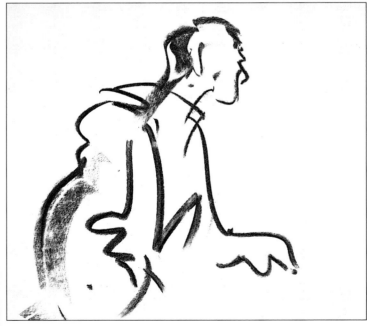

The charcoal stick is one of the most effective of the dry media for gestural drawings. Bold responsive lines can be put down quickly, as in this figure drawing. Using the side of the stick produces areas of shade.

GRADATIONS

These are smooth transitions from a light to a darker tone or from one colour to another. The ability to make these smooth transitions is most important if rounded forms are to be drawn realistically. The most complex arrangement of these forms occurs in the human figure, but vases, kitchen utensils, fruit and vegetables – the familiar objects in a still-life drawing – all have rounded forms. When drawing landscapes the ability to recreate the forms of trees and shrubs depends on subtle tonal and colour gradations. The representation of sky and sea, too, frequently requires the use of gradation.

There are various ways in which these transitions can be made. With BLENDING techniques, for example, watercolour and ink washes can be graded by controlled addition of water onto the paper, or by blotting with absorbent tissue. HATCHING can also produce gradations of colour and tone, as can STIPPLING. It is possible to produce very smooth gradations using different grades of pencil on a medium-tooth paper. With pastels, coloured pencils and conté crayons, white can be blended in to lighten a tone or colour.

Coloured pencils are ideal for producing gradations of colour. The left-hand column was achieved using considerable pressure on the pencil, and the right-hand column by using very little pressure.

This gradated wash of blue ink was produced with the drawing board tilted at a slight angle, to help merge individual brush strokes. First, a stroke of pure ink was brushed onto slightly dampened paper. A second brush-load of diluted ink was then applied below it, with the procedure repeated a number of times using increasingly diluted ink.

A combination of a B pencil, a 4B pencil and vigorous rubbing with the finger has produced a smooth tonal gradation containing very delicate greys and a rich black.

HATCHING

Hatching is a form of SHADING carried out using parallel lines placed closely together to produce the effect of tone. These can be meticulously ruled or drawn quite freely. The lines may be thick or thin but the width and weight of line and the density of the hatching can be varied to create a range of tones. When hatching a figure drawing, for example, the lines may curve slightly to follow the contours of the form, in a similar way to BRACELET SHADING.

The essential feature of hatching is that no attempt is made to blend the lines together. It has traditionally been used in tempera painting, in pen and ink drawing, and can be used with pastels and other point media. The broken nature of hatching, when seen at a normal viewing distance, can produce a more vibrant quality than flat areas of tone. Like CROSSHATCHING, variety is important and it is worth experimenting with different media, colours and types of line.

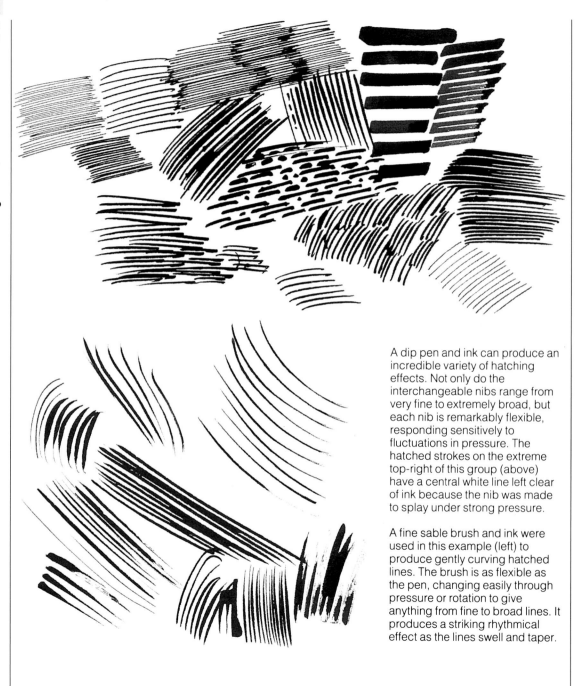

A dip pen and ink can produce an incredible variety of hatching effects. Not only do the interchangeable nibs range from very fine to extremely broad, but each nib is remarkably flexible, responding sensitively to fluctuations in pressure. The hatched strokes on the extreme top-right of this group (above) have a central white line left clear of ink because the nib was made to splay under strong pressure.

A fine sable brush and ink were used in this example (left) to produce gently curving hatched lines. The brush is as flexible as the pen, changing easily through pressure or rotation to give anything from fine to broad lines. It produces a striking rhythmical effect as the lines swell and taper.

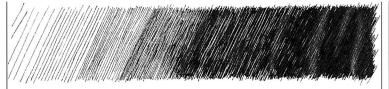

By varying the density of this freehand hatching the artist achieved a GRADATED range of tone. Depending on the choice of pen or nib, different textures are produced.

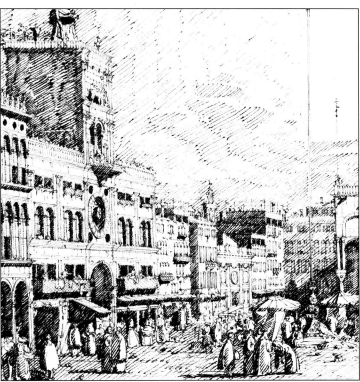

This drawing by the eighteenth-century Venetian artist Canaletto shows a virtuoso performance of hatching. Diagonal hatching with a nib-pen creates the effect of sunlight falling across the Piazza San Marco. Such lively hatching can add a feeling of movement to an otherwise static composition. In this way the direction of light rays — or even falling rain — can be emphasized.

More formal hatching, consisting of strictly parallel lines, can be drawn using a ruler. Example **1** shows different densities of ruled black-ink lines. A ruler was also used to draw example **2**, but this time employing different-coloured pencils with a black ink line interspersed between them at the lower end of the scale. The softer coloured lines produced by felt-tipped pens were used for the ruled hatching in example **3**. Individual lines placed close together merge when viewed from a distance, enabling bands of colour to be subtly modulated.

HIGHLIGHTING

Highlights are the tiny brilliant reflections of the light source that can be seen on shiny objects. They could be the reflections of sunlight on a pool or on the glasses on a table beside it. Glass, highly polished metal, water and wet surfaces will often have highlights and they are always the most brilliant and lightest points in the subject. In drawing, they usually have to be pure white, which means that they must be represented by the paper itself or by adding white highlights using white paint or pastel as the drawing develops.

Depending on the medium being used, highlights can be produced by using an eraser to remove tone and get back to the paper surface, but with some subjects it may be possible to identify where the highlights are to appear and deliberately leave that area of the paper untouched from the outset. Masking tape or masking fluid can be used to retain the highlights in a drawing, preserving the whiteness of the paper beneath it.

Generally, highlighting is putting the final touches to a drawing. It is giving it those last features that add sparkle and bring the drawing to life. It may involve adding a tiny touch of white to the eyes in a portrait or lifting out tone with an eraser to create ripples on a lake. To ensure that the highlights do not 'jump out' from the drawing, they need to be in keeping with the way the drawing has been made and – particularly where white paint is used in a drawing made on off-white paper – it is essential that the highlights do not appear to be detached from the drawing. Sometimes, very light shading over the paint or a very thin wash (depending on the medium used in the drawing) may be necessary to make the highlight more subtle and integrate it into the drawing effectively.

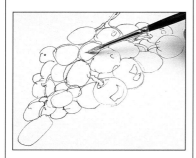

Highlighting • Masking Fluid
1 The basic outline of a bunch of grapes is drawn with pen and ink. Using a small sable brush the artist paints masking fluid where there is to be a highlight.

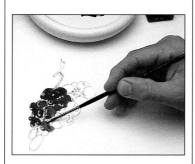

2 Once the masking fluid is dry an ink wash is put down to develop the tonal qualities of the drawing.

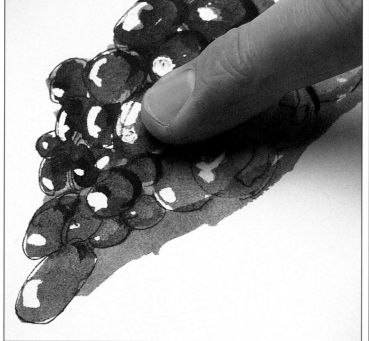

3 Making sure that the ink wash has dried completely throughout the whole drawing, the artist then carefully rubs the drawing with his finger. The rubbery masking fluid peels away to reveal crisp white highlights.

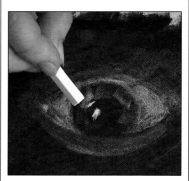

The artist uses a white conté crayon to create the glistening highlight on the pupil in this very dense tonal drawing of an eye.

IMPRESSING

Place a sheet of paper over a soft surface such as a rubber mat or folded sheets of newspaper and draw on it using a blunt stylus. A nail with the point filed down and rounded could be used or, alternatively, the end of a small paintbrush handle. The stylus needs to be sharp enough to make an impression in the paper but not so sharp that it tears it. A more manageable tool in hardwood or metal could be made if this technique was to be used extensively.

After making this invisible drawing, lightly shade over the paper's surface with, for example, charcoal, crayon or chalk. The impression in the paper will remain untouched and appears as a white line through the applied tone or colour. If you substitute a tinted paper, a coloured line will result. Powdered graphite, charcoal or pigment can also be rubbed across the surface, or ink applied using a hard roller.

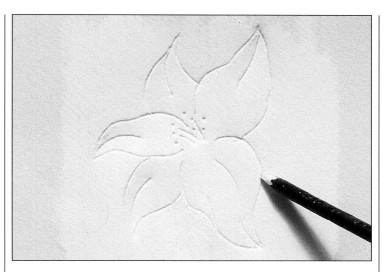

Impressing • Coloured Background
1 A fluorescent yellow felt-tipped pen was used to tint the white paper before drawing with a sharpened paint brush handle.

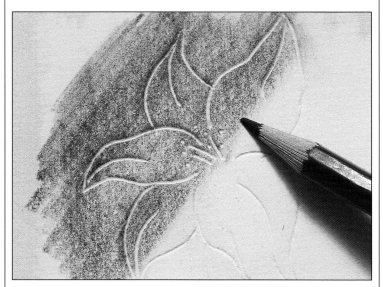

2 Using a purple pencil the artist adds some light SHADING. The impressed drawing now appears as a bright yellow line on a brown ground.

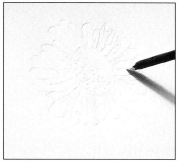

Impressing • White Background
1 Using the sharpened tip of a paint brush handle and firm pressure, the artist impresses the outline of a flower into the surface of a sheet of white paper.

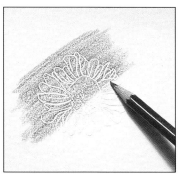

2 Red coloured pencil is then used to lightly shade across the impressed drawing. The valleys of the impression are not touched by the pencil and so appear as a white line.

LIFTING OUT

Lifting out is a technique for removing areas of tone in a drawing to reveal the white paper underneath. It is often used when drawing with charcoal or conté crayon, to introduce a highlight into an area of tone. A pliable rubber eraser is generally the most effective method because particles of charcoal can be lifted cleanly off the paper without too much rubbing. For lifting out small detailed highlights shape the eraser into a point. A tip to remember is that soft bread is useful for 'softening' an area of tone that is too dark. Alternatively, masking tape rubbed gently onto a pastel drawing will lift off the pigment and produce a paler tone, but care is needed to avoid damaging the paper.

It is also possible to lift out highlights when using soluble ink or watercolour. While the wash is still wet, lift out the paint or ink from the paper with a dry sable brush. A more absorbent material such as a sponge or blotting paper removes wet paint completely, producing bright highlights. If a crumpled tissue is pressed onto the wet image a variety of textures is produced. Should the wash have dried it can be dampened with clean water applied carefully with a sponge or a clean brush; after a few seconds the area will be wet enough for the paint or ink to be removed.

If a sheet of paper is completely covered with charcoal a putty eraser can be used to draw an image that will appear in white on the dark charcoal background.

A wash of dark blue ink has been applied. Before it dries the artist uses a small cotton wool swab to lift out patches of ink.

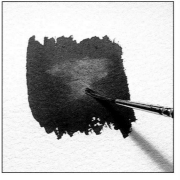

A completely dry brush touched onto a patch of wet ink or watercolour will soak up a small amount. Here the technique has been repeated several times to lift out a large patch that appears as a paler tone.

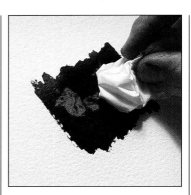

Absorbent paper such as kitchen paper or, in this case, tissue will lift out areas while a wash is still wet to give a textured effect.

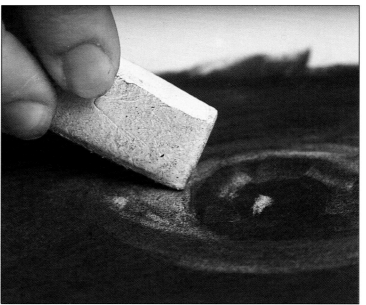

The white of the eye in this drawing is being made by lifting off the particles of charcoal with a kneadable eraser.

LINE AND WASH

There are no rules to say that you have to restrict yourself to a single medium in a drawing. It is both interesting and constructive to try out combinations. One traditional combination many contemporary artists still exploit is line and wash. The line might be produced with pencil or pen and the wash is usually diluted ink or watercolour. The artist has at his fingertips all the flexibility and expressive potential that line can offer and the facility to render tone, light and shade or colour rapidly with a wash. Unlike a tightly rendered drawing, line and wash drawings suggest far more than is actually revealed They capture the viewer's own imagination, allowing him to play an active part in the work.

The biggest problem with line and wash drawing is to achieve a unity between the two media. It is difficult to avoid producing a drawing which looks as if the tone has been merely added as an afterthought. The secret is to develop both line and tone together. You might begin by lightly sketching in shapes and contours with line and then lay in some tones with wash. Then draw back into this with more decisive line work and strengthen the tones with bolder washes. Alternate or chop and change as much as you like and don't get bogged down with details too early on. It is possible to convey a wealth of information – texture, colour, light, form and movement – with a simplicity that is quite breathtaking.

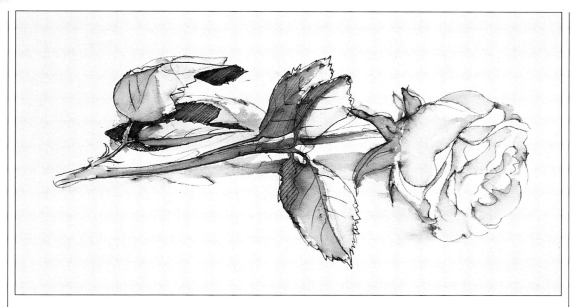

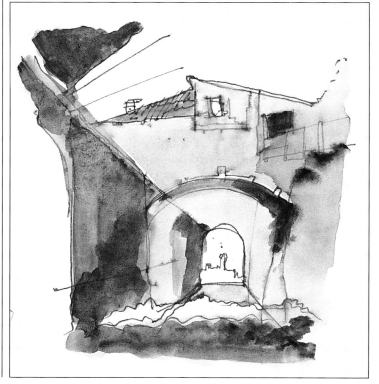

Soluble Chinese ink was an appropriate choice for this delicate sketch of a rose. The flower, drawn only in outline, was washed over with clean water to dissolve and spread the ink and produce the subtle tones. Diluted ink was added for the darker tones on the stem and leaves. Once this was dry, crisper HATCHING and line drawing modified the SHADING and indicated details.

Black ink and watercolour were combined to create this rapidly executed drawing. The first washes were added wet-in-wet to merge the tones together. Once the drawing had dried out, a dark wash was added to strengthen areas of shadow.

LINEAR MARKS

Many of the traditional point media, such as pencil and pen and ink, draw lines more easily than they produce areas of tone. However, in skilful hands, line on its own is capable of describing almost all the visual effects that can be produced in drawing. There is a vast range of linear marks possible and a great variety of media in which to make them.

The weight and thickness of line, its fluency or tentativeness, the way it can be continuous or broken, are all devices that can create effective visual illusions in drawing. One of the most engaging features of linear techniques is the way that breaks and overlaps in lines which describe the contours of an object can create an illusion of depth and solidity of form. Figure drawings by Ingres, Degas, Matisse and Picasso are excellent demonstrations of this.

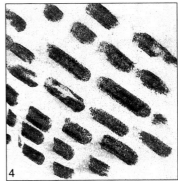
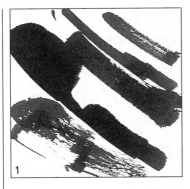
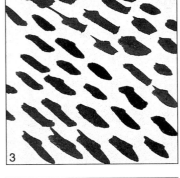
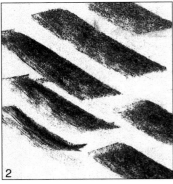
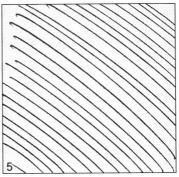
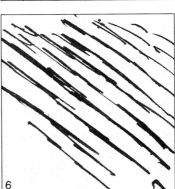

Black ink swept onto the paper with the side of a sable brush produces broad, consistent marks (example **1**). As the brush becomes drier, interesting textured strokes of broken colour result. Similarly, textured strokes can be made with black pastel if it is used on its side across the paper as in example **2**.

A host of different marks occur when ink is dabbed onto the paper with a round sable brush (example **3**). In the case of soft black pastel, abrupt strokes replace the dabbing motion of the brush to produce the broken marks in example **4**. With both media, the individual marks vary slightly and yet are related, which is what makes them so engaging.

The nib-pen is a perennially popular drawing tool because the line it makes is not too mechanical and is inherently variable. Example **5** shows how, even with straightforward HATCHED strokes, the line varies in thickness and texture. In example **6** a broader nib was employed. The pressure applied and the angle of the nib can be altered to create calligraphic fluctuations.

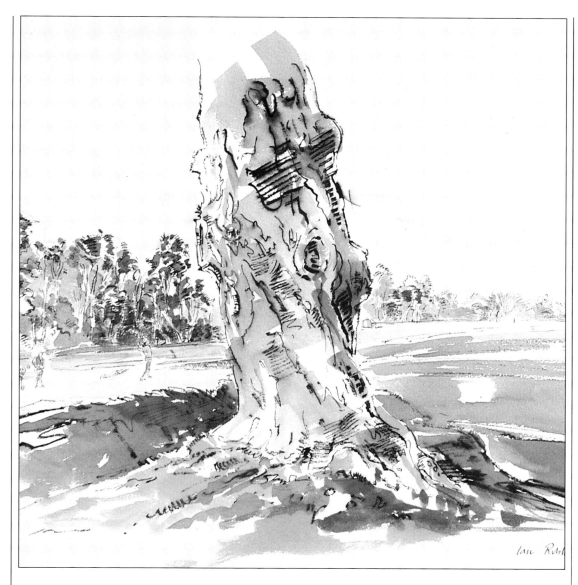

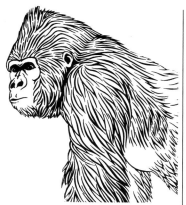

Flowing lines, expressed with the tip of a sable brush, aptly describe the character of this wild animal of gentle character. Swelling and tapering lines show the natural 'fall' of the hairs in the gorilla's coat. Doubling up as contour lines, the brushstrokes also suggest the undulations of the muscular form beneath the coat.

The flexible qualities of the nib-pen, together with those of the brush, were combined to make this drawing. The foreground tree displays a variety of linear marks — fine outlines, HATCHING with broad strokes and calligraphic squiggles. Small dabs of watercolour make up the background foliage, and sweeping brushstrokes laid in the greens of the middle distance. The angular washes on the foreground tree were made with a flat (square) brush.

MIXED MEDIA

Using more than one medium in a drawing does not stop with LINE AND WASH. Any or all the drawing media can be used in the same drawing. For example, a landscape may be swiftly blocked in with a wash of ink and the main elements drawn in using a pen. Foliage might be introduced using chalk, crayon or charcoal and highlights picked out in white gouache.

If dark washes are applied over a coloured oil pastel or wax crayon drawing, the crayon line repels the wash and stands out clearly through it. Other media such as coloured pencils or felt pens can be added once the wash has dried.

By using the technique of collage, even more unusual effects can be created. Collage involves sticking materials such as paper, fabric, other drawings or photographs onto your work. Once glued down you can draw into or add colour to them. There is a vast range of media and techniques that can be included in one drawing. The only major limitation is the artist's ability to control them. He must ensure that they work together to create a unified result, rather than become a series of pictorial incidents that merely reflect technical skill.

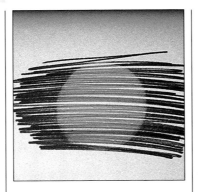

A black felt pen was used to make this patch of SHADING . Cigarette lighter fuel was then dropped onto the centre of the patch to produce the moon-like circle of paler tone.

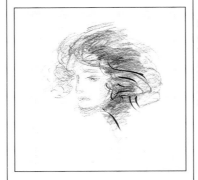

This portrait was first sketched with charcoal and then developed using a nib pen and black Indian ink.

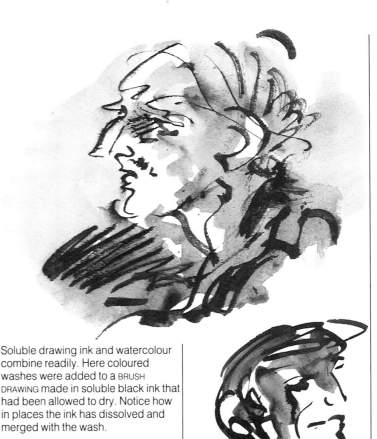

Soluble drawing ink and watercolour combine readily. Here coloured washes were added to a BRUSH DRAWING made in soluble black ink that had been allowed to dry. Notice how in places the ink has dissolved and merged with the wash.

A brush and soluble black ink were used in the initial drawing of this portrait before watercolour washes were added while the ink was still wet. The merging of the two media is much more unpredictable when they are combined wet-in-wet.

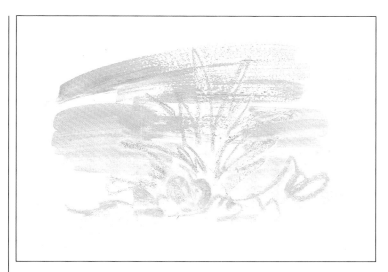

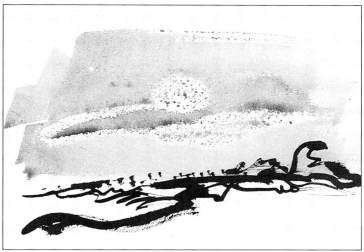

The principle that oil repels water was used to produce this colourful sketch. The linear oil pastel drawing was washed over with gouache to leave the greasy lines breaking through the paint.

An effective combination of media and techniques lends atmosphere to this landscape. A candle was used to draw the cloud shapes before they were washed over with watercolour. This WAX RESIST technique was then augmented by drawing in the land with black Indian ink.

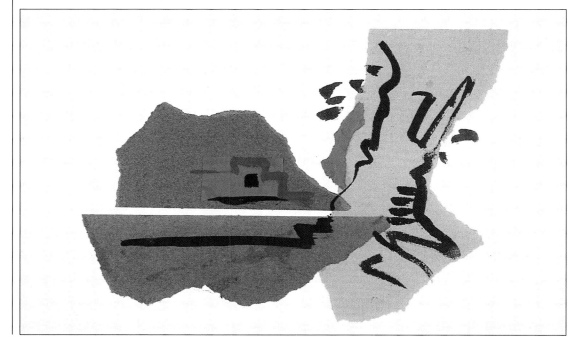

Using a brush and dilute paint, the artist has experimented with drawing over pieces of torn coloured paper glued down onto a sheet of white paper.

PHOTOCOPIER DRAWING

Photocopiers, which these days are accessible to many people, can be used both to make drawings and as a technical aid. Small objects placed on the photocopier screen usually reproduce with a dark background, because anything except a paper-thin object admits unwanted light to the screen. Drawings, providing they are not too large, can be copied at various stages and the copies then drawn on and developed in different ways.

With modern photocopiers, it is usually possible to reduce or enlarge the size of your photocopy. Drawings can look completely different when their scale is altered. Try comparing different sized copies with the original drawing to see which is the most effective. A black and white copy of a coloured original will show you the relative tonal values it contains, and can help you decide on light and dark relationships in a drawing.

Photocopiers are changing rapidly and machines that copy in full colour are now quite common. Manufacturers realize their value to the artist and have recently sponsored art competitions and exhibitions where all the work on display has been made using photocopiers. The machines will undoubtedly continue to be improved and open up new creative techniques for artists to explore.

Photocopier Drawing
1 An outline drawing of an interior was created with pen and black ink before a number of photocopies were taken of it.

2 One of these copies was developed tonally with black felt-tipped pens. The paler tones were achieved by using an old but useful dried-out felt-tip.

3 A second copy of the original outline drawing has been shaded in, but this time exploring the impact of a different light source. The resulting effect on the appearance of the spatial configuration is entirely different, and yet all the elements of the composition remain in the same place.

4 In this treatment of the copied original the interior has been shaded with felt-tipped pen, as if lit only from a table lamp glowing in the corner. Such experimentation with chiaroscuro on photocopier drawings is useful when gauging the effects of different-light sources in preparatory drawings for a painting.

POINTILLISM

Pointillism, or Divisionism, as the artists themselves preferred to call it, is a system of painting developed in the nineteenth century, most notably by the French artists Seurat (1859–91) and Signac (1863–1935). It was based on the new scientific and optical theories of that time. One underlying principle is that from a suitable viewing distance, small dots of different colour but similar tones placed closely together will be automatically interpreted as a single colour by the viewer. For example, what are clearly dots of blue and yellow paint at close quarters will appear as an area of green paint from a distance. This method produces a more vibrant effect than would be achieved by blending the colours on the palette and then applying the mixture to the painting.

In relation to drawing techniques, pointillism can be exploited with any coloured medium, such as pastel, watercolour or felt pen. A small STIPPLING technique usually produces the best results. With black and white media, luminous tonal areas can be produced by the same method. Groups of small black dots placed closely together will read as a patch of grey from a distance. By altering the size of the dots and the spacing between them, it is possible to create a full tonal range.

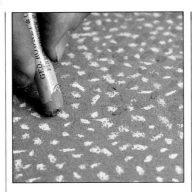

Pointillism • Tinted Paper
1 With the sharpened tip of a soft pastel, the artist adds vermilion dots to a random pattern of yellow dots, keeping them separate and unblended.

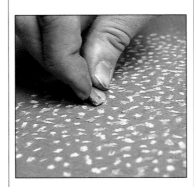

2 Now dots of a third colour, blue, are added. Because each dot of colour is separate, the pointillist technique makes it possible to exploit the additional effects of different tinted papers. Here the green tint of the paper acts as a unifying element, against which this combination of vibrant pastel colours appears to scintillate.

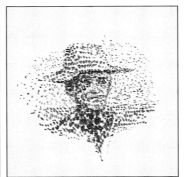

Varied densities and sizes of dots made with a 5B pencil form a pleasing portrait. It demonstrates the basic STIPPLING technique used to create most pointillist images.

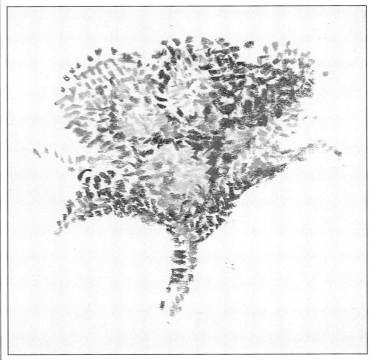

At a suitable distance, small splashes of different colour but similar tone are interpreted by the viewer as a single colour. The vibrant result the method achieves is shown to striking effect by this example of a flower.

POUNCING

Pouncing is a technique for transferring a line drawing onto another surface. It is normally associated with mural painting, when an image from a preparatory drawing is transferred to the surface of a panel, wall or ceiling. This drawing, known usually as a cartoon, is made the actual size of the mural and may be very large. It is pierced with a sharp tool to produce a series of small holes that follow the main outlines of the image. These holes are often made by using a special tool, called a tracing wheel, which consists of a handle and a wheel with sharp spikes that is run along the lines of the drawing. (Tracing wheels are used for transferring patterns in dressmaking and can be bought from dressmaking suppliers.)

The next step is to attach the perforated cartoon to the wall or panel, making sure that the whole of the underside of the cartoon touches the surface. Finely ground chalk or graphite is then dusted all over the cartoon. Placing the powder in a small muslin bag that is tapped onto the drawing to force the dust through the holes is a simple way of doing this.

When completed, the cartoon is removed to reveal an image composed of dotted lines. The technique could be used on a smaller scale to transfer a drawing to a canvas. If you do not want to damage your drawing, make a tracing of it and perforate the copy.

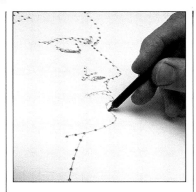

Pouncing
1 Having drawn the cartoon the first stage of the pouncing process is to pierce the outlines of the cartoon with a sharp stylus.

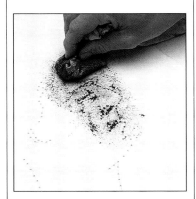

2 The pierced cartoon is placed over another sheet of paper and graphite powder held in a muslin bag is pounced through the holes.

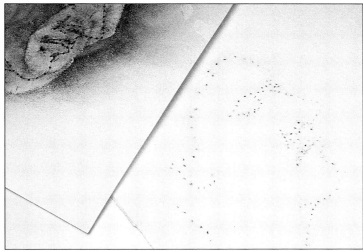

3 Here the cartoon has been lifted away from the sheet beneath it to reveal the pierced outlines reproduced as a dotted line.

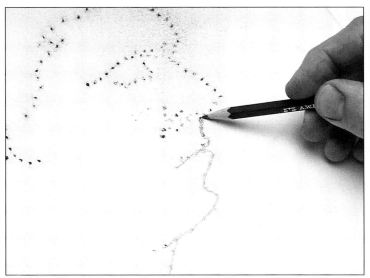

4 Excess graphite is blown away from the undersheet, and the dotted line is re-drawn with a pencil as a continuous line.

SCRAPERBOARD

Scraperboard (or scratchboard) is a soft white board that can be easily marked with a sharp instrument. It is usually bought coated with black ink so that the sharp drawing tool cuts through the black surface to reveal the white underneath. Special tools are available that will produce fine lines or thick lines. For experimenting, the point of a pair of compasses makes a good drawing tool. A scalpel or craft knife is useful, not only for cutting a large board into smaller pieces but also for scraping broad marks and clearing large areas. Try using a broken saw blade for HATCHING or CROSSHATCHING; in fact anything with which you can scratch or scrape is worth a try. A finished drawing on scraperboard can look rather like the negative of an etching or a wood engraving.

Scraperboard can be bought without a surface colour so that any colour of your choosing can be applied. Use waterproof drawing ink for this, building up a smooth coating. This is best done in layers, allowing each coat to dry before the next one is applied. Scraperboard has always been very popular in commercial art, and is becoming more widely used.

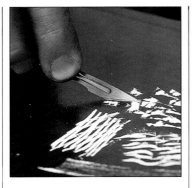

The point of the scalpel was used to make these lines. The blade does not have to be razor sharp, so an older one is perfectly adequate.

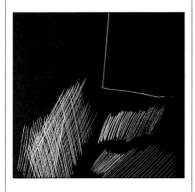

Almost any type of sharp steel point can be used as a stylus, so long as it travels easily across the board in any direction and produces a fine line.

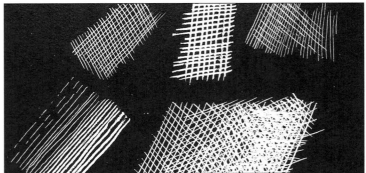

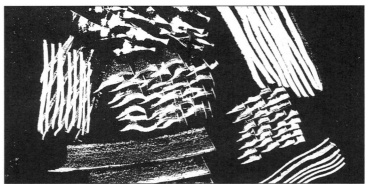

Scraperboard can be likened to a negative pen drawing: white lines are produced, rather than black ones. And as with pen drawing, the techniques of HATCHING and CROSSHATCHING (made here with lines of different width) are particularly suited to the medium (top).

A collection of marks made with a scalpel (middle). Where the blade has been drawn across the board quickly and lightly it has produced a stroke of half-tone. Depending on the effect that is wanted, the point or the edge of the scalpel blade can be utilized to produce a variety of broad lines and textural marks (bottom).

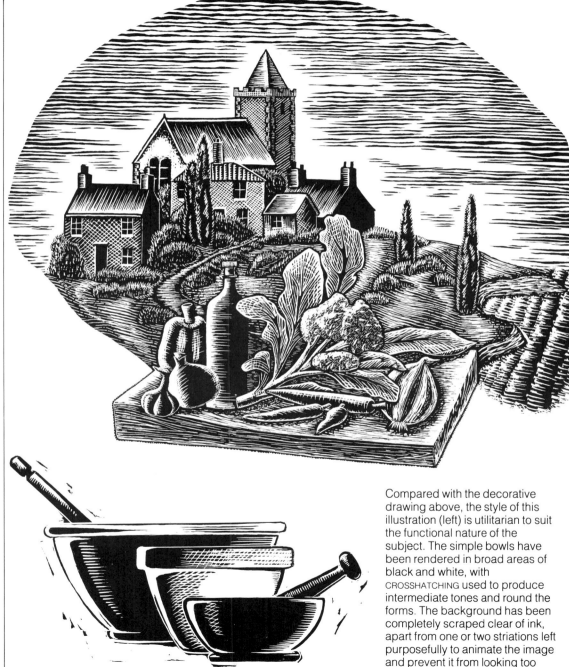

Compared with the decorative drawing above, the style of this illustration (left) is utilitarian to suit the functional nature of the subject. The simple bowls have been rendered in broad areas of black and white, with CROSSHATCHING used to produce intermediate tones and round the forms. The background has been completely scraped clear of ink, apart from one or two striations left purposefully to animate the image and prevent it from looking too sterile.

Scraperboard is a popular medium for magazine and book illustration because the stark black and white image is easy to reproduce. This design (above) was produced for a cookery book, hence the chopping board of vegetables superimposed onto a landscape. The artist has exploited the decorative precision of the medium, juxtaposing different patterns to create tonal variation. Note how each facet of the small group of buildings is described with a different pattern. Around the design, the black ink coating has been completely removed to form a halo of light which silhouettes and clarifies the composition.

SFUMATO

The Italian word sfumato can be interpreted in English as evaporated, softened or shaded. When applied to drawing, it refers to the production of very subtle tonal gradations, such as the misty effects created by using wash or charcoal carefully blended to describe objects without drawing outlines or contour lines. Leonardo da Vinci (1452–1519) regarded the softening of contours and the blending of forms into their shadow as being of paramount importance in creating an impression of solidity in drawing.

The development of the sfumato drawing technique was closely related to the development of oil painting. The latter allowed artists to blend colours easily and produce very smooth tonal changes. A painter's preparatory sketches are often done in a medium with similar capabilities. Charcoal, for example, is commonly used because it blends and smudges easily and possesses rich tonal qualities.

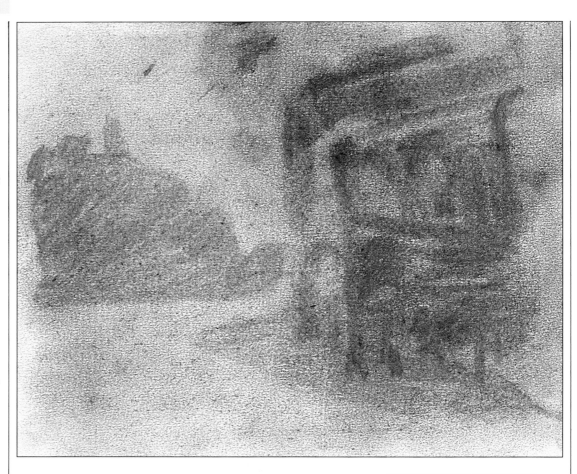

Charcoal is the ideal medium for sfumato drawing. Here the misty tones were produced by rubbing the charcoal into the paper with the fingers. Background and foreground are integrated into an atmospheric whole.

Created by LIFTING OUT with an eraser, from a dense layer of charcoal, this figure seems to emerge from the shadows. Indistinctness is the key to this type of drawing. The almost invisible face stimulates the viewer's imagination.

SGRAFFITO

This technique (from the Italian for scratched) is often used to decorate plasterwork or ceramics. An overlay of tinted plaster is scratched through to reveal a different coloured, or white, plaster beneath. More recently it has been adopted by artists such as Dubuffet (1901–85) who drew through one layer of paint to reveal another underneath. In drawing, one technique is to use a sharp instrument (the end of a brush handle, a knife or metal point) to scrape lines through areas of tone and reveal the white paper underneath.

Sgraffito is very effective when combined with layered pastel or crayon. Soft pastel is rubbed onto the paper with a tortillon to produce a strong, even colour. This is then fixed and a second layer of dark pastel is applied all over it, but not rubbed in. It is now possible to scratch through the dark layer, revealing the colour beneath. Try working on coloured paper as a base, or perhaps over a wash of ink or watercolour covered with a layer of oil pastel.

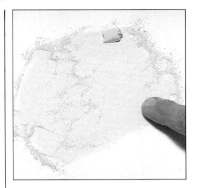

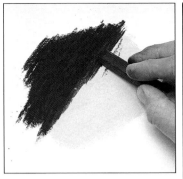

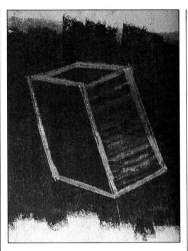

Sgraffito using a Scalpel
1 A yellow pastel is used to make a solid patch of colour that is rubbed into the paper. Any excess particles are blown away before the patch is sprayed with fixative.

2 When the fixative has dried a soft black pastel is stroked across the yellow ground. Just enough pressure is used to produce a complete coating. Fixative is again applied.

Different coloured pastels were rubbed into the paper in this example, so that a line drawn through the top layer changes colour along its length.

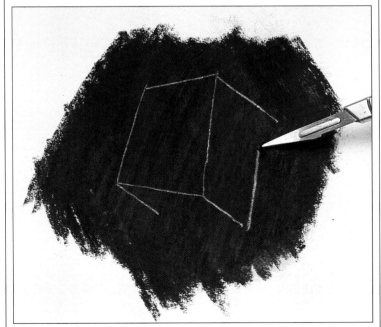

3 The black coating can now be carefully scraped away with a scalpel or the sharp point of a stylus to reveal a bright yellow line.

SHADING

Shading refers to the tonal elements in a drawing rather than the linear ones. For example, wherever light falls on an object, you would need shading to indicate areas of tone, representing the parts of the subject in shadow, and to give them solid form. Although shading can be done successfully with HATCHING or CROSSHATCHING, less linear methods of applying tone are often preferred. Pencils or charcoal sticks can be used on their sides to produce solid patches of tone. Sensitive shading with continuous tones does more than simply define the shape of an object – it can also create the illusion of three-dimensional reality, fooling the eye completely.

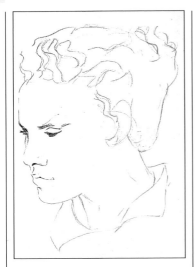

Shading • Conté Crayon
1 After the main outline of the portrait had been sketched on cream paper, a black conté crayon was used to establish the main features.

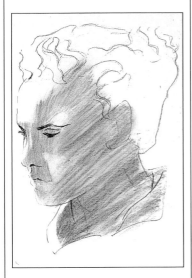

2 Using a red–brown conté crayon the basic areas of tone were shaded in. These hatched lines establish the main planes of the face.

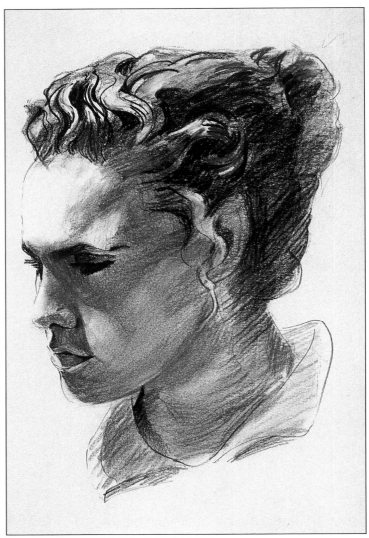

3 The SHADING is then strengthened with black conté crayon. Rubbing with the finger and hatched strokes produce carefully graded tones.

A range of tones can be produced for any colour. In this example, yellow pastel is applied with varying degrees of pressure to produce a gradated tonal scale.

This still-life sketch was made with a ballpoint pen. HATCHING and CROSSHATCHING were employed to turn lines into the main areas of light and shade.

SILVERPOINT

In the fifteenth and sixteenth centuries, silverpoint was a popular medium. It involves preparing a sheet of paper with a layer of pigment, usually white, and then drawing on it with a piece of silver. Today, the paper is most often prepared with Chinese white watercolour, which makes a perfect coating. Paint it on using a diluted first coat and, when dry, add a second layer at full strength. (You might want to stretch the paper first to prevent it cockling. However, if it is heavy enough, this will not be necessary.) The traditional silverpoint stylus was a silver rod or wire set into a wooden handle. You can improvise by inserting a small piece of silver wire into a clutch pencil.

As you draw over the coated paper, tiny particles of silver are worn off the point and adhere to the surface. Just like silver-plated cutlery or ornaments, the deposited silver tarnishes in the air and darkens. This happens as you draw so that a grey line can be seen immediately. Over a period of time the line gets darker.

The sharp silverpoint can produce very fine and detailed linework, and the line itself is perhaps the most delicate of all linear marks. You do not have to use silver wire as a stylus; any real silver·or silver-plated object will produce a mark on the coated paper. Try drawing with the edge of a silver coin or a piece of jewellery. Silver-plated cutlery will also produce beautiful and varied marks.

Silverpoint
1 The artist prepares a sheet of paper for a silverpoint drawing by applying Chinese white watercolour all over the surface with a bristle brush.

2 Once dry, the prepared paper is ready for use. The artist chooses a piece of silver wire to produce fine grey lines.

All kinds of silver objects make good drawing tools. Here a small silver spoon is employed to give delicate broad strokes.

SKETCHING

Sketching is usually associated with rapid drawings made outdoors, or with other studies done at great speed that are intended to serve as a preliminary to the final piece. They are sometimes called 'working drawings' because they are part of the working process involved in making a piece of sculpture or a painting. At one time, sketches like this were not thought of as having any great value beyond their preparatory function, and once the painting or sculpture was finished, they were thrown away.

Sketches, then, are not usually intended as exhibitable drawings because they are often only basic or experimental ideas. Nevertheless, since the great draughtsmen of the Renaissance, the sketch has been more highly valued as a work of art in its own right, revealing as it does the artist's genius most directly.

Artists often employ 'shorthand methods' for including information in their sketchbooks that there may not be enough time to record in full. This may occur when you are working in a crowded street, a restaurant, or in a landscape where the weather conditions keep the scene constantly changing. Written notes might be added to describe colours or tones that will be needed to complete the drawing or painting later. Inexpensive books can be bought for sketching; some are spiral bound but the most practical have a sewn binding and a rigid cover. They can be carried around easily and become valuable stores of visual information and ideas for reference. The English painter Hogarth (1697–1764) once reputedly drew a scene on his thumbnail because he did not have any paper with him when he needed it. Ever since then, any small rapid drawing done to record the basics of a subject has been called a 'thumbnail sketch'.

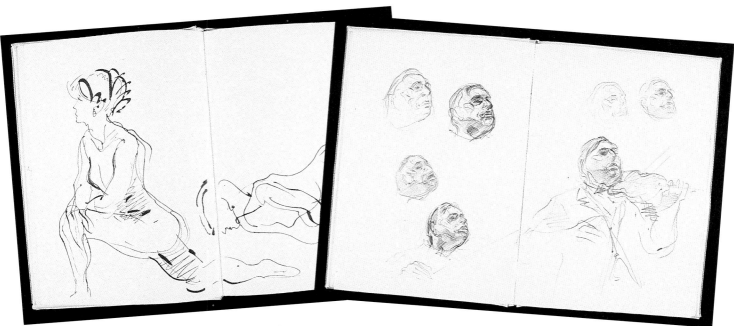

Drawing a moving figure requires a responsive medium that will perform quickly and expressively. Pen and ink has been used to make these two lively sketches. Many artists use books like this to 'warm up' before carrying out a more studied drawing. Because of their private nature, sketchbooks will often reveal an artist's more uninhibited drawings, in terms of both style and content.

This open sketchbook reveals a number of lively pencil sketches of a violinist. The shape and position of the head and the changing facial expressions have been studied quickly, using contour lines and HATCHED SHADING. On the right-hand leaf of the open book, the musician's head is related to the position of the violin and his torso, suggested with rapid outlines.

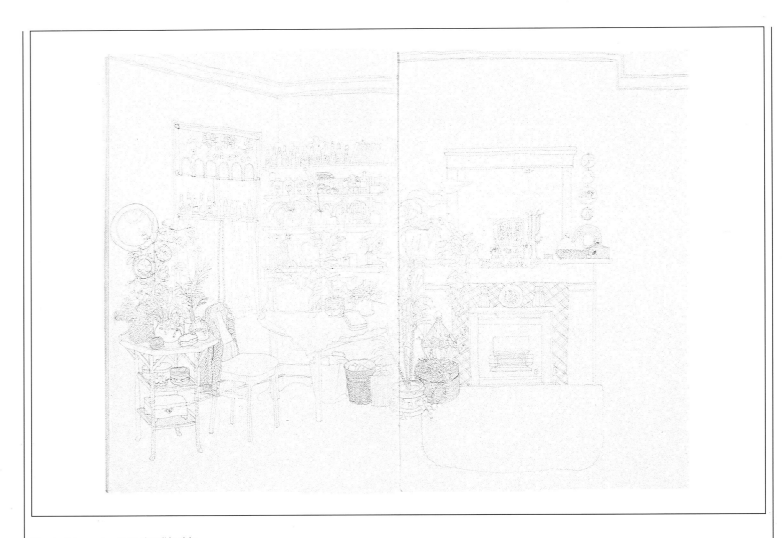

The build-up of ornate detail in this sketchbook is quite a contrast to the previous illustrations. Here the book is used as a place in which to amass a store of detailed information. Pencil line, only, carefully maps out the beautiful variety of shape and pattern found in a room full of small ornaments.

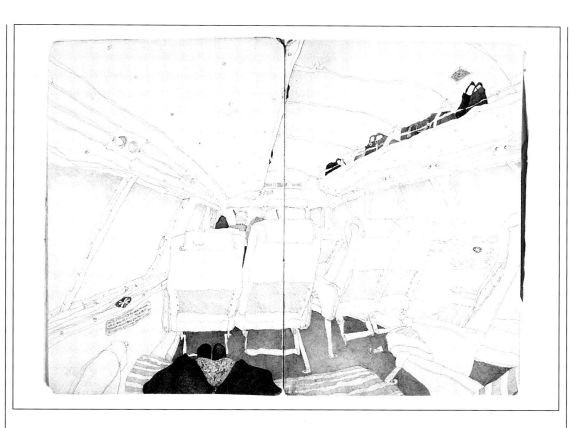

Sketchbooks can easily be smuggled into places where a large drawing board or easel would be either impractical or not allowed. What better opportunity to sit and draw than on a long bus journey? Pencil was used to delineate the shapes and produce the smooth tones of this drawing.

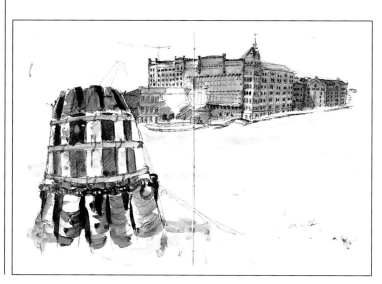

Artists have carried sketchbooks to all corners of the world, especially before the invention of photography and television. Many artists still take them along on journeys to act as a visual diary. Drawings penetrate the character of a place much more thoroughly than a snapshot. This pen and ink drawing of a blustery day in Venice was tinted with watercolour.

SQUARING UP

Sometimes it is necessary to enlarge a drawing, and squaring up is the easiest way to do this accurately. This technique, also called scaling up, involves drawing a grid of squares over the original drawing and a similar grid of larger squares on the paper on which the larger drawing is to be made. The information in each square is then faithfully transferred from the original drawing to the larger squares of the larger drawing.

It is possible to avoid drawing a grid on the original drawing by using pins at the edges of the drawing to plot the squares and stretching thread between them to make the grid. Or, if your drawing is not too large, make a photocopy of it and draw the grid onto the copy, so preserving your original intact. Another method that will avoid damaging the earlier drawing is to use a clear perspex (acrylic) sheet on which the grid is drawn with a suitable felt pen or wax crayon. This grid can be placed over the original drawing, which is then transferred to a larger version as described above.

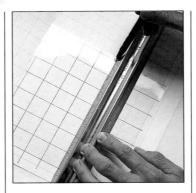

Squaring Up
1 With a permanent marker pen, the artist draws a grid onto a sheet of acetate. The grid is traced from a sheet of graph paper underneath, which not only saves time but also is very accurate.

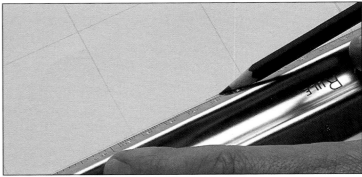

2 In the next stage, a pencil, set square and ruler are the necessary tools for drawing a grid of larger squares onto the paper. The lines should be only just visible.

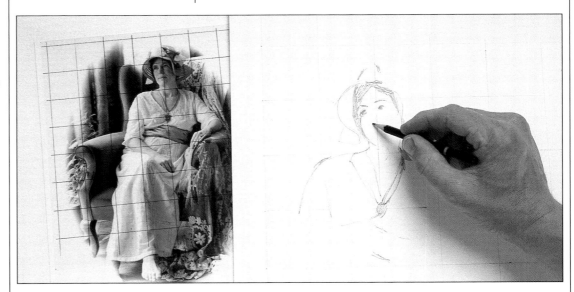

3 Finally, the transparent grid is placed over the photograph to be transferred. With a pencil the artist copies the image square by square onto his drawing paper. The larger squares of the drawing sheet serve to enlarge the original image.

STENCILLING

In this technique, shapes are cut out of a piece of paper or card to leave holes through which ink or paint can be applied. The ink is often dabbed through the holes using a short round stiff-haired brush. When the stencil is removed, the cut-out shapes are reproduced, in ink, on the surface beneath.

The card shape itself can also be used as a stencil. It is placed on a sheet of white paper and ink is dabbed over and around it. When it is lifted away, a white shape will remain where the ink was prevented from touching the paper. The ink or watercolour can also be sprayed across the stencil by means of a mouth diffuser or airbrush.

All kinds of objects, such as leaves, feathers or wire-meshes can be used as stencils to produce interesting shapes or patches of texture in a drawing. Pencil, pastel, crayon or charcoal can be used to draw through a stencilled shape and reveal the image. It is a drawing technique that is particularly useful if a great number of the same shapes need to be repeated. It could, for example, be used to depict tree shapes in a distant forest or simple house shapes in a townscape. It is also found in such applications as architectural drawing.

Stencilling • Cartridge Paper
1 A piece of cartridge paper was folded and small shapes torn or cut out to produce a symmetrical hole when the paper was flattened. This stencil was placed on a sheet of paper and using various media (ink, pencil, wax crayon, charcoal and wash) repeated images were produced from each stencil. A medium such as pencil produces a precise image. Wash produces the interesting blurred images in the corner.

2 A piece was torn out of this sheet of paper to produce a hole that was then utilized as a stencil.

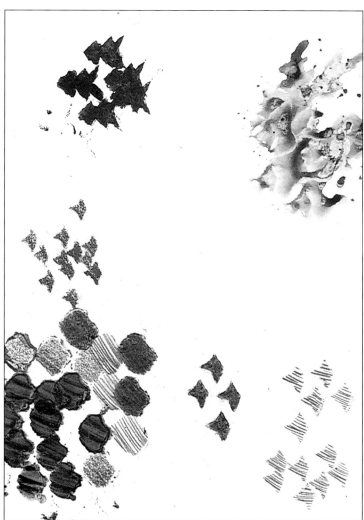

3 Repeated shapes made with the stencils illustrated in the previous stages are given striking variety, despite their simplicity, by the use of different media.

STIPPLING

This is a drawing or painting technique in which dots rather than lines form an image. Groups of small black dots placed closely together will read as a patch of grey tone from a distance. By altering the size of the dots and the spacing between them – their density – it is possible to create a full tonal range. This method was often used in engravings to produce half-tones and very delicate lines. The technique is still common in commercial illustration, especially those in black and white. They are made with a pen or pencil, the stylo-tip-type pen being particularly suitable. With its tubular nib, it will produce very neat dots of equal size. The nibs are available in a variety of precisely measured diameters. Another alternative is an electrically powered stippling pen that has a dot-producing vibrating nib.

Stippling does not have to be so mechanical, of course. Dots can be all shapes and sizes when made with the point of a brush or with a sharpened conté crayon, for example. Coloured stippling is used for the POINTILLIST technique of colour mixing. Stippling is also useful as a texture-producing technique in which paint is applied in a dotted texture using stiff-haired brushes. This can be done with ink and an old toothbrush.

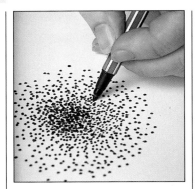

Felt-tipped pens are ideal for stippling, as a variety of tips are available and only gentle pressure is required. Here a black fibre-tipped pen is being used.

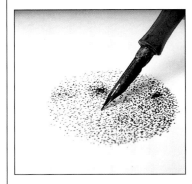

An old-fashioned dip-pen produces beautifully varied dots and flecks when used for stippling.

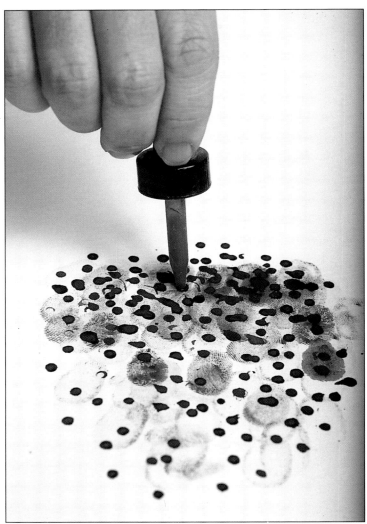

Large stippled dots can be made with the glass dropper from an ink bottle. Here black ink is dropped over the top of a layer of fingerprint stippling made with brown ink.

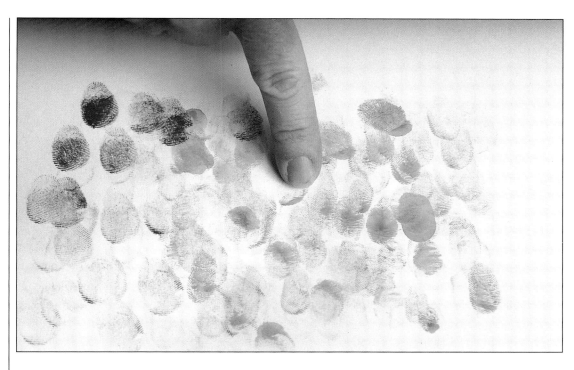

Inky fingerprints are very useful for producing unusual patches of textured stipple. Executed with coloured inks this technique could be used to create foliage in a landscape drawing.

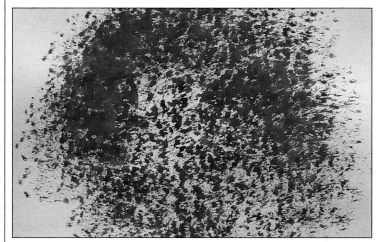

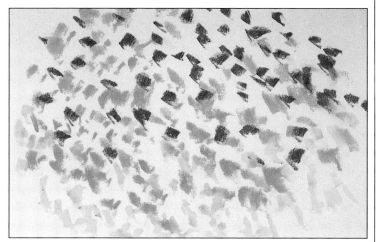

A stiff housepainter's brush can be dipped into ink or watercolour and then dried on tissue paper. There will still be enough pigment left on the bristles to produce a stipple when the brush is pounced down onto the paper.

Coloured pastel was used here to stipple these different colours together. The choice of a flat-sided pastel produces irregular angular marks.

Controlled stippling with extremely fine black ink dots is capable of producing very subtle tonal GRADATIONS. The fur of this rabbit combines stippled dots with short broken lines. Careful control of the density of the dots makes a range of pale grey tones on the inside of the ears.

The two natural history illustrations above were drawn with black ink stipple. Note how, on the underside of the frog's mouth, the stippled dots link up to suggest the skin pattern. In the lower drawing the white of the paper has been left to show through as strong highlights on the shiny black shell.

TONAL DRAWING

Just as you can draw purely in line, so you can also make drawings entirely in tone. Certain drawings by Seurat are excellent examples of this approach. He used conté crayon to describe the overlapping planes of light and shadow; in other words, the tones rather than the outlines of his subject.

Drawings like these, conceived in tone and carried out using a tonal medium such as wash, conté or charcoal, are full of mood and atmosphere. By studying the way an object is illuminated and by recording the resulting tonal pattern, the artist can recreate the solidity and appearance of three-dimensional form.

To help you see the tonal relationships in a subject, a good exercise is to make a collage of it using pieces of toned paper. Newspaper photographs can be torn up to represent patches of tone and glued into position as a collage to render accurately the tonal patterns of the subject.

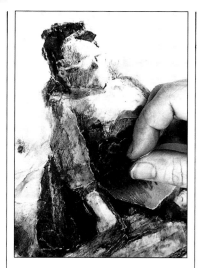

One approach to tonal drawing is to build up an image in collage. Here, tracing paper was first shaded with different grades of pencil and then torn up. These small fragments were then re-assembled and glued down to produce a strong tonal image. Such an exercise forces the artist to think in tonal masses and ignore details.

Charcoal has been used freely to describe trees and a dark sky in a winter landscape. To convey both the starkness of the scene and its less defined aspects, the charcoal was smudged with a finger for the sky, elsewhere drawn directly and left untouched.

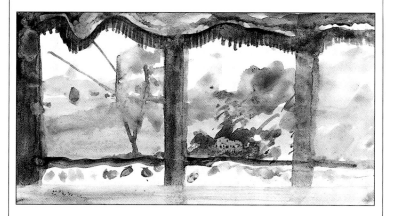

A great variety of tones can be produced rapidly with a brush and diluted black ink. This view through a window illustrates the importance, when using the technique, of concentrating on the main tonal areas rather than on details.

TRANSFERS

It is possible to transfer pictures from illustrated magazines and newspapers to paper so that these images (they will, of course, appear in reverse) can be used in a drawing. A solvent such as turpentine, methylated spirit, acetone (nail varnish remover) or cigarette-lighter fuel is usually sufficient to 'soften up' these pictures and allow them to be transferred to a clean sheet of paper. Remember to be very careful handling any of the above solvents because all are dangerous. Do not use petrol – it is highly explosive and particularly dangerous indoors.

Sheets of half-tone transfers can be bought from suppliers of transfer-lettering. As with the letters, the transparent sheet is held in position over the paper and the reverse side is rubbed with a burnisher. When the sheet is removed, the detached half-tone stays on the paper. Tailor-made burnishers are available, but the back or smooth handle of a metal spoon makes an adequate substitute.

Not so satisfactory is the carbon paper method. Typists' carbon paper can be placed beneath a photograph that you wish to copy. Both are then positioned over a sheet of paper. If you subsequently draw on the photograph with firm pressure, the lines will be printed onto your paper via the carbon paper.

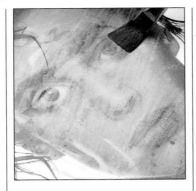

Transferring a Photograph
1 Cellulose thinners are used as a solvent that is painted across the magazine photograph with a soft brush. This should be done quickly with as little pressure as possible. Solvents are toxic and must be handled carefully in a well-ventilated room.

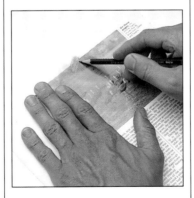

2 Before the solvent dries the photograph is turned over onto the drawing paper and the back is burnished with a pencil. Quite firm pressure is needed.

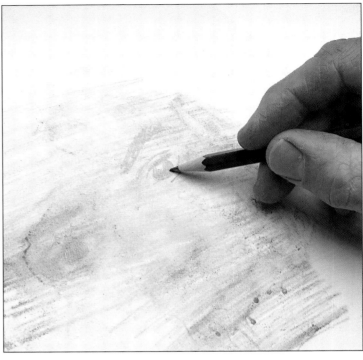

3 When the photograph is removed a mirror image of it will have been left on the drawing paper, which can then be worked on with another medium. In this case coloured pencils were used to develop the drawing.

WAX RESISTS

Wax repels water, and this principle can be used when drawing with ink or watercolour. With a candle, draw an 'invisible' image on a sheet of white paper. When the whole sheet is washed over with ink or watercolour, the wax drawing will resist the wash and be apparent as a white line. Coloured paper will, in the same way, produce a coloured line. A further refinement is to make the wax drawing with coloured wax crayons or oil pastels.

The technique of FROTTAGE carried out by rubbing over a rough surface with a candle can produce interesting textures when a wash is applied. If the side of a wax crayon is used on rough paper, broad swatches of texture will result when watercolour or ink is painted over them. This is effective in creating texture in buildings or skies in a wash drawing.

The wax can be removed from the drawing by scraping carefully with a razor blade once the wash is dry. A more successful method is to cover the drawing with sheets of clean newsprint-type paper and then apply a hot iron. The heat will melt the wax, causing it to soak into the newsprint.

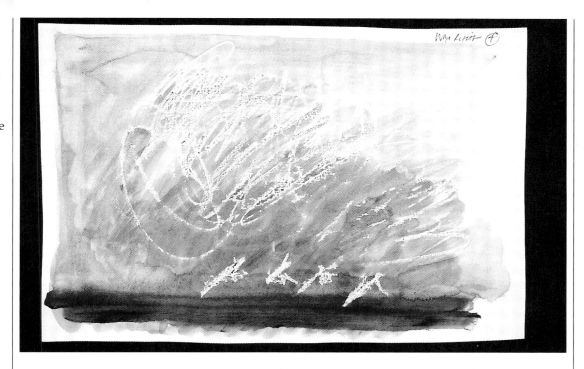

Swirling lines and stars have been described using candle wax that has been painted over with an ink wash. Wax drawings can be very effective but are often problematic because it is virtually impossible to see the marks on the paper until the wash reveals them. For 'fine' effects, ordinary sharpened candles are useful, as are special birthday cake candles.

Drawing with a combination of coloured wax crayons and an ordinary white candle before applying an ink wash produced this delicate, textured effect.

PART TWO

THEMES

Many people approach drawing with preconceived ideas about what makes a suitable subject. Readers of this book are asked to put aside their prejudices, particularly when they leaf through the themes section. Any and every subject is capable of providing the inspiration for exciting drawings. Henry Moore produced memorable depictions of people sleeping in the London underground stations during the Second World War and L. S. Lowry has made beautiful atmospheric drawings of squalid streets in the industrial north of England.

The purpose of this part of the book, then, is to show how the techniques described in the first section can be employed in drawings of a number of popular subjects. Most are readily accessible, some are studio-based, others require sketches to be made on location – but all are designed to give the reader guidance in discovering the potential in subjects to which they might not otherwise have been attracted.

Each theme has an introduction that gives general advice on the particular problems associated with the subjects illustrated, posing a model for example, or how to work from photographs when making an architectural drawing. Throughout, the emphasis is placed on experimenting with different media and techniques to show how, even within a single drawing, the introduction of a new medium can completely transform not only the picture itself, but also the artist's perception of it.

There are many theories about how artists should be trained. Some teachers believe that students of drawing should use pencil exclusively until competence and flair are well established. I, on the other hand, take the view that because drawing is fundamentally concerned with seeing, the use of a variety of media is necessary to stimulate the imagination and avoid getting into a rut. All artists need to develop their skills, learn new techniques, and experiment and use them to make drawings of as wide a range of subjects as possible. You should also be alive to the things that happen accidentally in your drawings and be prepared to exploit them to the full.

Everyone has the capacity to find in any theme something that is uniquely significant or meaningful to them, and it is this ability that makes every person a special kind of artist.

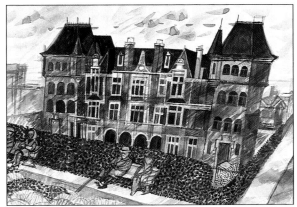

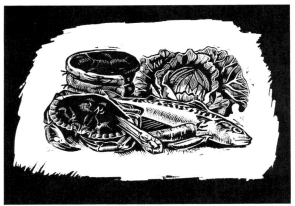

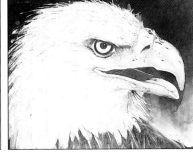

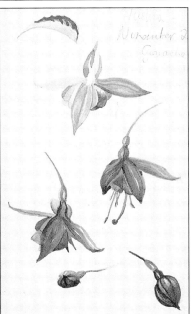

THE FIGURE

Although the oldest surviving drawings are of animals, the human figure soon became a feature of drawings and paintings and ways of depicting it have fascinated artists over the centuries.

Some of the earliest representations are in Egyptian art. They are flat and unrealistic, because the artists were trying to explain clearly, within strict pictorial rules, what they knew to exist, rather than what they saw. Everything in a picture was shown in the position that best explained what it was. More important people were shown as larger than less important ones. The paintings also depicted a period of time. They might describe the life of someone of stature and show the honours he gained during his lifetime.

Roman artists made much more realistic representations of the human figure. This was helped considerably by the discovery of foreshortening, round 500 BC, which enabled them to draw a foot, for example, as seen from in front. This is the moment in the history of art when artists began to consider not just the shapes that objects have but also how these shapes appear when seen from one particular viewpoint.

The nude

Realistic representation of the figure did not develop further for several centuries until Giotto (1266/7–1337), Masaccio (1401–28) and the Renaissance. The anatomical investigations of Leonardo da Vinci (1452–1519) and the drawings of the nude figure by him and by Raphaël (1483–1520) and Michelangelo (1475–1564) provided a basis for the representational drawings of today and firmly established the nude figure as an art form in itself. Nude figures had appeared in Roman and Greek art but it was in sixteenth-century Italy that the naked human figure was re-established as a form that could be used to invest stories with power and intense feeling. This use of the nude figure led over a period of time to the distinctive and dynamic figures of Rubens, the classical nudes of Ingres (1780–1867) and the dancing figures of Degas (1834–1917).

In this century, the nude drawings by Matisse (1869–1954) and Picasso, for example, have continued this tradition; and the survival of the life class in art schools indicates how firmly the drawing of the human figure has become established as an almost obligatory skill for the Western artist.

Alongside these developments in the depiction of the nude figure, the clothed figure continued to be drawn and painted in many religious, allegorical and historical pictures. Indeed, the increased refinement of nude representation brought higher standards of representation to the clothed figure. Portrait drawings and paintings have developed since Roman times, recording for posterity the appearances of the good and the great.

Problems with figure drawing

Although some major developments in the depiction of the human figure came about as a result of increased anatomical knowledge, it is not essential to know about anatomy in order to be a success at figure drawing. What is needed, however, as with drawing any object, is a keen and analytical eye. Drawing the figure is often regarded as the supreme challenge. Many students who excel in other areas can do nothing with the figure and avoid drawing it. There are many reasons for this, but two are significant. First, more than with any other subject, it is difficult when drawing the figure not to have preconceived ideas about what you see. Subconsciously a particular pose may remind you of some admired drawing so that you begin to draw what you think ought to be in front of you rather than what is actually there. The second reason is that being human ourselves, we know much more about the human body than we do about, for example, animals or trees. You can pretend that a tree you have drawn is something like the actual tree, but it is much more difficult to ignore any defects when comparing a drawing of a figure with the actual person.

Whether drawing the nude or the clothed figure, the basic strategy should be the same. The figure must be seen in terms of simple forms that fit together. The proportions need to be accurately assessed and it is of the utmost importance that the balance of the figure is correct, particularly when drawing standing figures.

There is no better way of ensuring that the balance is

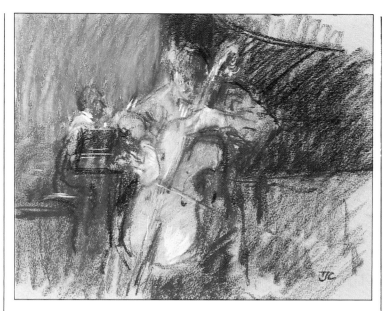

The passionate playing of this cellist is captured with a loose, expressive pastel technique.

right than by checking with a plumb line (a weight on the end of a thread, which provides an instant vertical) where the feet are positioned in relation to the head. Drawings by Degas show how, even in his maturity, he drew verticals on his drawings using a plumb line to check the balance of the figure.

Portrait drawing

Portrait drawing has the same inherent pitfalls as figure drawing but the artist has the added problem of achieving a recognizable likeness of the sitter. The secret is keen observation and analysis of those features that are significant and likely to be most memorable in the person you are drawing. The first thing to notice about all faces is that they are not as symmetrical as you might think initially. Their asymmetry is often important in achieving a likeness, as is the slight exaggeration of prominent features.

Posing the sitter for life drawing, costume drawing or a portrait is most important. Front on and silhouette views are difficult to depict and often look flat and cut

out. I cannot, for example, think of a single convincing drawing or painting of a seated figure seen from the front where the thighs are correctly foreshortened to appear as two ovals. Three-quarter views with the light from one direction provide views that generally allow the form of the figure to be most clearly seen and realistically drawn.

Figures in motion

So far we have been concerned with static figures, but drawings of figures in movement are an essential part of figure drawing. If the person is making a series of repeated movements, as a dancer might, it is necessary either to work very quickly on a number of drawings or to concentrate on freezing the body in one particular pose, observing it and then responding rapidly. Drawing moving figures requires gestural drawing: free linear drawing with pencil, charcoal, pen or possibly a fine brush. Rapid sketches taking only a few seconds can be vital in establishing the main features of the particular action. A figure in action can be frozen at a particular moment in time and yet the drawing may still imply movement.

One of the best ways of understanding a particular movement and so be able to draw it better is to try out the movement for yourself. This makes you feel for yourself the particular stresses and strains on the body and makes it easier to express these in your drawing.

What to use

Figure drawing basically consists of drawing complex forms, and building them into a convincing and recognizable structure. These forms need to be related to, and in some instances, lost in, their background; the relationship between figure and background is most important if the figure is not to look flat and formless. Any drawing medium can be used for figure drawing and there are excellent examples of drawings made in all possible media and all possible combinations. Choose media that let you express round forms most easily. Charcoal and wash are probably the best examples; either is appropriate for figure drawing on most occasions.

STANDING FIGURES

Drawing the standing figure presents its own particular problems. It is much harder for even an experienced model to stand for a long period of time than it is to sit or recline. The model therefore usually requires more frequent rests and may move considerably while posing. This movement, however slight, is the first problem that needs to be dealt with. Most artists mark the position of the model's feet on the floor (or on a large piece of paper on which the model stands) so that the same basic position can be returned to after resting.

Every figure is slightly different from another, and measuring can be useful in getting one or two main dimensions correct. Students tend to draw the top part of the figure too large, failing to observe that the head is approximately one seventh of the height of the figure and that the legs are one half. The most important problem related to proportion is that of making the figure stand properly in the drawing. The distribution of the figure's weight—on one leg or on both—has to be established, and crucial to this is getting the vertical positioning of the neck, hips and feet absolutely correct. In order to do so the artist can use any vertical in the background (for example, the corner of a room or the frame of a window) as a reference, but much the most useful device is to use a plumbline to check the precise position of key parts of the figure. Some artists attach the plumbline to a horizontal rod that is secured to the top of the drawing board and position it to mark a single vertical reference line running through the model's neck and the ankle of the foot on which most weight is placed.

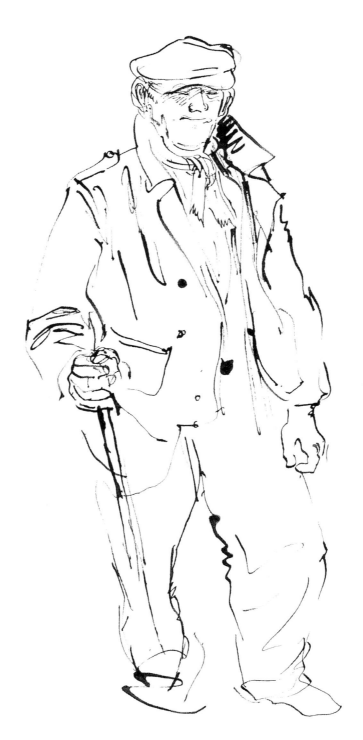

This silhouette described in black ink shows clearly how careful selection of the main shapes of the figure produces a result that, although drawn as a pattern, still gives an impression of three dimensions.

The artist has drawn this figure with great freedom using pen and ink. Although the clothes are baggy there is an excellent feeling of the structure of the figure underneath, and the tension of the hand gripping the stick has been beautifully realized. Note the variations in line and the way these help to give the figure its feeling of solidity.

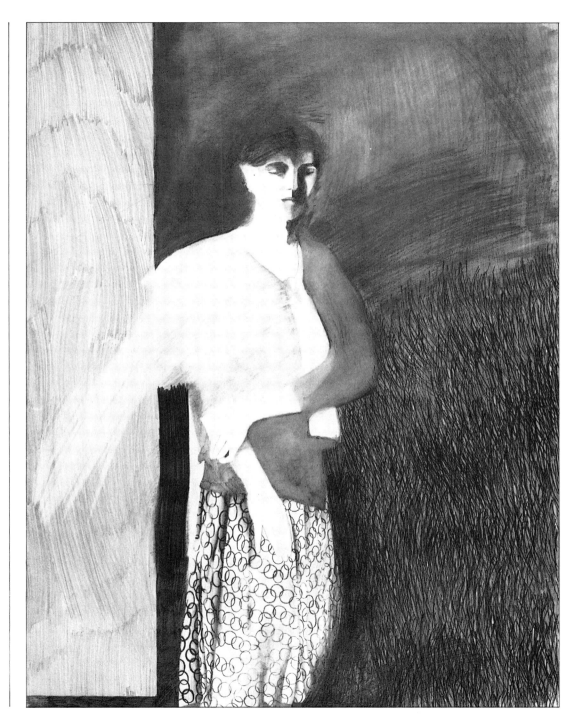

Pencil drawings do not have to be small and sketchy or highly detailed. This drawing is approximately 22in by 30in (56cm by 76cm) and shows a very bold use of pencil. The background is interesting because three completely different textures have been created by using contrasting HATCHING techniques. Carefully smudged tones describe the figure's face and torso, and a prominent pattern is used for the skirt. The light falling on the shoulder was LIFTED OUT with an eraser.

By rubbing a pencil drawing with the fingers or a hard eraser, a very smooth texture can be produced. The detail (above) shows the variety of texture possible in one drawing.

A combination of charcoal line and SHADING has been used here. Note the tilt of the shoulders and the counteracting tilt of the pelvis with the weight thrown onto the right leg, the ankle of which is directly under the figure's neck. These features have to be accurately drawn if a standing figure is to look convincing.

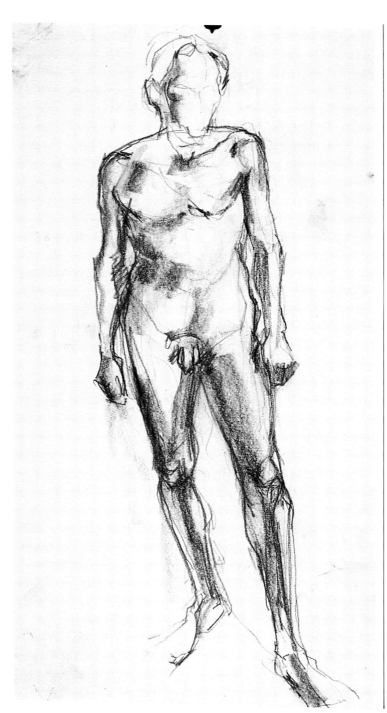

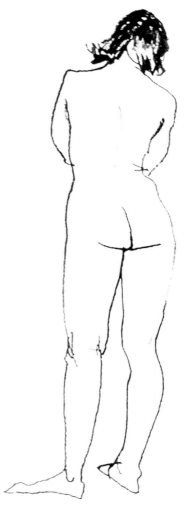

This line drawing was made using a matchstick dipped in Indian ink. The form of the figure has been explained using line only, but overlaps and variations in the line are sufficient to give the figure its convincing three-dimensional appearance.

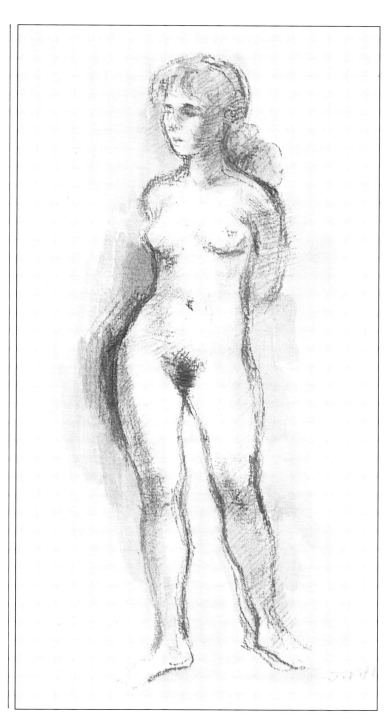

Different media were used together in this sketch of a standing figure. Outlines and contours were established with pencil and brown crayon, and pale washes of watercolour were added to darken the background. Watercolour and pencil HATCHING modelled the figure's form.

In the final stages of this drawing the artist used a pencil to refine the form. This can be seen clearly in the detail (above) where SHADING helps to strengthen the shadows and sets back one leg in relation to the other. Note how the position of the lower leg was corrected but the original outline was not erased. 'Pentimenti', as these marks are known, actually add vitality to a drawing.

SEATED AND RECLINING FIGURES

The most significant problem related to drawing seated or reclining figures is that of foreshortening. The brain will often not believe what the eye sees, so that when students first draw a figure that is lying down with the feet foremost they cannot believe how large the feet appear in comparison with the head. The secret is to use perspective to give an idea of what the relative scale of parts of the figure might be.

Objects associated with the figure being drawn can be extremely helpful guides. For example, if the figure is reclining on a bed, the rectangular plane of the bed assists in getting the correct degree of recession in the figure lying on it. If the figure is sitting on a chair, it is essential that the chair is constructed accurately (even if it is not drawn in great detail) before the figure is drawn in its correct place on the chair.

In almost any drawing of a seated or reclining figure, there will be angles and planes that recede in space, often quite sharply, so the choice of viewpoint the artist takes is very important. It is best to avoid a viewpoint that presents the figure 'flat on'. Foreshortening, however accurately assessed, looks unconvincing in certain poses, for example when the figure is lying flat and straight and is viewed from either the head or the feet. In a similar way, a formal seated pose may appear implausible when drawn from a head-on viewpoint, because the foreshortened thighs can look odd. In short, there are two golden rules: try to get at least an element of informality into the pose, and adopt a drawing position that avoids unconvincing foreshortening.

In this study in conté the shadow side of the face and the body have been drawn using HATCHING and SHADING, and a sense of solidity has been achieved by varying the strength of the line and breaking it in places. Only rarely do you find a single-strength contour line drawn round a figure; when drawing you have to 'feel' the form the contour is describing and as you do this you find with experience that the line automatically varies.

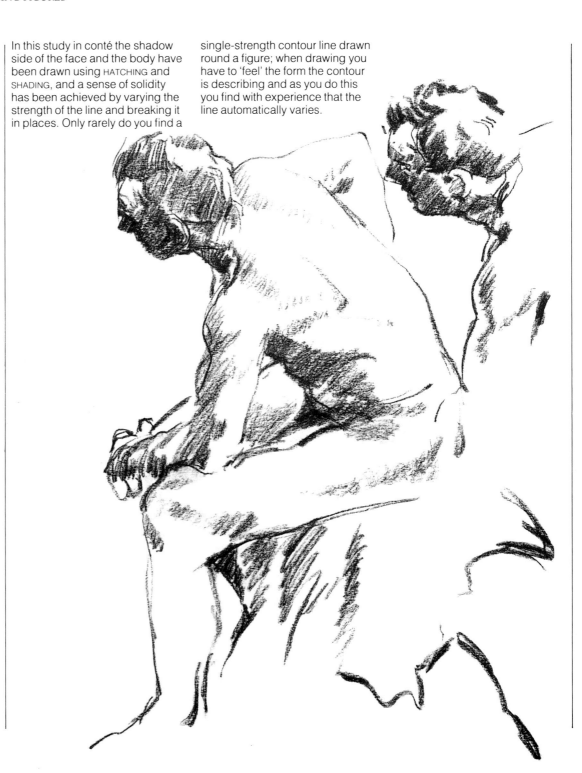

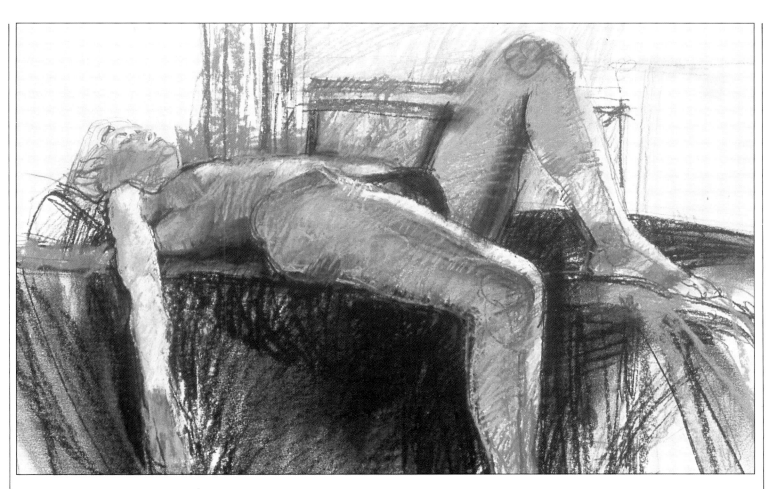

Pastel and chalk are often associated only with delicate drawing techniques. This dramatic life study shows how they can be manipulated in a bold and GESTURAL manner. Smudging and HATCHING are combined to produce warm and colourful skin tones. The background of cool colours and strong black strokes makes a powerful contrast.

Drawing this seated figure was an exercise in TONAL DRAWING. Tracing paper was shaded with different grades of pencil, producing a full tonal range. The toned paper was then torn into small pieces, and these were positioned and glued down onto white paper to create the drawing. Working like this forces the artist to concentrate on tonal values alone and not on superfluous details.

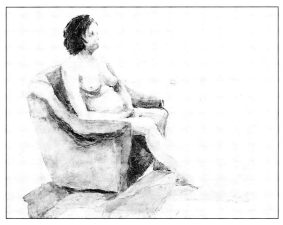

Sensitivity is the keynote in this study of a mother and baby, achieved by the use of chalk for the line, HATCHING and SHADING, with pastel added to draw attention to the woman's face and to her child. Note how the figure and the background are related by allowing one to meld into the other.

This detail shows how skilfully the artist has made an expressive profile with a few flicks of chalk, leaving the details to the viewer's imagination. White pastel catches the flash of light on the spectacle lens.

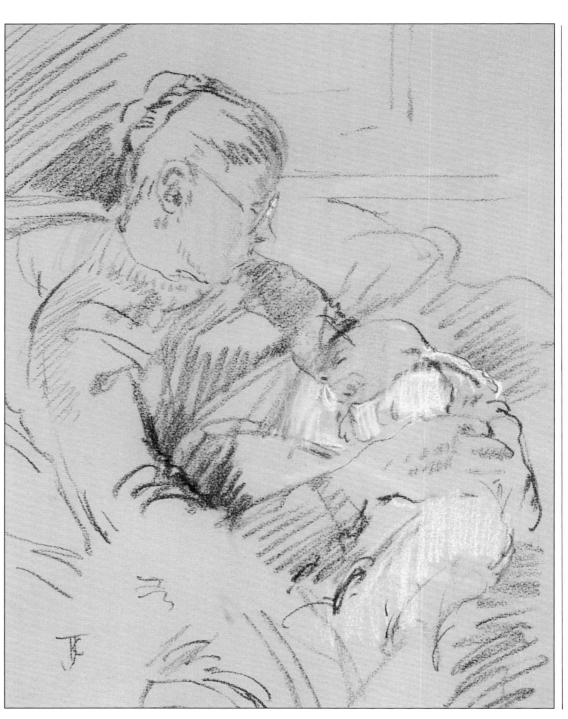

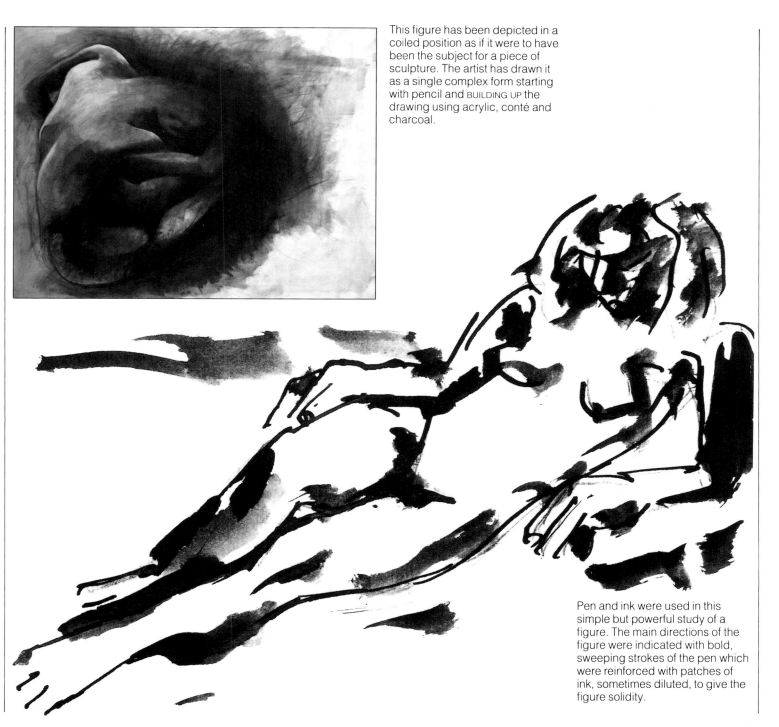

This figure has been depicted in a coiled position as if it were to have been the subject for a piece of sculpture. The artist has drawn it as a single complex form starting with pencil and BUILDING UP the drawing using acrylic, conté and charcoal.

Pen and ink were used in this simple but powerful study of a figure. The main directions of the figure were indicated with bold, sweeping strokes of the pen which were reinforced with patches of ink, sometimes diluted, to give the figure solidity.

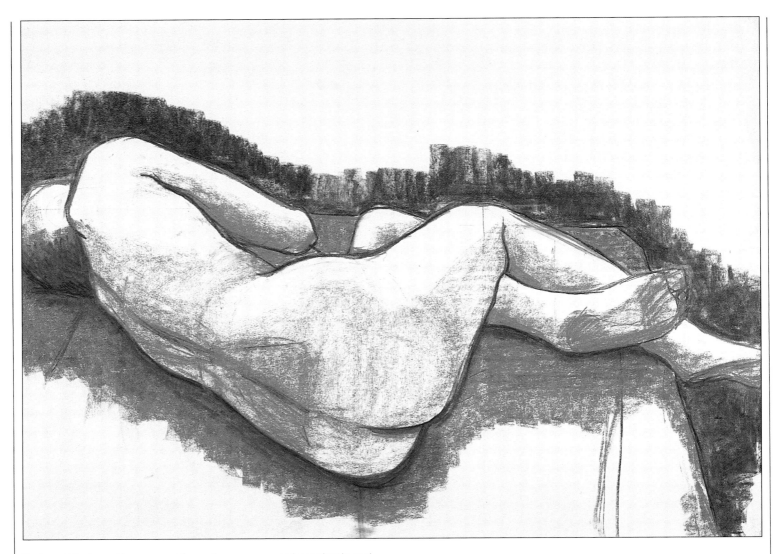

Red and black conté crayon work well together as a combination for figure drawing. The grainy mid-tones of the red crayon express the soft luminosity of the body's surface. The black crayon allows the artist to strengthen outlines and create dark shadows. In this example the white paper was allowed to show through the BROKEN COLOUR HIGHLIGHTING the illuminated parts of the form, and the SHADING was kept simple and direct by using the side of the crayon. This economical technique produced an uncluttered, well sculpted image.

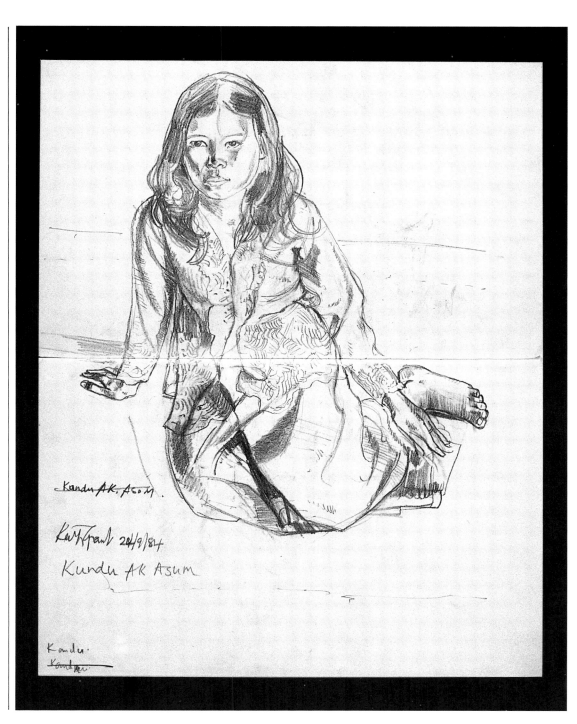

A soft pencil can produce both line and tone with ease and is ideal for this type of developed sketch. Children are notoriously difficult models and cannot be expected to sit completely still for long. You need to draw quickly, therefore, trying to capture the sense of latent energy and movement before it is physically expressed by the sitter. Here the lines are gentle and flowing, capturing the relaxed pose of the model.

FIGURES IN ACTION

There are plenty of readily available sources for drawings of figures in action, showing the different positions of the figure in movement. The most obvious of these are strip cartoons, where each frame shows the figure in a new position as the story unfolds. Cartoonists learnt from early pioneers, such as the Futurists and Marcel Duchamp, to indicate a range of movement by drawing figures in various stages of the same action in a single drawing.

Most drawings of figures in action attempt to imply the action by freezing it at a particular, typical, moment. The danger is that such freezing can produce a static result unless the movement before and after the represented action is implied in various ways. Sometimes the free style of the drawing technique itself insinuates continued action, but more often it is the clever choice of the representative action which distils the whole movement to one frame.

The key to making action drawings is to observe closely and to draw quickly. The artist has to spot what is most important, commit it immediately to memory and then record it as soon as the movement has been completed. Practise by drawing people engaged in some activity that involves repeated movements and gestures, such as playing golf or serving at tennis. It is then possible to observe the action repeatedly and add to the drawing rather than have only one chance to record it.

Drawing figures in action involves the visual memory even when the time lapse is small. Like all memory exercises, it is largely a matter of training and practice; the eye must learn to distinguish the significant action, and the memory to retain it.

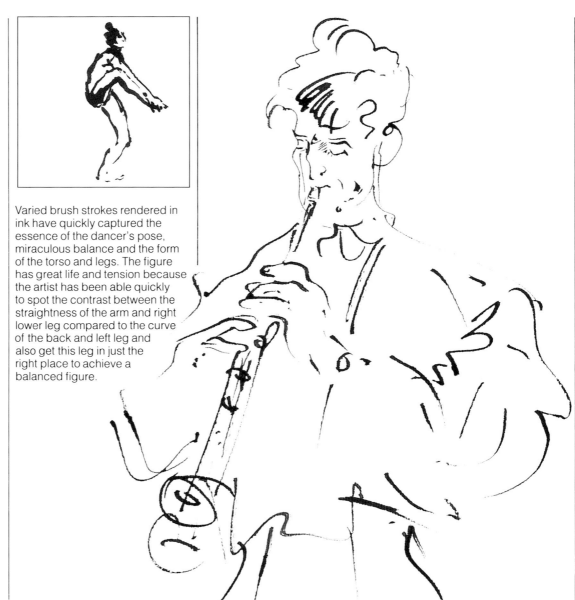

Varied brush strokes rendered in ink have quickly captured the essence of the dancer's pose, miraculous balance and the form of the torso and legs. The figure has great life and tension because the artist has been able quickly to spot the contrast between the straightness of the arm and right lower leg compared to the curve of the back and left leg and also get this leg in just the right place to achieve a balanced figure.

The artist has made a convincing study of a man playing a wind instrument, but it is not until you examine the drawing carefully that you realize how much is only suggested. A feature of drawing is its ability to give clues, such as those in this drawing, which the viewer automatically adds to. Yet everything is there; the dark falling forelock, the bow tie, and the shirt pulled in tightly at the waist are all shown with the tight-lipped figure, blowing in the characteristic way of woodwind players. The drawing has been rapidly sketched in pen and ink from direct observation and is an excellent example of a figure in action drawn with great economy of means.

A successful combination of MIXED MEDIA produced this energetic cyclist. Collage was the starting point; printed textures, shapes and images were cut out from magazines and assembled to make a composition. In the next step, a black and white photographic print was made of the collage. This print, worked over with pen, brush, ink and watercolour, was then transformed into the final image. It would be possible when using this technique to make a number of prints and re-work each one in a slightly different way, as in PHOTOCOPIER DRAWING.

This is a detailed study of dancers who posed in a particular position for the artist to draw. A strong but varied line in conté describes the figures, with the muscular structure of the legs emphasized by the use of HATCHING and SHADING, including BRACELET ·SHADING. Lines drawn in attempts at initially establishing the correct position of the two bodies have been left round the figures. These act as movement lines and help to give an impression of two figures caught at a moment in time. Colour has been added in pastel to indicate the tights and leotards.

The artist has employed a variety of media and techniques in this freely drawn sketch of a violinist made on warm-toned paper. An initial watercolour wash was laid down using a fine brush, followed by the addition of warm background washes. The light areas on the face and forehead were then lifted out with a brush dipped in clear water. Finally, orange oil pastel provided a touch of colour on the hand and white gouache was chosen for the dramatic highlight of cuff and collar.

Long unbroken lines made in charcoal pencil admirably capture the stretching action of the figure and are complemented by touches of watercolour for the flesh and the dancer's garment to give the drawing a more life-like, three-dimensional feel.

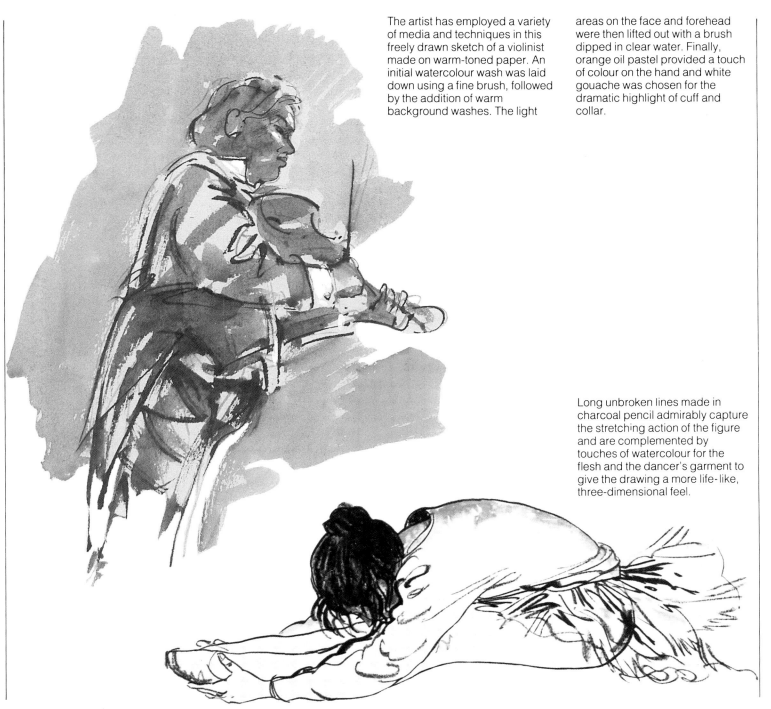

FIGURES IN A SETTING

There are few figure drawings by great artists in which the figure is drawn in isolation. The background may involve only a few lines and marks, but there is nearly always some indication of something behind the figure. There are a number of practical reasons for this. Drawing the setting in which the figure is posed can actually help you to draw the figure. Verticals can provide useful reference points when drawing standing figures, and defining the space behind a figure helps to establish it as solid and three-dimensional. An absence of background often makes the figure look flat and cut-out.

The particular relationship between figure and background is most important. The lighting conditions may cause parts of the figure to appear to blend into the background, and much of the poetry of drawing is attained by softening an edge here and omitting a detail there, so as to leave something to the viewer's imagination. A common mistake made by beginners is to draw a hard outline around the figure, completely cutting it off from the background.

The setting, especially if it is an interior, often involves problems of perspective. But the perspective can be used to advantage to establish a clear ground plane; and the scale of the figure in relation to the objects in the setting can again be extremely helpful in creating a realistic representation of the figure itself. The background does not need to be drawn in elaborate detail, but the relationship between objects and setting is such a significant one that to ignore it is to deny the drawing what could be one of its most important features.

This pen and ink drawing looks deceptively simple. It makes excellent use of HATCHING and CROSSHATCHING to describe the tone of the figures and to position them in their correct place in space in relation to the background. Although the figures have not obviously been drawn in great detail, a closer look shows that with great economy of means, quite a lot of information is given about the clothes they are wearing. What is most impressive is the typical hunched pose of the patient angler and the bored resigned stance of the child well wrapped up against the cold. The relationship of the figures to each other and also to their landscape environment has been caught perfectly.

This drawing done swiftly in pen and ink has been made from direct observation. The weight of line and the scale of the objects give an excellent feeling of space, which is enhanced by the indication of the tiles on the floor and the construction of the ceiling. The foreground figure has been drawn quickly but is carefully constructed in relation to his chair. The background figure standing at the bar has been 'balanced' against the vertical ends of the bar and the verticals of the doorway behind. This is an example of a quick sketch where the artist has skilfully used verticals and inter-related shapes to place the figures in context.

The artist has used a variety of media—pencil, watercolour, black fibre-tipped pen and coloured felt-tipped pens—for this drawing, which makes great use of pattern. The foreground figure's hat echoes the umbrellas over the tables behind. Her white dress links her to the café setting through the areas of white that have been left elsewhere in the drawing. Colour has been hinted at by the use of felt-tip line and small areas of watercolour wash. The total effect is one of lightness, with the artist concentrating on use of line, tone and colour to give a feeling of a bright sunny day.

A pen with a fine nib was used to sketch in the basic outlines throughout this drawing. Grey washes of diluted ink were added to define the shadows of the bridge and distant buildings. Then, taking a broad nib normally associated with calligraphy, the artist strengthened the foreshore and beachcombing figure. The finished result is a drawing full of varied LINEAR MARKS and controlled emphasis.

Although this drawing is crammed with dynamic shapes, they are contrasted with very controlled SHADING. This ambiguity creates a seemingly relaxed atmosphere but with underlying tension. The arms and legs are shaded towards their edges to produce stylized, curved forms. Colour was built up gradually, working throughout the whole drawing to ensure overall balance and harmony.

PORTRAITS

Successful portrait drawing demands the ability to create a solid, lifelike head and features that are a recognizable likeness of the sitter. It is this likeness of the sitter that provides portrait drawing with an additional dimension over and above straight figure drawing. The basic problems of portrait drawing are concerned with the proportions of head and features, the asymmetry of the face and, above all, the identification of those characteristics that make the portrait instantly recognizable.

Cartoonists are often very clever at identifying and exaggerating the prominent nose or receding chin of a celebrity they wish to lampoon. Although the degree of exaggeration needs to be reduced, the portrait artist should take a leaf out of the cartoonist's book and concentrate on the salient features by analyzing the head. Matisse's comment that accuracy is not the truth, probably relates to portraiture more than to any other form of art.

There are various approaches to drawing portraits. It can be a slow, methodical construction of the head, looking carefully for the difference between the two sides of the face — which are never symmetrical. Few noses, eyes or mouths are classically equal, and identifying these minute differences can help to produce a good likeness. Alternatively, you can go directly for those elements of the features that you consider characterize the sitter; these could be the main shape of the head or details of eyes, nose, lips and hair. Once these main characteristics have been captured, the drawing can develop around them to whatever degree of detail the artist requires.

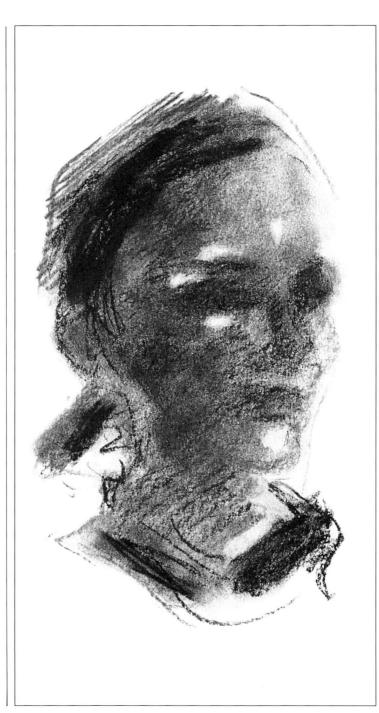

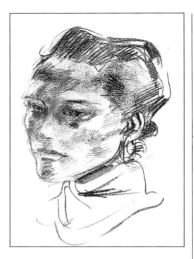

The artist has used charcoal pencil and a combination of SHADING and HATCHING to draw the model's head. The shading on the face carefully describes the cheekbones, jaw and chin construction, whereas those parts of the face that are illuminated have been indicated by leaving the light paper untouched. This use of light and dark gives a strong three-dimensional effect that is complemented by the line drawing of the sitter's hair and collar, which both act as simple contrasts to the more complex details of the face.

This three-quarter view of a head has been drawn simply in compressed charcoal. The dark areas of tone were put down swiftly using the 'side' of the charcoal, with the black areas and the sharp lines drawn with a corner of the stick. The highlights, the final touches that give the drawing a brilliance and create the effect of the head being turned towards the light, have been made by taking off some of the charcoal with a kneaded eraser.

This bold portrait of a miner incorporates torn paper collage for the background and shadow side of the head, with the outline of the head and the details of the features freely drawn using black ink and a brush. The extensive use of GESTURAL marks makes for a total effect of energy and vitality.

Excellent use of SHADING and HATCHING is the main feature of this study of a man deep in thought (below). The anatomical structure of the hand has been described lightly to contrast with the much darker face, whereas hatching gives information about the texture as well as the colour of the hair and beard. The softer shading on the side of the head and on the nose give the head a feeling of solidity. Note the deft contour line of the left cheek and forehead and that there is almost no line to describe the nose. The freely drawn hatched lines of the tie that flow from the STIPPLING used to describe the pattern on the shirt collar is yet another example of the finely judged balance and contrast that make up this portrait.

This lively portrait (right) has been drawn in brown ink with a fine brush before some touches of watercolour were added. The artist has seized on what he considered important—the wild hair, the well-shaped nose, the glasses and ears—and recorded these rapidly. The head is HATCHED in with a few almost vertical strokes in a similar treatment to that used for the hair. In a few free lines, the striped shirt, waistcoat and suit were indicated and touches of watercolour wash incorporated into the drawing to give colour to the features and emphasize the nose.

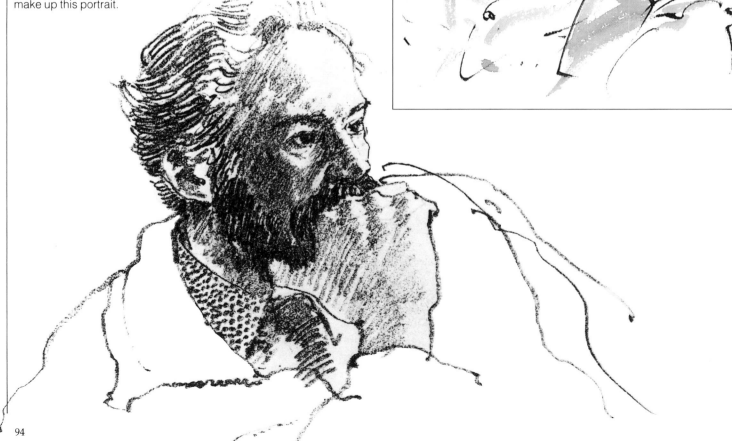

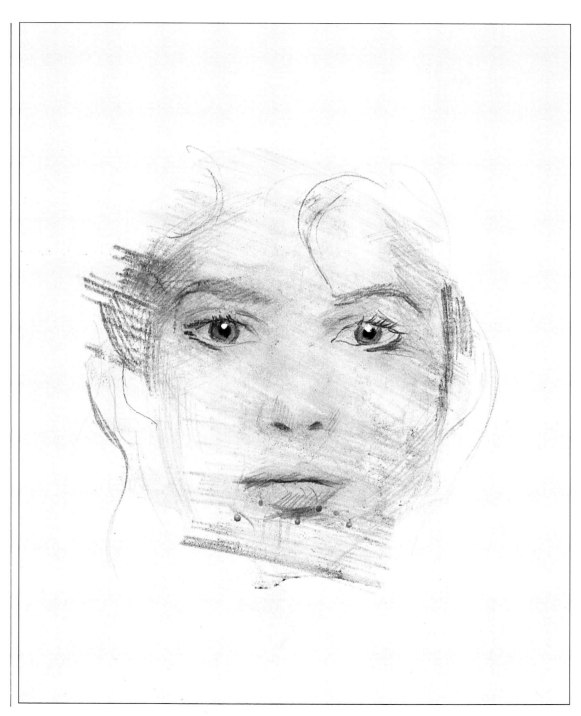

A sense of liveliness was imparted to this TRANSFER by the use of coloured pencil to add light SHADING and to accentuate the eyes, nose and mouth. The transfer was made by applying cellulose thinners over a photograph in a colour magazine to soften the printing ink. The photograph was then placed face down on a piece of paper and the back rubbed hard with a finger, transferring the image. The result is a softer version of the original magazine picture and gives gently blended tones.

Exploring a traditional subject with unusual media or techniques can produce exciting, novel results. Here a portrait was produced with a well chosen combination of MIXED MEDIA. Tinted paper formed the ground onto which the collage—assembled fragments of coloured paper—were glued down. Collaged white paper then provided an excellent back-lighting effect. Next, to describe the rounded form of the sitter, the artist shaded black pastel over parts of the collage. The final touch was provided by coloured inks, applied to modify the effect of the tinted paper.

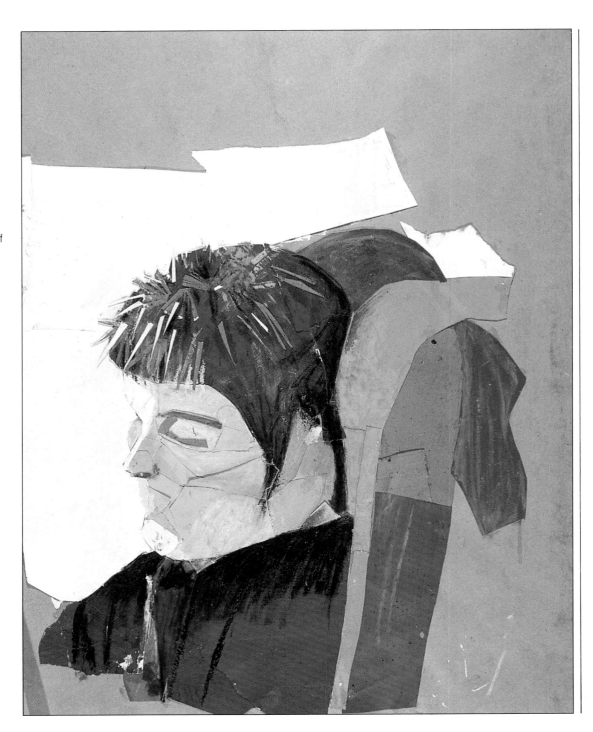

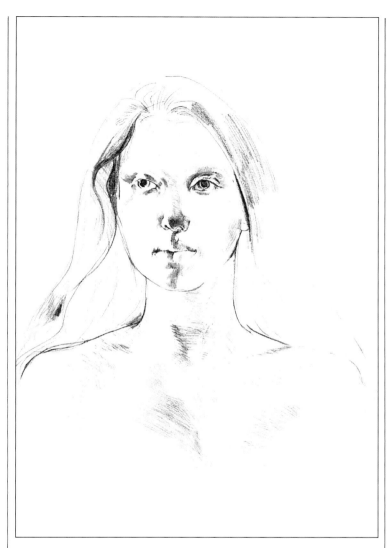

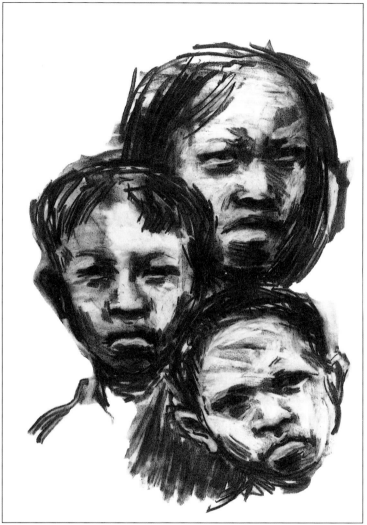

Soft pencil produced the sensitively sculpted form of this portrait. The contours and subtle modelling of the upper chest and throat are expressed with HATCHING. However, detailed description is reserved for the facial features which, slightly exaggerated, attract the eye. The hair is rendered with simple LINEAR MARKS, framing the face but not diverting attention from it.

Charcoal, handled with bold GESTURAL movements, created this powerful image of Vietnamese refugees. Once the basic shapes had been established with broad strokes, the artist covered the whole drawing with a dense layer of charcoal. She then worked back into this with an eraser, LIFTING OUT broad highlights, almost as if carving out the forms. The finished drawing has a simplified tonal range, the dark tones massed together to unify the image.

Figures ● Charcoal

Charcoal is regarded as one of the most flexible and expressive of all drawing media. The range of tones possible, from pale silver-grey to rich velvety black, constitute only part of its appeal. In this demonstration, the artist carries out a powerful figure drawing with an expressive and GESTURAL technique. She first draws with bold LINEAR MARKS and then exploits the SFUMATO qualities of the medium, BUILDING UP a composition charged with emotion. At one point the drawing becomes a mass of tone and is reworked by LIFTING OUT with an eraser.

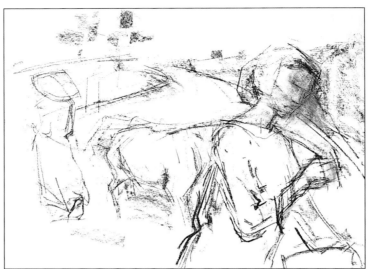

1 Rough hand-made paper was chosen for this drawing, giving it a lively texture. A mixture of thick 'scene-painter's', comprising of charcoal, thin sticks of charcoal and compressed charcoal were all used to rough in the basic lines and shapes of the composition with bold expressive marks. The artist made the drawing from a standing position with the paper pinned to a vertical board. This allowed for fluid, sweeping arm movements which fill the image with energy and drama. It is essential to stand back frequently when drawing in this GESTURAL way, so that the total effect can be assessed.

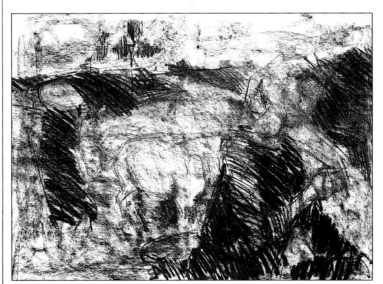

2 The drawing now takes an unusual turn. Scene-painter's charcoal is rubbed on so that the paper is almost completely covered with grey and black tone. Original outlines can only just be seen through the violent HATCHING and sweeping strokes. Because of the rough texture of the paper selected, the surface does not become too clogged, and the white breaks through, keeping the drawing fresh and also retaining a gentle luminosity.

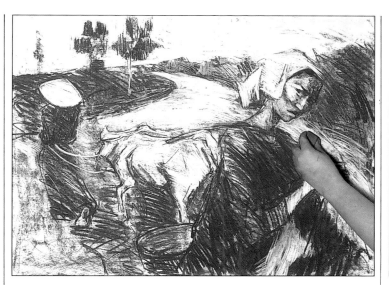

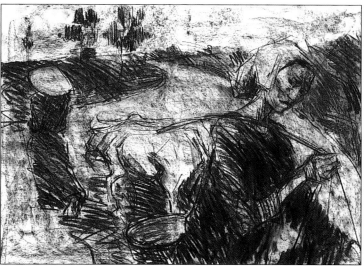

3 Taking a hard eraser, the artist works back into the drawing, LIFTING OUT the paler tones. The edge of the rubber produces HATCHED strokes which are utilized to model facets of the forms.

4 Thin sticks of charcoal and compressed charcoal are then skilfully manipulated to re-establish the original lines and shapes.

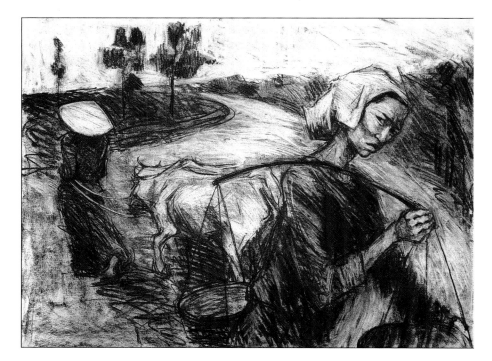

5 The soft, dense black line produced by compressed charcoal is used in the final stages of the drawing. The eyes, eyebrows, mouth and leading hand of the foreground figure are strengthened. Reworking, however, is kept to a minimum. The real power of this image lies in the GESTURAL, expressive marks which convey the artist's emotional response to the subject. The drawing was kept in a constant state of flux, with the artist concentrating on the main elements of the image. It is a good example of how an eraser can be used positively as a dynamic mark-maker rather than as a negative piece of equipment used only for correcting mistakes.

LANDSCAPE

Of all the subjects chosen by artists, landscape is almost certainly the most popular, particularly with the amateur painter and with visitors to museums and galleries.

It is surprising to what extent landscape drawing and painting, which seems to give so much satisfaction to so many people, is a relatively new subject in Western art, and one that has been developed only over the last few centuries. Although artists in the East portrayed nature from early times, in the West landscape was usually a small-scale backdrop against which the action took place.

The idea of a landscape being the main subject for a picture dates from medieval times. Dürer (1471–1528) painted some highly detailed studies of nature, but it was not until the early seventeenth century that true landscape painting began to be widely practised. Artists such as Poussin (1593/4–1665) and Claude Lorrain (1600–1682), for example, painted formal landscapes with the effects of light and shade, clouds and sunlight cleverly organized and displayed. Increasingly, artists began to travel, and many made the journey to Rome. The experience found them painting mountains and valleys based partly on their travels and partly on what they had seen in Rome.

In the Low Countries, Rubens (1577–1640), even though a court painter, was painting landscapes for his own pleasure by the beginning of the seventeenth century. The eighteenth century saw this love of the countryside become influential in England. Cotman (1782–1842), Crome (1768–1821), Gainsborough (1727–88) and Constable (1776–1837) (all East Anglian artists) observed and painted their local scenes. The work of this group of artists, together with that of Turner (1775–1851) constitutes what is considered by many to be England's most important contribution to art. Influenced by Constable and Turner particularly, later French artists such as Monet (1840–1926) and Pissarro (1830–1903) painted landscape, breaking up the elements of light to produce an 'impression' that moved landscape away from reality towards expressionist and abstract art. A more traditional group of artists, including Paul Nash (1889–1946) and John Piper (b. 1903) continued the English landscape tradition, giving it new directions; and as a follow-on from Modernism, artists are returning again to landscape as a subject.

Of all subjects, landscape probably offers the most potential material. In the case of almost every landscape subject, the problem is what to select from the scene in front of you. A viewfinder (a piece of card with a rectangular hole cut in it) can be helpful in isolating an area of landscape that has pictorial possibilities. Quick sketches are also a good means of exploring the choices available.

Inside or outside?

Many landscapes are painted in the studio rather than directly at the scene and to do this it is normal practice to make drawings, colour notes and studies on the spot. The dilemma of whether it is better to draw or paint the finished work outdoors or to recreate it in the studio from references is one that faces all landscape artists. Working on the spot produces a spontaneity and a dynamism that are difficult if not impossible to achieve in the studio. You have only to compare the sketches by Constable with his finished studio pictures to see this illustrated very clearly. Working in the studio, however, allows time to consider the composition of the picture more carefully than is possible on the spot. Working outdoors also means coping with the weather. It may rain, it can be windy (which is disastrous with a large painting or drawing behaving like a sail as you are trying to work on it) and the light changes constantly. On balance, however, there is nothing to compare with drawing from direct observation, although each artist has to decide for himself or herself which is the most satisfying way to work.

Texture and perspective

It is all too easy in landscape drawing to fall into the trap of concentrating on foliage and grass to the exclusion of anything else, whereby the work soon acquires an overall effect of similar textures, without any focal point or major visual interest. Generally, it is useful to find something, a tree or a large rock for example, that arrests the eye in the middle distance, without also de-

tracting from the background.

Perspective, which may on the face of it be of little consequence in landscape painting, is in fact very important. The scale of foreground to background trees or hills needs to be accurately established, for example, and rectangular fields in the middle distance need to be drawn as accurately as you might draw a number of books in a still-life group. Perspective can also create a strong feeling of space across fields, where the furrows drawn to recede accurately or the corn stubble drawn to show the diminishing texture across the field can give a drawing considerable depth.

The tree problem

Trees are an important part of many landscapes and drawing them so that they have their distinctive character and yet take their appropriate place in the drawing can be particularly difficult. In a sense, their depiction poses the same problems as those of drawing a flower and drawing a figure. They have to be seen as a simple form that can be broken down into the more detailed elements of branches and clusters of foliage. They have also to be constructed to stand in a particular way with the correct balance of trunk and roots to the umbrella of leaves above.

What to use

Pen and wash or mixed media are the most adept at producing the textures and contrasts of rocks, fields and trees and for quickly recording the swiftly moving clouds. Reflections, cloud formations and shadows are examples of landscape elements that often have to be speedily recorded as sketches and added later to a drawing, because they change so rapidly.

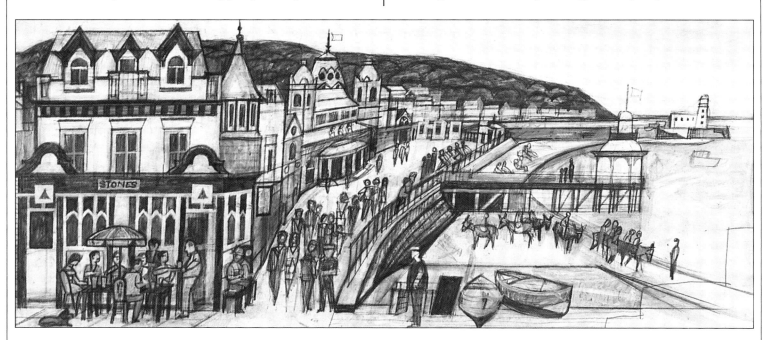

Landscape drawing doesn't have to mean just trees and fields! Figures, architecture, donkeys and boats compete for attention in this busy conté drawing of the seaside.

SEASONAL VARIATIONS

Perhaps the most appealing aspect of a landscape as a subject is that it is constantly changing. The seasons and the different weather conditions associated with them serve as an inexhaustible source of visual stimulation. Strong summer sunlight fills a landscape with colour and dark shadows, ideal for a pastel drawing. The same view, when snowbound, could provide the artist with the perfect subject for a calligraphic black and white BRUSH DRAWING. Storms can transform a placid scene into an arena of contrast and drama. Rain and wind create movement as they travel across a view, perhaps transforming a static leaf-laden tree into a dynamic feature yielding to the unseen force.

To capture the effects of weather, it is best to work outdoors immersed in it. Sound and smell are often overlooked as important elements in our experience and understanding of weather. Try to push the medium used to its limits, so that the actual substance of the drawing reinforces the subject. A charcoal drawing of a storm might be handled so expressively that it develops a patina, as if weathered itself; a delicate loose LINE AND WASH drawing might appear to tremble as if laid down by a gentle breeze.

Three studies of the changing seasons of the year explore the changes in the physical landscape as well as tonal variations. Coloured pencils and a variety of HATCHING techniques help to record the changing contours, colours and tones.

The tonal contrast is high in the bright sunlight of the picture above. Right, the same scene is viewed in the subdued light of a dull winter's day and the contrast is reduced. Note also the change in the basic shape of the landscape. In the drawing opposite the soft leafy hedgerow is captured in its bare wintry state.

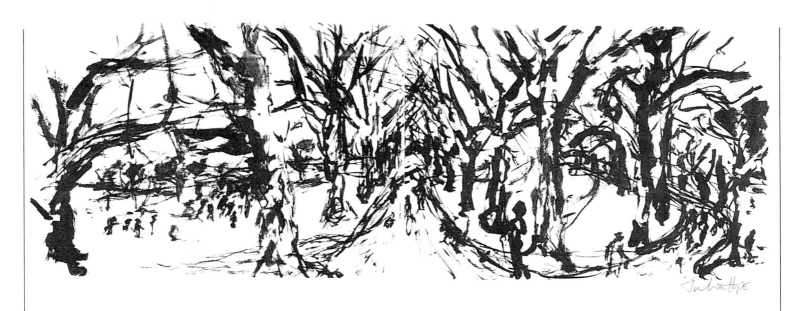

GESTURAL DRAWING with brush and black Indian ink (above) helped the artist explore the harsh, linear rhythms of leafless tree branches. The stark tracery of the tree forms and the agitated brush-strokes of the surrounding landscape convey a sense of cold blustery weather. But the drawing skilfully leaves much to the viewer's imagination; the ground might even be covered with snow.

The image (right) has been developed to the point where the weather described appears to have physically battered the drawing itself. Printing ink, rubbed through a silk screen, produced a textured ground on the paper. Then, by BUILDING UP a number of such layers, the artist produced a SFUMATO effect. With oil pastel and pencil she developed the image, transforming the marks produced by ACCIDENTAL DRAWING into dramatic weather conditions.

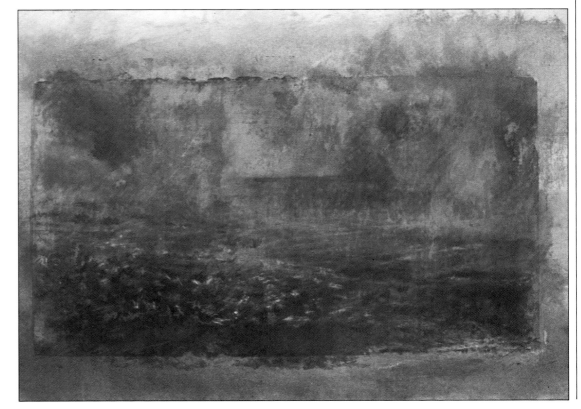

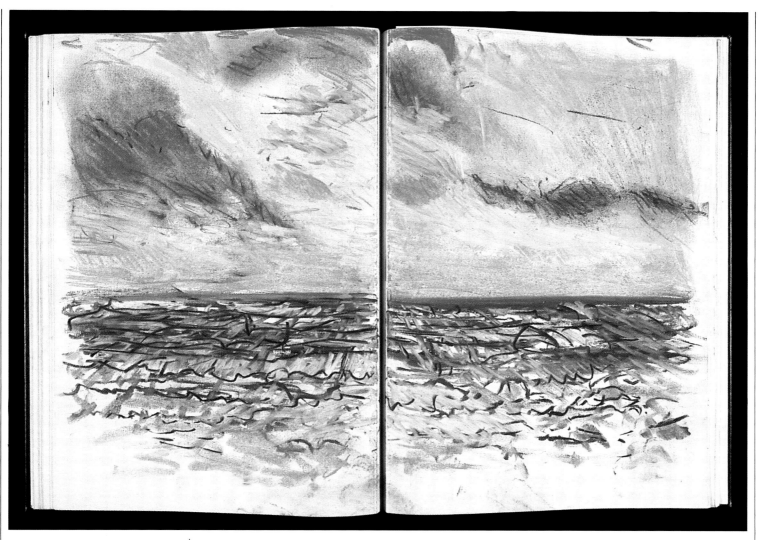

'Explosive' is one way to describe this seascape (above). Coloured pastels capture the dramatic effect of the sun breaking through after a storm. White wave crests on the choppy sea are expressed by allowing the white of the paper to show through the BROKEN COLOUR. Lively, black calligraphic squiggles reinforce the sense of movement.

A stormy sea has been recorded by the artist on another sketch book page, but this time in pencil. Here the heavy sky is captured with strong vertical HATCHING, suggesting rain falling from a thunderous cloud as it races across the sky. Again, skilfully chosen areas of white paper help to create the wave forms.

DISTANCE

The depth of view in a still life or figure drawing may be only a few feet. In a landscape, on the other hand, it could stretch all the way to the horizon, perhaps many miles away; and the field of vision might be narrow or panoramic. Defining such qualities of distance and calculating how to recreate it in a drawing have always both inspired and tested the artist.

The invention and development of linear perspective drawing in the fourteenth and fifteenth centuries was a major step in the quest to record distance. Added to this were the insights of Leonardo da Vinci, one of the first artists to make a thorough study of depth in landscape painting. In his notebooks, he discusses the phenomenon of aerial or atmospheric perspective, where things in the distance appear paler in tone and bluer in hue because of the effect of the intervening atmosphere. Drawing overlapping planes is another way of reinforcing an illusion of depth. The viewer can follow the logical progression from one plane back to another. By placing a familiar-sized object, such as a tree or a figure, into a landscape the artist introduces a benchmark from which other dimensions can be gauged. However, there are no hard and fast rules in art. Indeed, Turner substituted the indistinct for all the logical techniques described above. Even so, a dramatic feeling of depth is created in his paintings through veils of misty tones or colours that draw the viewer into a seemingly infinite space.

Overlapping tonal planes and aerial perspective create a feeling of space in this pencil and wash drawing. The palest tones in the far distance were produced with a brush and dilute black ink. Objects closer to the viewer have a higher tonal contrast and appear in more detail, achieved by the addition of pencil. The lower half of the drawing has been left virtually untouched, but although it is less detailed than the middle distance, it still forms a strong foreground shape.

It is difficult in a drawing to recreate the sensation of looking out to sea. Huge distances are involved, with little to guide the eye. Most artists therefore include a foreground and background object to give an idea of scale, as in this ink drawing. Here, a double line near the bottom of the drawing represents a low, dark horizon, leaving a vast area of sky, dominated by a monumental cloud carefully modelled with intricate CROSSHATCHING.

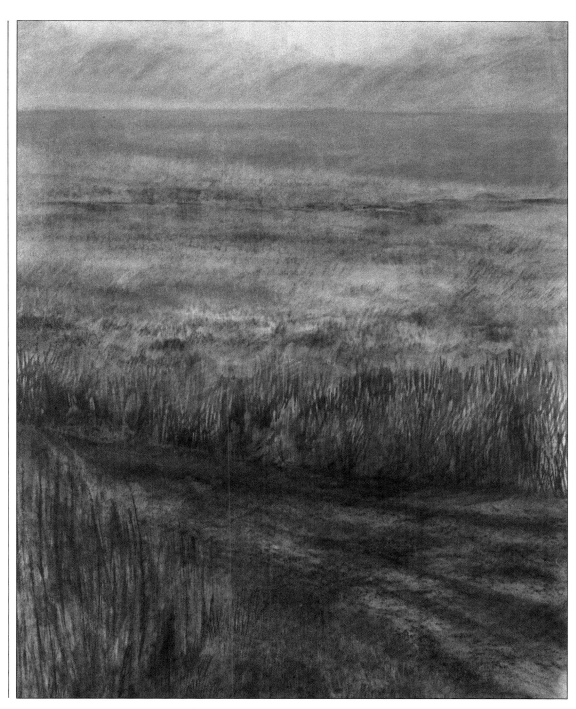

In a landscape drawing a high horizon line leaves plenty of space to create a well-controlled progression from the foreground into the background. Here, it is through subtle variations in colour, tone and texture that the eye is drawn deeper into the picture. The artist set out to create an atmospheric image by rubbing and BLENDING pastels on the paper. In the foreground grasses, drawn in black chalk, the length of the vertical HATCHING diminishes as it progresses up the paper, thus creating the impression of a receding plane.

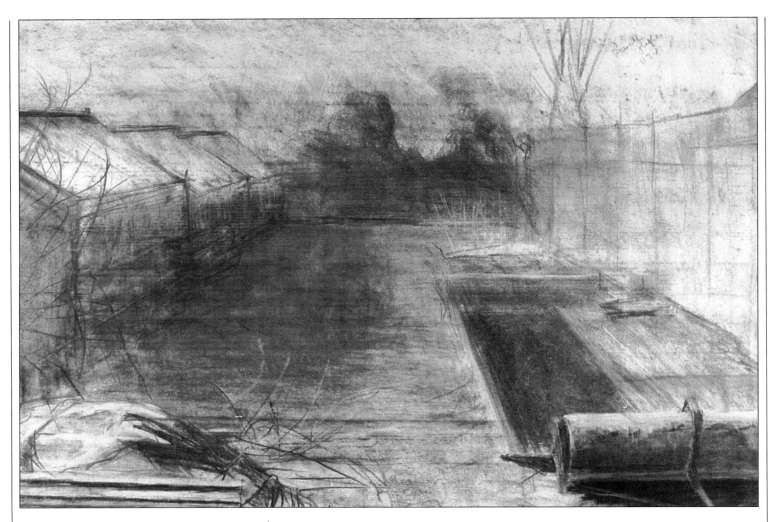

Linear perspective is the principal agent that creates a sense of space in this charcoal drawing. Converging towards a vanishing point, the compositional lines carry the eye towards the the horizon. The predominant misty tones of the drawing were produced by gently rubbing charcoal into the paper. Patches of light were then LIFTED OUT with an eraser. Note how the strongest shadows and brightest highlights were reserved for objects closest to the viewer, such as the roller.

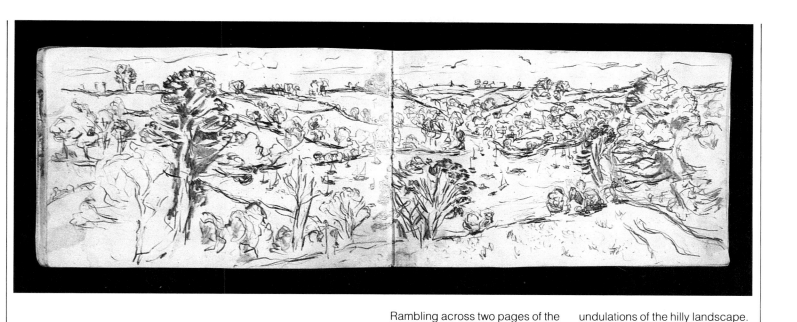

Rambling across two pages of the artist's sketchbook, this view takes the eye across a large river valley, over the hills and into the distance — without sacrificing the wider field of vision. Sensitive broken lines explore the rhythmical undulations of the hilly landscape. Broader tonal marks, especially in the foreground, add foliage to the trees. The tiny boat shapes on the river are instrumental in creating a sense of scale and therefore distance.

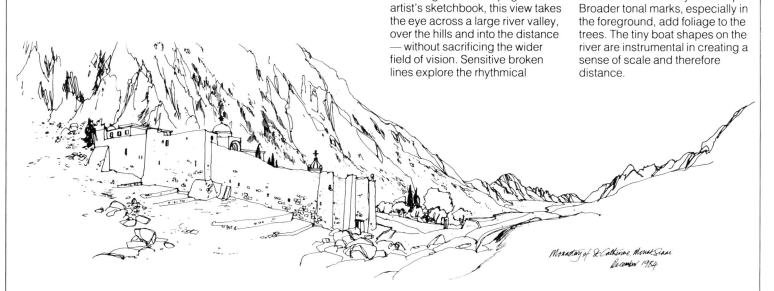

Monastery of St Catherine, Mount Sinai
December 1984

Exploratory, almost scribbled, marks guide the viewer into this panorama from the top left of the drawing. These soon develop into steep slopes and then distant mountains as the eye naturally scans from left to right as if reading a book. Limiting himself to thin lines of black ink, the artist has conveyed the concept of infinite distance and given a strong sense of the isolation of the monastery in its rocky setting — perhaps because the drawing was made on the spot, working directly with pen and ink. By following the lines, we can accompany the artist as he searches out the rocky forms.

ATMOSPHERE

Imagine a hot sunny day in a small English village and then a similar day somewhere in the Mediterranean. Although the weather may be the same, you would expect the atmosphere of each place to be completely different. Many artists choose to draw a particular place or landscape because of the aura generated by it. It is not the individual elements of weather, the buildings, trees or people that impress, but usually a combination of all these things and more which create a particular atmosphere. Our own state of mind also contributes to what we perceive. For example, the farmer sees the countryside as a workplace, whereas, to the day-tripper out from the city, the atmosphere is usually one of freedom and relaxation.

So how does the artist set about capturing the complex and transient qualities of mood and atmosphere? One approach is to draw the landscape with opposites in mind. Is the mood relaxed or active? Are the characteristic colours warm or cold? Is the air clear or hazy, the view static or dynamic, the lighting dramatic or placid? Analyzing it in this way enables you to build up a broader vision. Combine this with your own emotional response and, through your drawing, you should start to realize the essence of the landscape rather than merely depicting the elements that make it up.

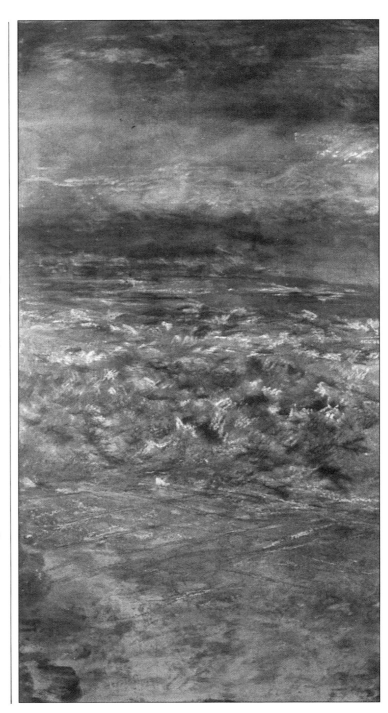

Subtle overlapping veils of tone and colour were created on a sheet of paper by rubbing ink through a silk screen. The SFUMATO effect created by this technique was then enhanced by drawing into it with graphite sticks and oil pastel. The result is an unusual combination of MIXED MEDIA, highly evocative of a stormy landscape or seascape. The viewer is left to interpret the drawing, but the artist directs the eye into the receding distance by carefully grading the scale of the marks. The detail draws attention to the different densities of the drawing and the white oil pastel highlights.

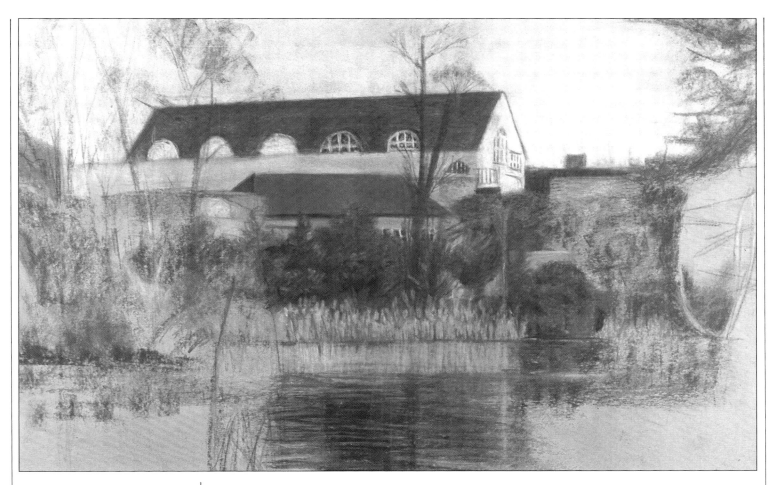

A tinted paper can help to set the tonal range of a drawing. In this example (above) the artist chose a cream tinted paper as a background before BUILDING UP basic colours and tones by using pastels on their sides to produce broad wash-like marks. The luminosity of the beautiful sky was achieved by BURNISHING with a white pastel. The clarity and stillness of the trees and water create a peaceful and relaxing atmosphere.

Vigorous marks made in charcoal produced this dynamic landscape (right). The artist has exploited thoroughly the capabilities of the medium, smudging tones, HATCHING shadows and creating foliage with AUTOMATIC MARKS. In the top left of the drawing, the woodgrain texture was introduced using FROTTAGE. The atmosphere of the finished drawing is one of dramatic vitality.

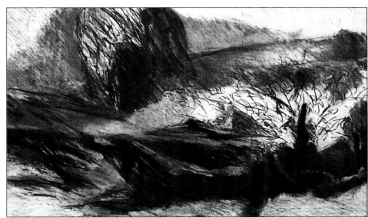

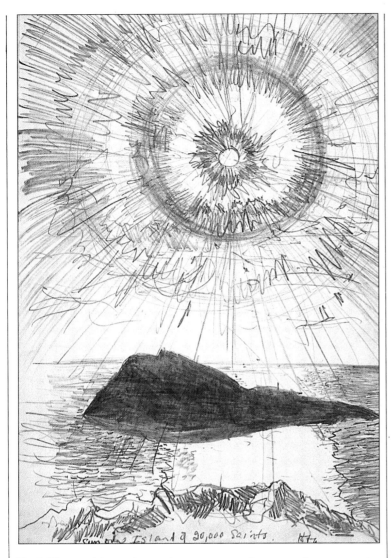

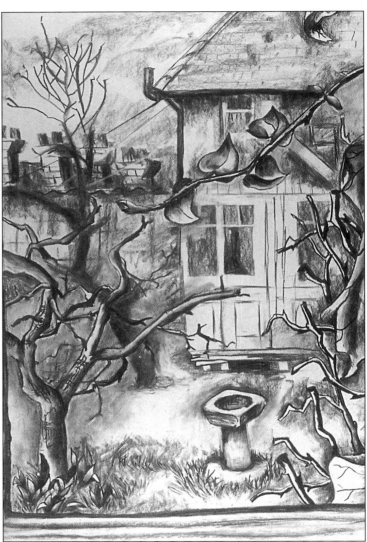

The brilliance of the sun's rays is difficult to capture, particularly if the artist is restricted to black and white. Even if the tonal GRADATIONS are painstakingly recorded, the effect is often dull and lacks atmosphere. Here, a more successful approach is evident. Rather than faithfully recording the tonal values present, the artist used calligraphic pencil marks to express the energetic movement of light across the sky, so that the light appears to radiate outwards in concentric lines. Dense HATCHING creates the deep tone of the rock, which contrasts with the highlighted reflection in the water. The result is one of striking beauty.

There is something theatrical about this charcoal drawing of a garden. The strong side-lighting and the animated pattern created by the bare wintry trees create melodramatic tension. The bright lighting simplifies the tonal range: broad grainy strokes of charcoal form the mid-tones, whereas heavier dark strokes describe the shadows on the trees. HIGHLIGHTING is provided both by leaving the white paper to show through and by LIFTING OUT the charcoal with an eraser.

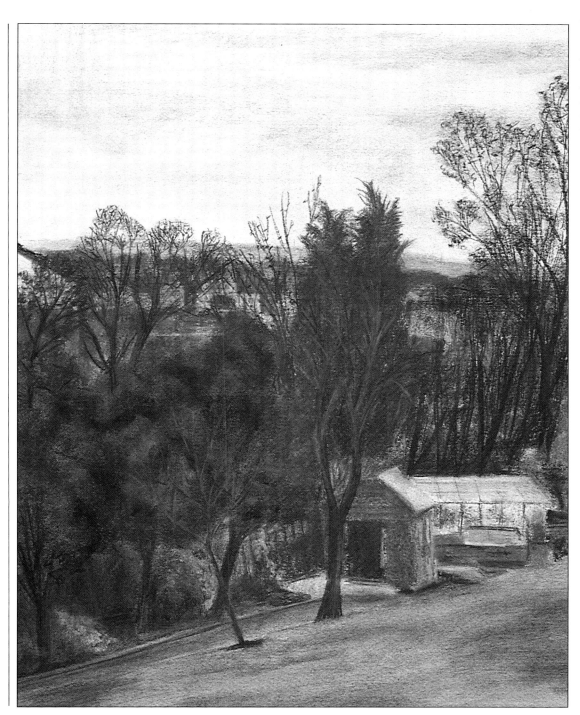

The relaxed atmosphere of this scene stems from the subdued colours and static composition. The pastels have been applied sensitively and are not too heavily worked; even the shadows are coloured with reflected light. The detail shows how white pastel was added to introduce further patches of luminosity.

FEATURES

For many landscape artists, it is not the shape or lie of the land that moves them to work, but particular features within it. These may be trees, buildings or figures, for instance. One outstanding feature may dominate a whole panorama — perhaps a patchwork pattern of fields, a mountain or a lake. The important thing is to assess the landscape as if seeing it for the first time. Avoid taking anything for granted; even the most ordinary object can be presented in an interesting way. Look for unusual patterns, textures and unfamiliar shapes. This is particularly important when drawing trees, as it is all too easy to generalize and produce repetitive, run-of-the-mill images. Each tree is a living thing and has unique characteristics of shape, texture and colour which can be analyzed.

Figures or animals can provide a focus of attention in a landscape and add a narrative element. Do not be afraid, however, to leave out any features that do not contribute to the composition or that spoil your view. The artist's task is to manipulate the raw material to get the most out of it.

Interesting features often come to your notice when you are least prepared – travelling in a car or on a train, for example. It is a good idea to carry a sketchbook so that such useful material can be quickly recorded and stored for use at a later date.

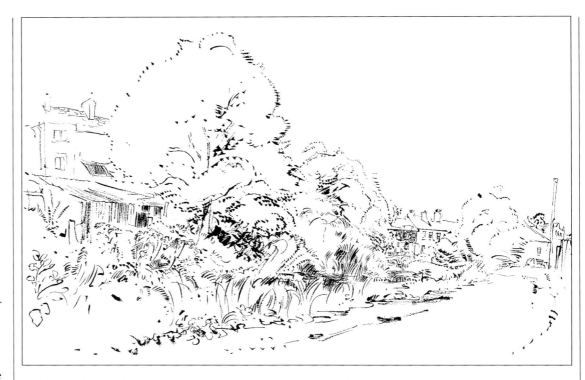

A wide variety of marks can be made with a brush and black ink. Such a combination was considered suitable, therefore, for the rich mixture of form and texture found in this landscape of terraced houses, trees and overgrown banks of vegetation. SKETCHING directly *in situ* the artist used the tip of the brush to produce the delicate outlines of the trees. Then flecks, POINTILLIST dots and HATCHING were used to explore the foliage. To balance out the energetic patterns of the brushwork, he left the paper untouched in places allowing the white to show through.

A humble telegraph pole and wires make a captivating linear image, rendered directly with confident calligraphic strokes. A broad-nibbed pen forces the artist to be bold and to economize on detail. This results in the subject being viewed more as a geometric, abstract pattern, than as a journey into the picture itself.

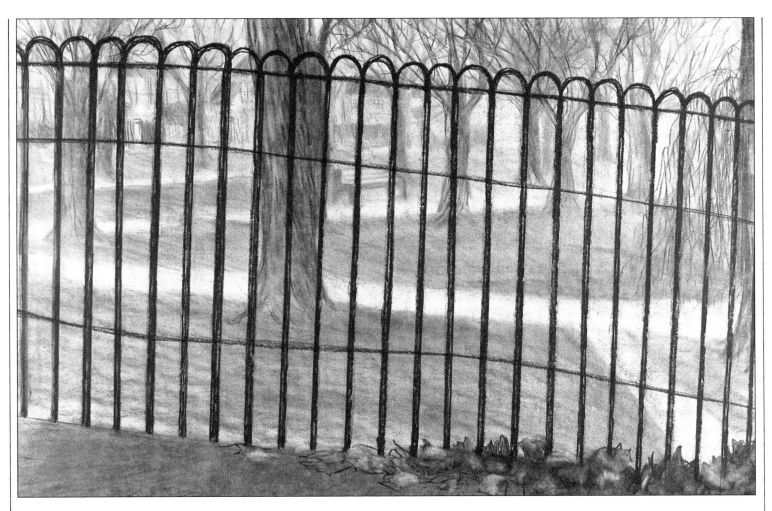

It is easy to walk past railings without even noticing them. Yet their artistic potential has been explored and exploited by many artists. This park scene has been sketched in pale tones with charcoal. In the detail, the white paper can be seen showing through the smudged tones of the drawing, creating a strong tonal pattern. Finally, some deft penwork, using black Indian ink, established the railings. The strong ink lines contrast with the charcoal work, making it seem even paler and more delicate.

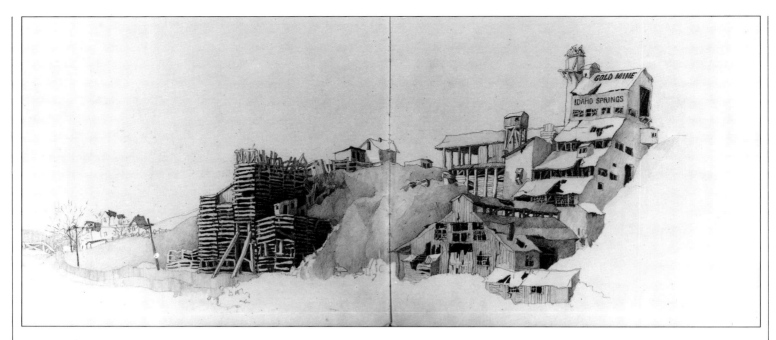

When travelling, it is a good idea to carry a sketchbook for recording images that can be developed at a later stage. Soft pencils, which produce a beautifully rich GRADATION of tones, were fully exploited in this sketch (above) of a tumble-down gold mine at Idaho Springs, Colorado. First, the proportions and main shapes of the drawing were established in outline. Then the drawing was built up with controlled SHADING.

When the artist came across these distinctive landscape forms, he recorded them with a rapid sketch (right). Coloured crayons and a black oil pastel produced a loose HATCHING technique — the cloud forms were literally scribbled in. Despite the haste and simplicity of the sketch, the artist has skilfully isolated the dominant features that characterize the landscape, particularly the dark, rounded tree forms punctuating the bumpy hills.

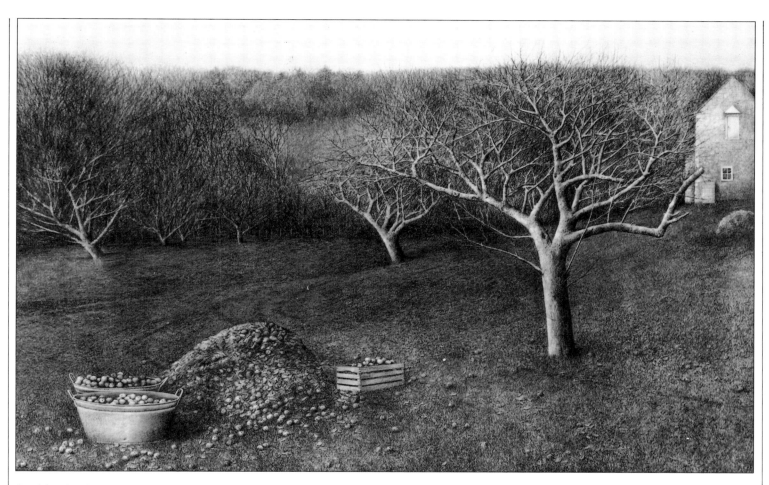

An old orchard such as this is steeped in character and history. The astonishing detail and beautiful texture of this drawing were built up painstakingly with small pencil strokes. In the detail, even the bruises on the apples can be seen. The side of the pencil lead was used to produce the basic tonal areas, over which small flecks, dots and strokes have been added. To represent the light falling on the trees, the artist allowed the white of the paper to show through the pencil marks. Further HIGHLIGHTING on some of the small twigs was created by carefully scratching away the pencil surface with a pointed blade to reveal the white paper underneath.

A feather quill can be trimmed to create a nib capable of producing a great variety of LINEAR MARKS. This relaxed ink drawing above uses as few lines as possible so the artist ensures that they are interesting. The trees are barely suggested, and a few squiggles of the quill constitute the foreground. There is very little detail, the artist attempting to capture a total atmosphere rapidly. He leaves a lot to our imagination.

In contrast to the ink sketch above, this drawing is rich in detail. However, the level of detail is carefully graded from background to foreground. Distant hills and moored ships are drawn with fine lines and only in outline. Closer objects are rendered in much more detail to create depth in the drawing. Black washes throw attention onto a cat sitting on a wall in the bottom left of the picture.

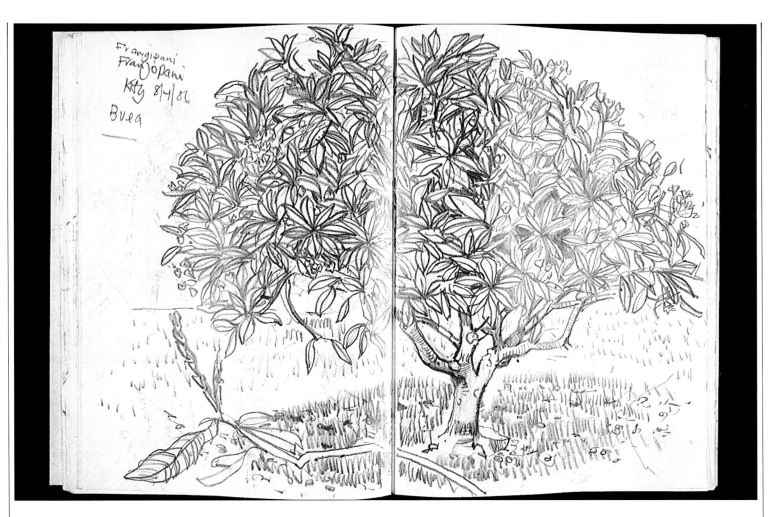

The beautiful and elaborate foliage of this exotic tree was recorded with pencil across two pages of the artist's sketchbook. The drawing was done quickly, using outline to render the variety of leaf shapes. BRACELET SHADING was used to model the form of the trunk and lower branches. Short HATCHED strokes create shadow beneath the tree and also suggest the texture of grass.

Landscape ● Ink, Masking Fluid

In this step-by-step demonstration, we follow the evolution of a dramatic landscape drawing. The artist works with brown and black ink and masking fluid. He explores not only his subject but also the inspirational properties of the media. With brush, quill pen and a variety of techniques, he exploits ACCIDENTAL DRAWING effects.

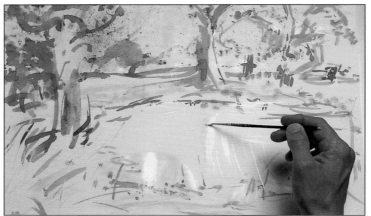

1 Following a heavy rainstorm the artist came across these 'blasted' oak trees set in a watery landscape. From memory and sketches made on the spot he decided to explore the subject by making a lively brush drawing. Burnt Sienna Chinese ink and a number 8 sable brush were used to sketch out the basic composition with gestural, semi-automatic strokes. After this initial sketch had dried the artist used a smaller brush to apply masking fluid. This will protect and preserve parts of the underdrawing while further work is carried out.

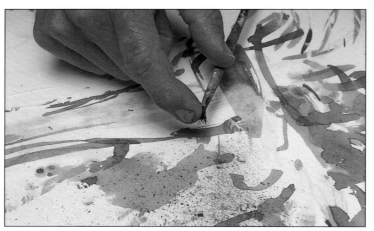

2 It is surprising how often an old bristle brush will come in useful. In this picture the artist flicks the ink-laden bristles with his forefinger to send a spray of fine dots onto the paper. This spatter work is used not only to build up tone but also to add a textural element to the image.

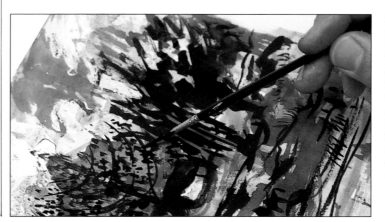

3 With black Indian ink and a number 2 sable brush the artist begins to introduce more detailed features. The tip of the brush is exploited to produce the decorative foliage patterns. Broad marks were made with the same brush but utilizing the full length of the bristles. Detail and form are developed throughout the whole drawing with a loose GESTURAL technique, exploiting any interesting accidental marks.

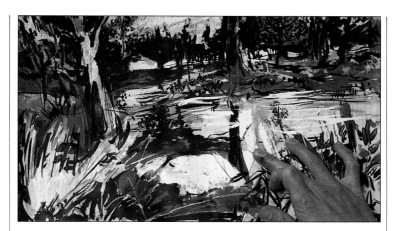

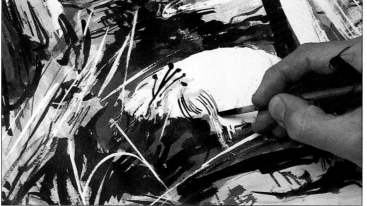

4 The drawing is left to dry, and then the artist gently rubs the paper with his finger to remove the masking fluid. This stage is always exciting because you are never sure just what the drawing will look like when the crisp white patches and brushstrokes are revealed.

5 The final stage of the drawing was done with a large quill pen. The tip was trimmed to make a sharp and flexible nib capable of a great variety of marks. Here the artist draws into an area previously covered with masking fluid. The finished drawing is below.

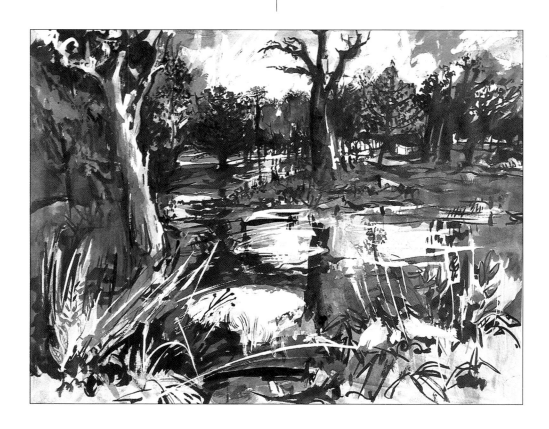

Landscape • Photocopier Drawing
Once the original brush drawing is complete, it is photocopied a number of times so that all potential developments of the design can be investigated and compared. Each photocopy is worked on to produce a unique interpretation of the original drawing. Changes in lighting, features and composition are explored via the copier, so that the original drawing remains intact.

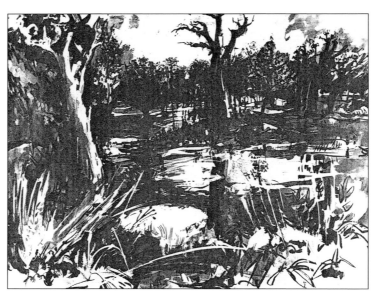

1 The finished drawing (from the previous demonstration) is photocopied a number of times. The copy can be made the same size as the original or reduced. In this case all the copies are A3 reductions from an A2 original. These copies are on white paper, but it is possible to experiment by feeding coloured or some textured papers into the machine.

2 Stark contrasts of black and white change the time of day in the drawing and produce an eerie moonlit atmosphere. Indian ink and a brush were used to BUILD UP the image on this copy. What were mid-tones have been blocked in as solid patches of black, leaving only the palest tones to oppose them. Starting from one original you could explore the complete 24-hour cycle of changing light and how it affects your subject.

3 It is possible to draw into a photo-copy by scratching out white lines with a scalpel. In conjunction with opaque white gouache and black Indian ink, scratching-out transformed this copy. Note how the light falling on the trees now comes from the opposite direction. The watery middle distance has been completely obliterated and 'grassed over'. The wispy scratched marks seem to suggest a breezy autumn day with the trees beginning to bare their branches again. In the same way that the time of the day might be explored, PHOTOCOPIER DRAWING can be used to experiment with suggesting seasonal transformations.

4 On this photocopy the artist has radically altered the composition, editing out unwanted features with opaque white gouache. The large tree on the left in the original was completely removed along with all the foreground foliage. We now view the trees from across a lake, black brushmarks suggesting ripples in the foreground. Some scratching out was used to highlight the trunks of the trees in the background copse. You can be as bold as you like with these alterations, knowing that the original is still intact and can be returned to.

ARCHITECTURE

Artists have always made drawings of their surroundings. There is evidence that prehistoric man made records of his home, but the earliest recognizable representational drawings of buildings appear in the backgrounds of early illuminated manuscripts. Sometimes these drawings are of natural places, sometimes they are of imagined cities, with Heaven portrayed as a place of magnificent cathedrals and beautiful palaces. Many important buildings that have long since disappeared are known only through the surviving drawings made of them.

Cityscapes produced during the medieval period were often intended as town guides and give an impressive record of commercial centres, residential districts and the general town planning strategy of the period, during which villages burgeoned into cities.

The development of perspective made it possible for the artist to suggest in a more impressive way the size and scale of buildings and to depict more realistically the architectural scene. During the Renaissance, artists displayed their skill with perspective in drawings of elaborate architectural arrangements but these themes remained mainly as backgrounds. It was not until the nineteenth century that architectural drawing became popular.

The romantic classical drawings of Piranesi (1720–78) were a possible starting-point that allowed artists such as Hogarth (1697–1764) to portray a more realistic and accurate picture of the contemporary scene. By the time of the Impressionists, artists such as Pissarro (1831–1903) had become obsessed with making drawings and paintings of Paris or any other place they visited. More recently, artists have used their depiction of cities to make a social comment or convey a particular emotional quality. The paintings of Edward Hopper (1882–1967) are particularly evocative of the trivial detail of urban nightlife in America. The drawings of L. S. Lowry (1887–1976) reveal the industrial north of England as a strange, misty, urban scene populated with stick-like figures. The paintings of European cities by Kokoschka (1886–1980), made from very high viewpoints, display a restless energy that characterizes the dynamism and sprawl of the modern metropolis.

Choosing a viewpoint

Kokoschka's paintings, almost like bird's eye views, were made from the windows of very high buildings; and sketches made from windows offering excellent vantage points are one of the most effective ways of making architectural drawings. There are many public buildings, such as museums, that can be used as places in which to draw. The main difficulty in making architectural drawings is firstly, finding a suitable place to draw from – try making a drawing in Times Square, New York City, or in St Mark's Square in Venice – and secondly, deciding the degree to which you will either work 'on the spot' or will recreate a drawing from sketches, notes and possibly photographs.

Working from direct observation almost always produces the best results. Working from photographs is difficult because generally they do not provide the information you expect. If the view you want depends on being at street level, then in many cities you may have to be at work at first light to be able to produce a drawing before your view is obscured by traffic and pedestrians. It is often very difficult in the high-density, modern city to be able to get far enough away from buildings to be able to see them from a single viewpoint. If you have to 'scan up' or across a building in order to see it completely, your resulting drawing is highly likely to make the proportions, and therefore the perspective, appear very distorted.

In choosing a viewpoint at ground level or higher, it is wise to avoid the 'flat-on' view of the façade of a building as a major element in your composition. This is because it is extremely difficult to give a building seen from this angle a feeling of solidity.

Geometry and detail

Above all else, a sound knowledge of perspective is required in order to produce convincing drawings of architecture. In order to simplify the drawing problems for complex buildings such as cathedrals and palaces, reduce them to basic geometric forms. Any building can be seen as a series of large blocks or cylinders, and once these have been lightly indicated, the building can be constructed, with the architectural detail gradually

introduced. When you look at a building you get a general feeling for it; you don't see the brick or stone patterns on the walls until you look at them separately. This overall impression needs to be retained in the drawing and the details of brick patterns or tiles must not become so prominent that they compete with more important architectural features.

Architectural drawings call in the main on the artist's skill in judging perspective, and in particular on his or her ability to create specific textures and depict the strong contrasts of light and shade.

'Artists' impressions'

Representational drawings of architecture and imaginative architectural views have already been mentioned; however, architectural drawing can also refer to a third type of drawing. These are impressions of buildings or urban complexes that have been designed but not yet constructed. These 'artists' impressions' are sometimes drawn by the architects who have designed them or, more often, drawn by artists who specialize in producing realistic drawings of buildings from architects' plans and elevations.

Conté crayon and watercolour are combined in this drawing to create an effect of great solidity.

TOWNSCAPES

Townscapes provide a rich source of material for the artist with an observant eye and an imaginative approach. Walk down any street and you'll find a wealth of shapes, patterns and textures that provide the raw material for exciting drawings. The precise shapes of buildings and rooftops afford the opportunity to create bold, geometrical compositions; in cities, high-rise blocks often jostle for space with ornate old houses, providing an intriguing contrast between old and new, smart and dilapidated. Or you might be more interested in recording the minutiae of urban decor: an old-fashioned lamp post, an open doorway, or an old stone fountain in a village square.

Whatever aspect of urban life you decide to draw, try to choose a medium and a technique that complements it. Do you want to record intricate details of a decorative façade, or express the noise and commotion of a modern city centre? For the former you may decide on a linear medium such as pencil or pen and ink; for the latter you might try a bold MIXED MEDIA drawing. There are no rules, it's for you to experiment. Remember that the most important thing is to capture the mood of the moment, a sense of 'life on the wing', rather than slavishly to record everything you see in perfect detail.

On a small sketchbook page the artist has recorded a dramatic and imposing skyline in which the dark buildings contrast strongly with the light-reflective surface of the water. Note how the gritty texture of the charcoal surface adds to the mood of the drawing. When SKETCHING like this, always look for an interesting silhouette, broadly blocking in the massed tones of the buildings using the side of the charcoal stick.

A peaceful village scene drawn with a brush and a reed pen and diluted black ink. This technique is especially suited to subjects like this which include buildings and foliage. Architectural details can be picked out in line and the foliage in broader washes providing a pleasant contrast of texture and tone.

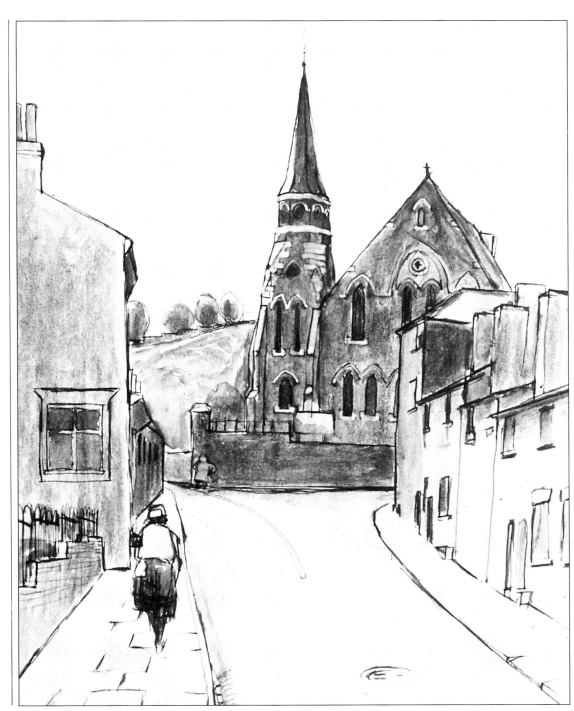

The church is the centre of interest in this drawing, and the artist cleverly leads the viewer's eye straight to it through the use of sharp perspective in the road and buildings. Note how the church is rendered in more detail and contains stronger tones than the terraced cottages we travel past. The addition of a single figure lends a sense of scale to the drawing and also acts as a counterpoint to the centre of interest.

When drawing a townscape choose features that represent, for you, the town's true character. In this picture the inclined street and hill in the background tell us something about the local topography. The details of the simple houses and the relatively ornate church convey an idea of the character of the local inhabitants.

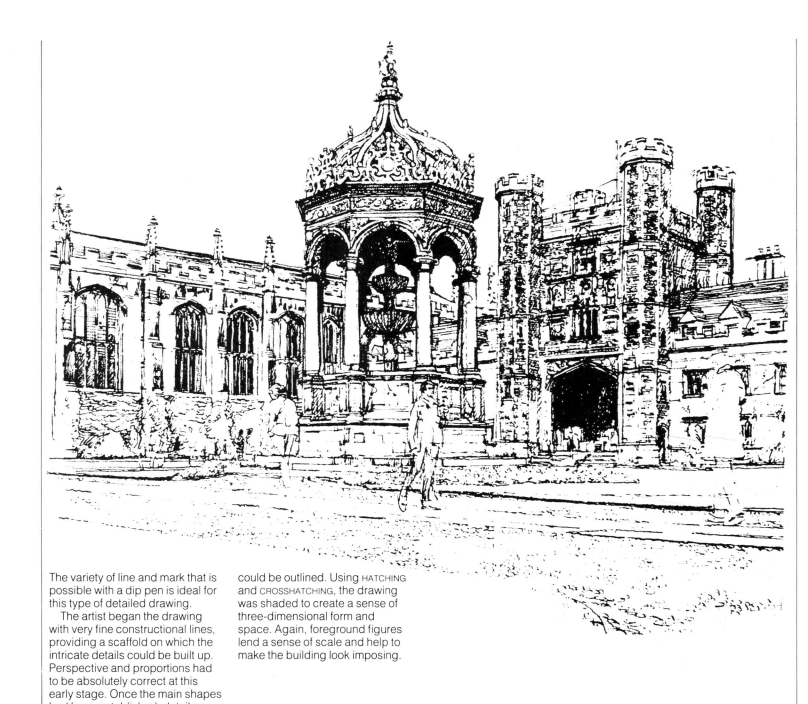

The variety of line and mark that is possible with a dip pen is ideal for this type of detailed drawing.

The artist began the drawing with very fine constructional lines, providing a scaffold on which the intricate details could be built up. Perspective and proportions had to be absolutely correct at this early stage. Once the main shapes had been established, details such as windows and stonework could be outlined. Using HATCHING and CROSSHATCHING, the drawing was shaded to create a sense of three-dimensional form and space. Again, foreground figures lend a sense of scale and help to make the building look imposing.

Experiments in drawing the different facets of an object simultaneously were first carried out by the Cubist artists, notably Braque and Picasso. For this drawing the artist adopted some of their ideas. Working *in situ* with pencil and watercolour he studied the features of the landscape from more than one viewpoint in the same drawing. An inventive approach like this necessitates breaking all the 'rules' of perspective, but the drawing is still full of space.

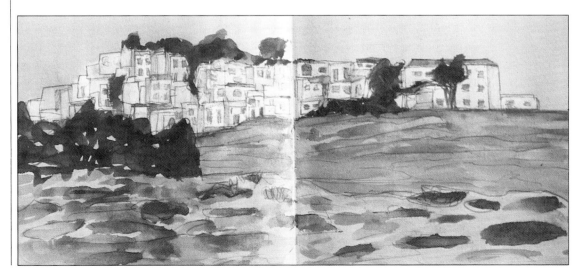

Pencil and watercolour were used for this double-page sketch made while the artist was travelling abroad. The simple block-like buildings were outlined and then watercolour was added to indicate the cool blue shadows and the surrounding features. Using watercolour for quick sketches means that some record of the local colour can be made.

FIGURES

As has been mentioned, figures added to a drawing lend a sense of scale. But they can play an even more important role in drawings of architecture. Buildings are centres of human activity, and for some artists this is their most important feature; it is the relationship between a building and the people within it or around it that becomes the subject, rather than the two being treated separately.

Townscapes especially can benefit from this approach. Indeed, in many historic cities it is almost impossible to draw or photograph an interesting building because of the sea of tourists. If you can't beat them, join them, and make this relationship between figures and their environment your subject.

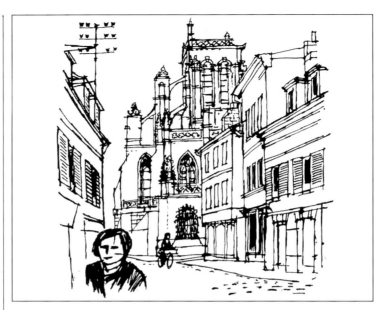

The artist used a dip pen and black Indian ink for this sketch (left). The solid tones of the figures provide a contrast to the predominantly linear treatment of the buildings. The simplicity of the drawing helps to convey the atmosphere of a small, quiet town with the residents going about their day-to-day business.

A lively sketch (below) in which pen and ink lines are overlaid with washes of transparent watercolour. Much of the paper has been left bare, yet the overall impression is one of colour and movement, due to the energy with which the lines and strokes have been applied. Note how colour and detail become diminished in the background, creating an impression of receding space.

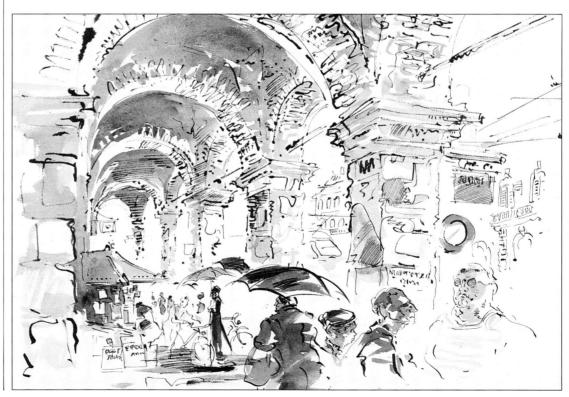

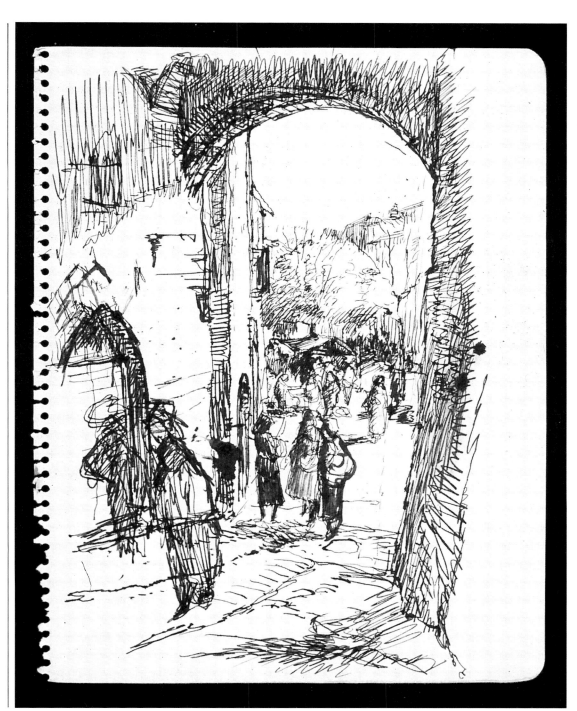

Vigorous HATCHING was used to create both light and shade and a sense of movement in this rapid ink drawing made in a small sketchbook. The artist was not concerned with the ink blotting while working—the important issue was to capture a quickly changing scene. Don't be too literal or over-concerned with detail when making sketches like this; just make sure that you collect the information you need.

LIGHTING

The play of light and shadow on a building is what makes it appear solid and real, and it's a good idea to observe your chosen subject at different times of the day to discover which lighting effects best reveal its three-dimensional form. At midday, for instance, there are few descriptive shadows because the sun is directly overhead, and architectural features appear somewhat flattened and uninteresting. Early morning and late afternoon are the best times to draw buildings, when the low angle of the light picks out textural details, and strong cast shadows emphasize form and solidity.

In the evening, buildings take on a completely different aspect as the light fades and they appear as silhouettes against the luminous sky. You can choose to emphasize a dramatic mood, with bold strokes and strong tonal contrasts; or you can create a mood of mystery and tranquility by softening the tones and the contours in your drawing. Either way, buildings in silhouette make exciting compositions.

When drawing an interior subject, the amount and direction of the light can have an effect both on the mood and on the spatial dimensions of the room. As with outdoor scenes, it can be instructive to draw an interior at different times of the day, and under artificial light.

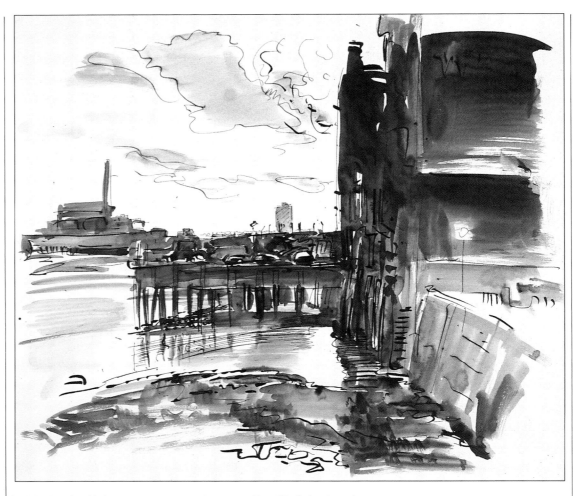

In this drawing high contrast lighting is used to create a dramatic effect. The bright sky acts as a back light, throwing the riverside buildings into silhouette. The LINE AND WASH technique is well suited to this form of atmospheric drawing done outdoors. The buildings were blocked in with a brush, the darkest edge of the silhouette being set against the brightest part of the sky for maximum impact. Though all the building is in shadow, it is not completely black because light is reflected onto it from the surface of the water. Detail is limited to a few calligraphic marks, which provide just the right amount of contrast for the sweeping tonal washes.

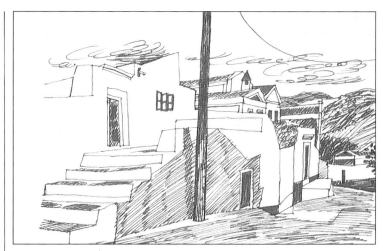

This drawing from a sketchbook was made with a black felt-tipped pen on smooth cartridge paper. The major shapes of the subject were drawn in outline and then, using a loose HATCHING technique, SHADING was added. Strong sunlight created sharply defined cast shadows, the shapes of which were carefully observed. This drawing is particularly concerned with the pattern created by light shapes and dark shapes. One other interesting observation the artist made was that the top half of the telegraph pole appears darker in tone than the lower half because it is set against the light tone of the sky.

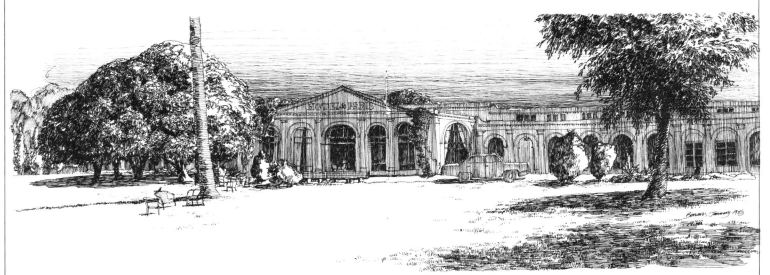

In this beautifully rendered drawing, texture, light and shade are created by means of line rather than tone. The artist has graduated the tone of the sky by carefully spacing long horizontal lines. Contrasting vertical HATCHING is used to shade the building and the motor car. The sun, low in the sky, streams in from the right of the scene, picking out a few highlights here and there which provide dramatic contrast to the dark, brooding light that prevails elsewhere. Late afternoon is often the best time to capture unusual atmospheric effects like this.

The detail shows different densities of HATCHING and BRACELET SHADING which define the tall tree trunk.

INTERIORS

The interior of a room or building can be an intriguing subject in its own right. Obvious choices include splendid public buildings such as palaces and cathedrals; but less imposing structures, such as factories, farm buildings, houses, your studio or even your garage, are also potential subjects.

But the first interior that most people draw is often a part of their own home, or perhaps somewhere they stay on holiday. Hotel foyers and airport lounges, where hours are often wasted waiting, are good subjects—and time flies when one is immersed in a drawing.

Buildings are constructed to be used for certain purposes and interiors and their contents reflect that function. A well-chosen room setting can therefore form an interesting background to your drawing of another subject, such as a group of people or an individual portrait. The type and arrangement of furniture in the room and the way the room is decorated and ornamented can all be made to say a great deal about a sitter's personality and lifestyle. Ask yourself whether the sitter is at odds with the setting or whether he or she blends comfortably into the scene, and decide which aspects of the room reflect those traits of the sitter that you most want to emphasize.

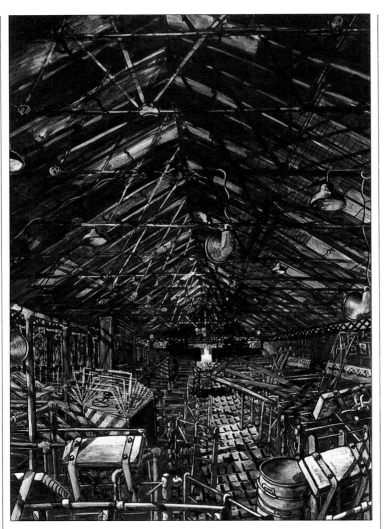

It is not always easy to gauge from a reproduction the extent to which the size of a drawing has dictated the choice of media. Here, in this large, bold drawing on cardboard 40in by 30in (102 cm by 76 cm), broad marker pens and coloured inks have been used with some freedom. The artist first made an underdrawing in pencil for the complex perspective. With broad black markers, he then developed the drawing and added lighter tones, using dried-out marker pens, which when rubbed firmly on the cardboard produce a grainy mid-tone. As a final touch, Chinese white was used for the highlights, as can be seen on the roof struts.

This vigorous and atmospheric pastel sketch shows the busy interior of an imposing building. Note how the figures are not treated as separate objects; they do not dominate the drawing but blend into, and become an integral part of, the overall surroundings. Lively HATCHED strokes and quickly blocked-in areas of colour record the animated scene. The artist has made good use of the interest and space created by reflections in the glass. By using a tinted paper he has established a consistent tonal key which helps to unify the loose handling.

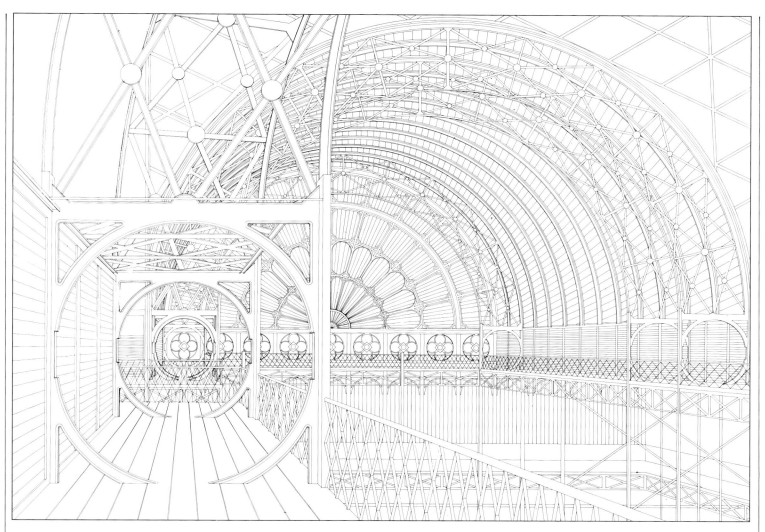

The technique used in this complex line drawing enabled the artist to transfer the image to a canvas so that it could be developed into a painting. The drawing was constructed, following precise specifications on transparent film, with a stylo tip pen. Then, using photographic printing techniques, the artist transferred the design to the prepared canvas. The single-point perspective and other constructional lines were worked out on the film, using blue ink, which the photographic process does not pick up. The drawing was subsequently executed on top of these lines in black ink. Such a drawing, though important, is just a stage in a larger creative process.

DETAILS

Architectural details, both decorative and functional, can be just as exciting to draw as the actual buildings themselves. Details such as windows and doorways also provide interesting material for the artist as they can be used as a compositional device making a frame within a frame. Artists and architects have often used sketchbooks to record details of buildings for later use, when painting from memory or designing.

If drawing a complete building, try to relate the details to the underlying structure before you start rather than tagging them on at the end. Contrast detailed areas with less detailed ones so as not to overload your drawing. If you are trying to draw the texture of a wall or roof it isn't necessary to record every individual brick or tile. Establish the overall tone and add a suggestion of texture here and there. Often, the suggestion of texture, pattern or detail is all that's needed to convey the whole story; the viewer actually gets more out of looking at the drawing when he or she is required to 'fill in' the details from imagination.

On the left-hand page of this sketchbook (above) the artist has drawn a modern building with a fine pen line. On the right-hand page an example of older architecture is recorded with a soft pencil. The media were carefully chosen to suit respective subjects. Any linear medium is good for picking out details of windows and wall texture. There is no colour or SHADING in these sketches as the artist was only concerned with recording details and therefore chose a simple technique.

Careful study of the shadows creates solidity and monumentality in this small pencil sketch of a ruined abbey (left). Here the artist has recorded the flying buttresses and windows; interesting architectural details such as these can be incorporated into more complex drawings or paintings at a later date.

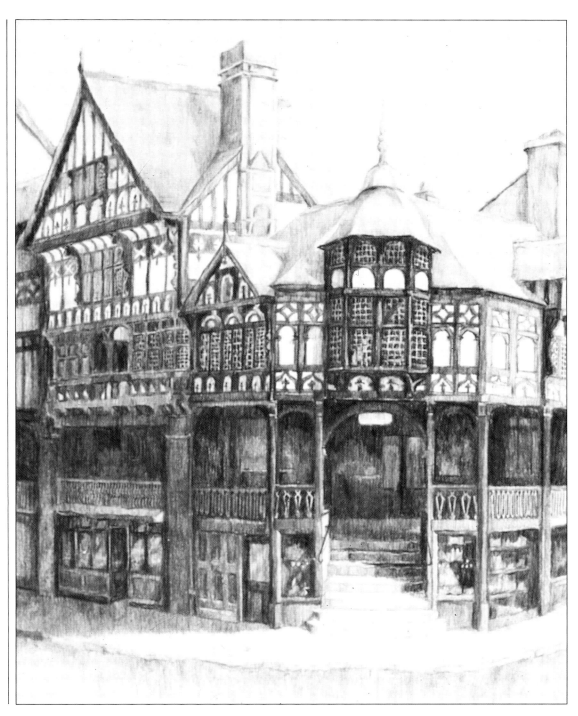

Coloured pencils were used to draw the intricate patterns of these timber-framed buildings. As well as recording surface details, the artist has used light and shade to create solidity and a sense of space. A drawing as complicated and skilful as this one needs to be built up in stages and is the result of careful observation, first of general structure and then of how the details relate to it. The detail shows how the white of the paper is utilized to indicate the window pattern.

In this impeccable coloured drawing, made in pastel, crayon and coloured pencil, architectural detail is used not as an embellishment but as the subject of the work itself.

Windows can be used as a frame within a frame as here. Evocatively called *Waiting*, the drawing leads the viewer's eye from the cool shady interior into a sun-filled garden. WAX RESIST and a bold ink wash technique were used to create the mood.

This beautiful collage was made with layer upon layer of torn and tinted tissue paper. The unusual dotted linework was produced with a needle and thread—an inventive response to rendering the textures and patterns found in architectural details.

Photographic references were utilized while making this drawing. Basic guidelines were drawn on the paper with pencil and then carefully graded ink STIPPLE was used to develop the subject. Note how the drawing is balanced: in the top right the empty wall creates breathing space and contrasts with the very dark complex pattern of the handrails. The detail shows clearly the careful attention paid to tonal relationships.

Pink earthenware roof tiles and pale stucco plasterwork inspired this beautiful coloured pencil drawing. The artist chose a pink tinted paper, which shines through the translucent pigment, not only enhancing the quality of the light but also unifying the image. The drawing was BUILT UP in pale tones, with white pencil reserved for areas under direct light. The darkest tones and deepest hues were added last of all, emphasizing the form of the leaves and flowers.

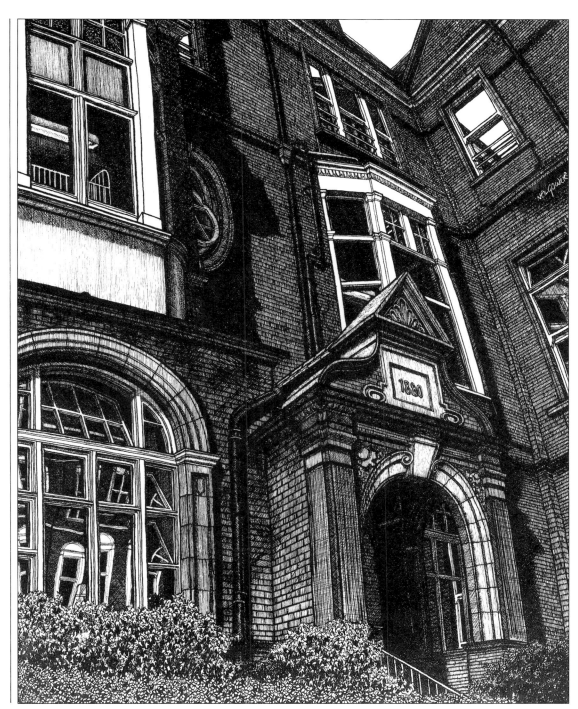

In reality, this imposing Victorian edifice must contain thousands of bricks, but the artist has not attempted to represent them all. By using horizontal and vertical HATCHING he has successfully conveyed the texture of the bricks, leaving the imagination to supply the details. Pen-and-ink linework has been used to create very dark areas of shadow by building up layers of CROSSHATCHING. Some spots of white paper break through these shadows, helping to retain a degree of luminosity and preventing them from looking dull and flat. The detail shows a lively use of HATCHING for the stonework of a large window arch.

Architecture ● Pastels

The dappled play of light around a cool palace interior provides a beautiful architectural subject. For this demonstration the artist chose pastels because the medium lends itself to unusual strokes and POINTILLIST flecks of vibrant colour. The textured oil-sketching paper used provides a good support that accepts the pastel well. The juxtaposition of warm and cool STIPPLED colours has been carefully controlled to capture the quality of the light both inside and outside the building.

1 The artist gives a suggestion of dappled light from the outset by working with a wide variety of STIPPLED strokes. Broken flecks of a deeper cobalt blue are added to strengthen the outline of the pillar.

2 With the composition established, the artist now develops the quality of the light by adding warm ochre and flesh tints to the drawing. Line work is constantly redefined to contain the effusive STIPPLED pattern. The striking plant forms are developed with green and blue.

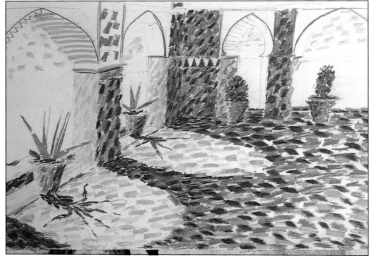

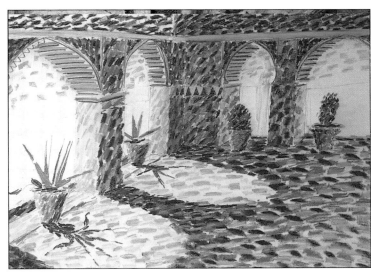

3 Bold HATCHED strokes are added to give clearer definition to the shape of the arch. Although drawn with the same colours as the STIPPLED walls and floor, this different pattern creates a lively contrast (right).

4 Paler hues are used to STIPPLE the sky, and grey, green and blue dots in the background convey the distant line of trees. Although the whole surface of the paper vibrates with colour, this does not undermine the sense of solidity and unity. There is a clear tonal division between the deep rich foreground interior and the paler tones of the landscape in the background. The darkest shadows have been developed with ultramarine blue and violet. Occasional flecks of warmer hues amidst the cool blues of the shadows give the effect of reflected light. They enliven the shadows and increase compositional unity by visually linking the foreground to the red roofs in the landscape beyond.

STILL LIFE

Although plants, flowers and fruits appear in medieval manuscripts and were used in pictures by Chinese and Japanese artists well before that period, still-life paintings and drawings, as we know them today, began in Germany and the Netherlands. They first appeared as part of the setting in which the main subject of the painting took place. Artists such as Rubens included bowls of fruit and flowers in their religious paintings, and the studies made for these sections of the paintings, at first not intended as pictures in their own right, later became appreciated for the skill used to depict particularly intricate fruit and flowers.

It was, however, a French artist, Chardin (1699–1770), who revolutionized the concept of still-life portraiture. He brought all the techniques and skills of formal subject painting to the informal subject of the kitchen table; and his clever use of light to emphasize the sensual pleasures of food and drink was a facet of his work that influenced the early Impressionists. Cézanne (1839–1906) found in still life an ideal subject for the long and detailed study from direct observation that was the basis of his painting. Later, Braque (1882–1963) and Picasso used still life as a means of demonstrating their new method of depicting space – Cubism. Next to Cézanne, Matisse is considered by many critics to have been one of the most accomplished of still-life artists. Many of his paintings depict an interior that frequently includes an open door or a window through which another view can be seen.

The still-life group can, therefore, be made up of any natural or man-made objects, seen either in close-up or from a little further away, usually as part of a room or some other kind of interior. Although it is common practice to collect together a number of objects and to arrange them carefully before beginning to draw or paint, some of the best still-life groups are found by chance. A table after a meal, a pile of discarded plant-pots and gardening implements left haphazardly in a shed are all subjects that have been used by famous painters.

Still life is usually thought of as concerning commonly used everyday objects, together with food and flowers, but it can include any man-made object that can be moved and placed in a predetermined position, including large machines and motor cars. Although still life as a subject can be extended to inanimate, outdoor objects, it is essentially an indoor subject, safe from the vagaries of the weather and one in which, even if a 'found' subject is used, the lighting can be controlled and the objects left undisturbed to be returned to again and again for reference.

The objects chosen for a still-life group may be assembled for their pictorial properties – their colour, texture or shape, for example – but still life groups can also consist of objects which in themselves have particular significance. After the Reformation, when religious painting virtually disappeared in northern Europe, much still-life painting became quasi-religious: hourglasses, skulls and candles demonstrated the mortality of life; and bread, wine and water were seen to represent the Eucharist. Similarly, flowers or fruit in still-life drawings and paintings are often selected to represent the seasons. Even still lifes of the 'set-piece' type – kitchen tables or dressers laden with meat, bread, fruit and wine – have their origins in religious pictures. Still-life pictures may also take as their subject matter prized possessions, or they may be virtuoso pieces whose objects have been carefully selected to show to full effect the artist's skill at drawing or painting, for instance, hard shiny surfaces, or the contrasting textures of plums or peaches on velvet.

Often, still-life groups are set up in the corner of a room or in a specially constructed 'corner' made from two boards placed at right angles to each other. These can then be painted in the most suitable background colour for the objects. Within this constraint, an enormous variety of compositions are possible with the same few objects. The Italian painter Morandi, for example, who died in 1964, drew, painted and etched countless different arrangements of bottles and the occasional jug and oil-lamp for most of his career, which spanned some fifty years.

Still-life groups need to be set up with some care, but not too much. After all, it is the composition of the drawing or painting that matters, and it is often best to place the objects very quickly in a haphazard way and

then try several different views of them to decide on their pictorial possibilities. The biggest danger in arranging the objects, prior to painting, is that they will be too separated and appear isolated in the eventual picture. The objects should generally be grouped so that some overlap each other, to give the group some depth, with some objects closer than others and the shapes between the objects (the 'negative' shapes) varied and interesting. Always try to choose a group of objects that can be left untouched for a long period of time. Bear in mind that the 'found' group will often consist of objects that naturally move or change and offer only the possibility of a quickly produced drawing.

Ideally, the light source should fall on the still life from one direction only because this will give a strong light-and-dark contrast to the objects and reveal to most effect their three-dimensional form. The group, particularly if the light is artificial and strong, needs to be positioned carefully in relation to the light source. Some lighting can cast shadows that completely camouflage some of the objects. Remember, too, that most artificial light has the effect of changing the colours of the objects.

This ability of the artist to control the positioning of objects and their lighting is the main feature of still-life painting and drawing and it makes it an eminently suitable subject for those who want to produce very controlled work that is dependent upon long and detailed study.

All drawing media are appropriate for still life, particularly those suited to building up tone over a lengthy period of time – pencil, for example. A wide range of techniques can also be employed. Techniques such as hatching, crosshatching, shading, etc, are most useful for producing tone; whereas linear marks and highlighting are particularly suited to interpreting detail.

Food packaging is one of the most prominent aspects of our modern economy, and can make an unusual and interesting subject for still-life drawing. SCRAPERBOARD was ideally suited to this collection of items because of the strong black and white patterns of the labels and lettering.

THE SINGLE OBJECT

The subject of still life embraces an inexhaustible range of inanimate objects. Once you begin to think beyond the jugs, flowers and skulls of traditional still-life painting, the choice is limitless. We tend to think of still life as being a group, but it is quite possible to make a drawing of a single object. Generally, the object needs to be complex enough to justify being singled out in this way, but this is not always the case. It goes almost without saying that if all that was required to create interesting drawings was interesting subjects, drawing would be very easy. What is important is that the artist has something significant to say about the subject, and it is this insight which can make an inspired drawing out of a simple unadorned object.

Nevertheless, still-life drawings of single objects are frequently concerned with mechanical subjects – an engine or a tool, for example – or commonly found objects which, when seen from an unusual viewpoint, are interesting in themselves, such as a clock or a chair. Many students cannot see the potential of an object until it has been drawn because of its associations with the mundane. But the most insignificant everyday objects, such as an electric plug or a pair of scissors, can make drawings of real impact.

Drama can be made from the most prosaic of subjects, here from a simple cup and saucer. The intricate pattern has been merely indicated rather than slavishly rendered, because the artist was more attracted by the repetition of the shapes — the dark circles of the cup and saucer echoed in the crescent-shaped shadow on the table. Executed quickly and directly in charcoal, this piece is as much about interlocking abstract shapes as its ostensible subject.

The choice of medium can be governed by the subject illustrated. Here, charcoal, which can produce sharp lines and strong tonal contrasts, admirably defines the hard quality of the metal vice. The chosen viewpoint distorts the expected contours of the vice, and it is this shape, rather than the mechanical construction of the object, that has been exploited. To the initial outline, dark tone has been added to describe the form. A little shading has been freely applied, with the highlights cleverly left as the pristine underlying white paper.

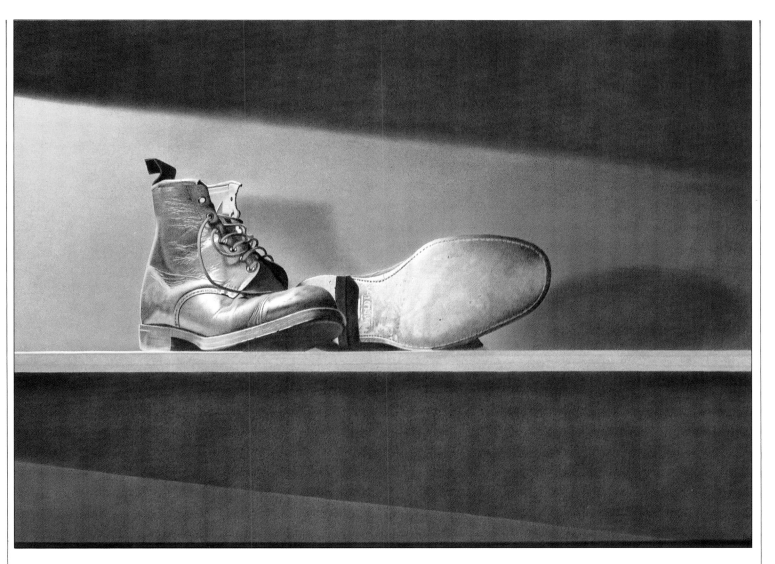

It is the artful lighting of these boots that attracts the eye and introduces a smack of drama. Their position, too, on the shelf at eye level establishes intimate contact with the viewer. The raised position with one boot on its side creates an intriguing and unfamiliar shape, which is spotlighted by a wedge-shape of light created by the dark stripes.

The detail shows the subtlety of technique employed in modulating colours and carefully grading tones. Coloured pencils and crayons were applied over a base of rubbed pastel.

'FOUND' SUBJECTS

Frequently the best still-life subjects are found rather than contrived. A few children's toys dropped by chance in a corner, or the kitchen table after a meal has been prepared, with knives and plates scattered at random, can make unusual subjects out of everyday situations. The disadvantage of the found subject, however, is that often it is impossible to keep it frozen in position for long. The still-life drawing has to be made quickly before the toys are played with again or the meal eaten.

There are excellent still-life subjects outside as well as indoors. The corner of a greenhouse with gardening tools and plant pots, junk in a scrapyard or agricultural implements in a farmyard could all serve as interesting still-life groups. But, again, sometimes a really exciting subject only remains composed long enough for you to make a very rapid sketch — a pile of deckchairs on a promenade for example. On other occasions something seen by chance can suggest a still-life group that you may deliberately set up in a more convenient place.

The main characteristic of found groups is that they never look contrived or deliberately posed, and coupled with the fact that they often have to be drawn quickly, this usually produces a drawing of great spontaneity.

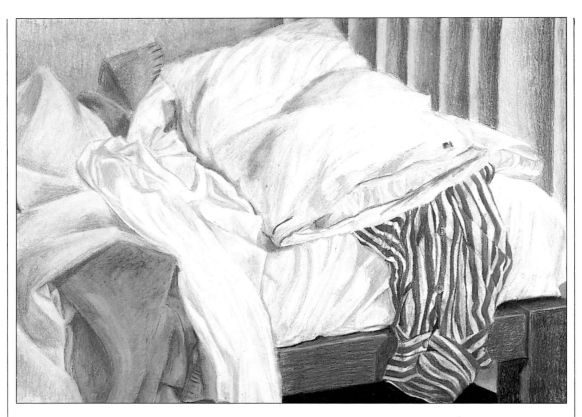

This found group of abandoned clothes, draped casually over the end of a bed, creates a mass of stripes, creases and folds, exploited by the artist to great effect. The soft stripes, formed by the folds in the white shorts and the sheets, contrast with the sharp blue and white striped shirt sleeves. A further dimension comes from the clean vertical stripes of a radiator in the background. Made with coloured crayons, the drawing consists mainly of carefully shaded areas.

In the detail we can see how the shadows on the sheet and the blue stripes of the shirt act as contour lines, describing the form clearly.

Speed was the essence of this strong, vigorous drawing of a table lamp and other objects left on a kitchen table. Using a brush and black ink, the artist has exploited the dark mass of the objects silhouetted against the light shiny surface of the table. The ink has been applied undiluted except for some light SHADING on the background plate and the table surface.

GROUPS

The range of objects that can be used to make still-life groups is limitless. The choice might be deliberate, or it may be almost accidental. You can choose related objects and place them together — for example, cricket pads, a bat, ball, sweater and cricket bag, a group all relating to a particular sport. You may, however, bring together objects selected at random that have nothing in common and which make an interesting group simply because of their complementing or contrasting sizes, shapes or colours. Some artists choose objects that, for them, have symbolic qualities or which artfully exploit their technical skill. Or it may be simply the surrealistic effect of juxtaposing completely unrelated objects that appeals.

It is certainly possible to bring a new approach to the most conventional subject, but it is often useful, particularly for the amateur artist, to seek stimulation through new material in a found subject. This type of still-life group could be given a theme such as texture, rather than necessarily being concerned with the literal relationship of the objects. For example, a composition could be arranged using various objects all made of stone, glass, shiny metal or coarsely textured fabric — to provide a fresh appreciation of commonly neglected subjects.

A random group of objects sometimes makes an arresting composition purely because of contrasts in scale and between curved and straight lines. The artist here has used charcoal and conté crayon to create mainly an outline drawing, with some SHADING. The strong line and the sharp black areas make this a particularly lively drawing.

This bold handling of media is seen more clearly in the adjacent detail. The black lines are ragged because of the heavy pressure used to produce them, and there has been extensive CORRECTION and smudging in the shadows.

The composition formed by these unrelated objects is seen by the artist as a two-dimensional pattern, and this effect has been emphasized by the floral frame drawn around the group. To achieve this, the artist has chosen to ignore the rudiments of perspective, so the plate under the teapot, for example, appears as though seen from above, and there has been no attempt to make the table top recede into the picture space. Each object, then, has been exploited for its decorative possibilities by the exquisite pen and ink line, producing a number of delightful patterns, skilfully linked together by the surrounding border and the SHADING which extends from each of the four minor groups within the composition.

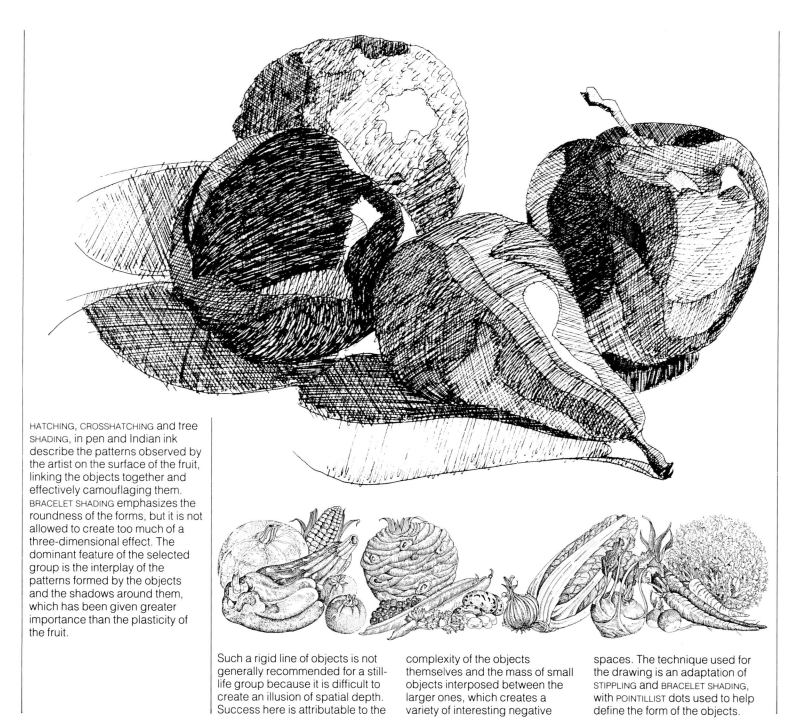

HATCHING, CROSSHATCHING and free SHADING, in pen and Indian ink describe the patterns observed by the artist on the surface of the fruit, linking the objects together and effectively camouflaging them. BRACELET SHADING emphasizes the roundness of the forms, but it is not allowed to create too much of a three-dimensional effect. The dominant feature of the selected group is the interplay of the patterns formed by the objects and the shadows around them, which has been given greater importance than the plasticity of the fruit.

Such a rigid line of objects is not generally recommended for a still-life group because it is difficult to create an illusion of spatial depth. Success here is attributable to the complexity of the objects themselves and the mass of small objects interposed between the larger ones, which creates a variety of interesting negative spaces. The technique used for the drawing is an adaptation of STIPPLING and BRACELET SHADING, with POINTILLIST dots used to help define the form of the objects.

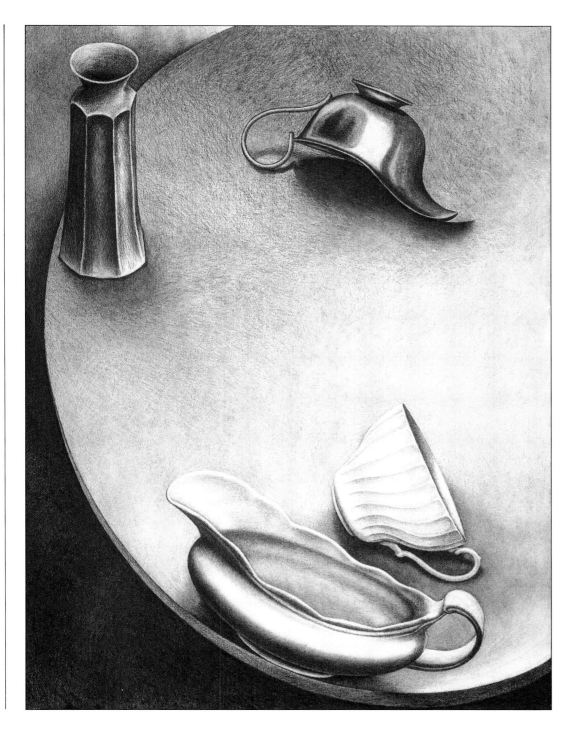

A frequently used still-life device is that of placing an ordinary object in an unconventional way. We would expect to see the sauce container standing on its base, but the artist has chosen instead to represent it lying on one side. Such manipulation can impart a feeling of unease in a drawing. It can appear as though the elements of the composition have been disturbed by some outside force. Here, this feeling is enhanced by the realistic, almost photographic, drawing technique. The cup and gravy boat are built up with areas of carefully graded tone, which clearly describe the smoothness of the surfaces, the fluting around the cup and the delicate form of the gravy boat. There are no outlines but, by careful selection and representation of light and dark areas, the artist has created a highly naturalistic interpretation of the objects.

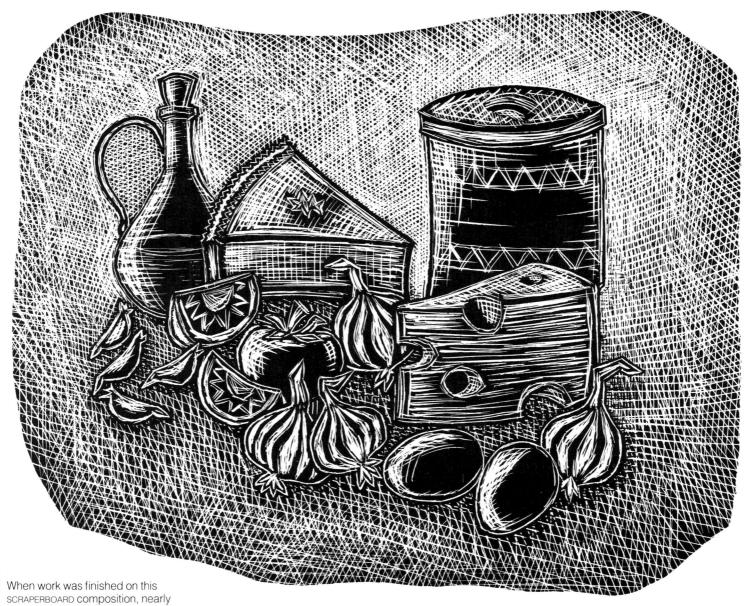

When work was finished on this SCRAPERBOARD composition, nearly all the black coating had been removed, making it a light-filled, vibrant drawing. The overlapping objects, described with broad scratched strokes, seem to jostle for position against a ground of dense CROSSHATCHING. Patches of solid black tone were left to punctuate the surface pattern of the arrangement, but they also add a sense of shadow and rounded form. The bold, direct marks making up this drawing produce a lively and highly decorative piece.

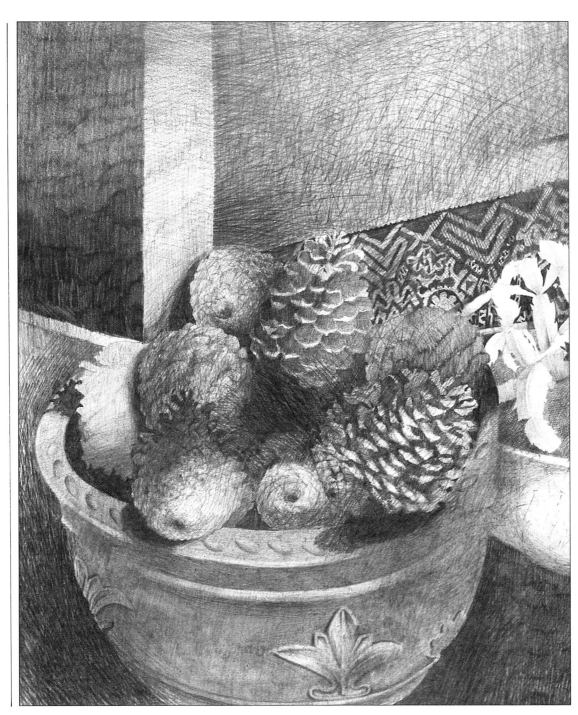

Pine cones, grouped together in a bowl, provide a challenging subject of complex forms and tonal patterns. In this carefully BUILT UP pencil drawing, the artist deftly conveys the subtle variations in light and shade. A range of HATCHING and CROSSHATCHING techniques produce a decorative setting for the foreground objects. Note how the pale tone of the plant is achieved by skilfully allowing the clean white paper to show through the shading.

BACKGROUNDS

There are times when a still life is found completely by chance. A number of objects are discovered miraculously grouped in a way that will make a good picture. In such cases the background is already there, and consequently there is no need to drape fabric behind the found group or use any other device to separate it from its surroundings. When a still-life group is deliberately composed, however, during an art class or in the artist's studio, it may be necessary to create a background. Convention, on these occasions, prescribes the use of either flat sheets of board behind the group, so as to give the appearance of a wall (or sometimes two walls meeting at right angles) or draped fabrics. Although draped fabric has become something of a visual cliché in still-life painting, nevertheless it can give an interesting contrasting texture to the objects in a still-life group, and if it is draped in folds, the material provides a useful background reference for drawing accurately.

But the background of a still-life painting is usually of limited importance and sometimes is reduced to negligible proportions. This depends on how large the still-life objects are in relation to the picture and on the viewing position taken. If the group is painted by an artist standing at an easel where the viewpoint is high, the background becomes the surface on which the objects are placed. Even when the objects are carefully selected and positioned it is often unnecessary to make a special background. The unfocused view of the room or studio where the objects are may be a perfectly acceptable foil to the still-life group.

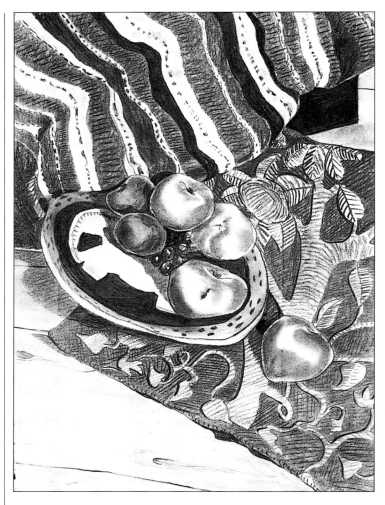

Although this is only a detail taken from the charcoal original, it demonstrates how the complete drawing succeeds without a definite background. The viewpoint is high and the striped fabric behind the plate with the apples extends beyond the top of the picture. The drawing concentrates on pattern: the contrasting patterns of the fabrics and the configuration made by the print on the decorated plate. Although the drawing is to an extent more concerned with the compositional pattern created on the two-dimensional surface, rather than the three-dimensional space, the apples and grapes have been modelled with highlights to demonstrate their round shiny quality.

This deceptively simple pastel drawing (right) achieves a certain drama despite a flat neutral background. The drawing's impact is achieved entirely by the effect of the three apples. The blends of red and green, together with the touches of white gouache for highlights, conspire to give the apples a vivid three-dimensional form. The shadows and reflections of the apples help to qualify the setting and assist in defining the space.

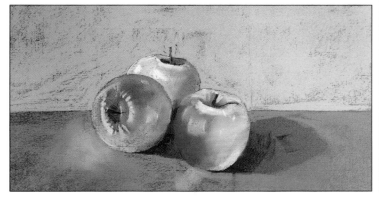

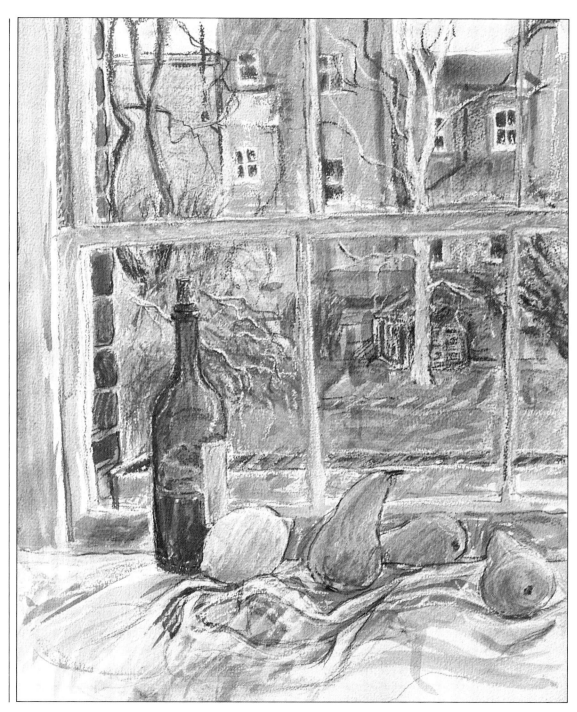

Such a conventional group — a wine bottle and fruit placed on a crumpled tablecloth — has been given an unusual twist by the choice of background. The feeling of space in the drawing has been largely created by the difference in scale between the still-life objects, the window frame and the background buildings. A brush and watercolour paint have been used to produce lines of colour as one might do with pastel or crayon. With the main shapes of the composition established in this way, colour was laid over the top, mainly in HATCHED lines. The still-life group has been described in dark outline, with highlights on the reflective bottle and the fruit to emphasize the plastic form of these objects.

Still Life ● Pen and Ink

Work on a still life usually starts with the selection and positioning of the objects. The artist needs to take into consideration lighting, colour, shape, rhythm and texture, to name but a few of the host of factors that will affect the composition. For this demonstration the components were assembled with contrasts of tone and texture in mind. Notice how, in the finished drawing, extremes of dark and light tones are set against one another. A pencil was chosen to explore the initial guidelines, which were developed with a pen and Indian ink, defining form with HATCHING, CROSSHATCHING and a spatter technique.

1 Having studied the arrangement from more than one viewpoint, the artist starts her drawing with a pencil. Only gentle pressure is used to SKETCH in basic shapes and establish proportions correctly.

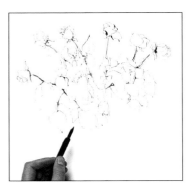

3 On top of these delicate guidelines a dip-pen and black Indian ink are used to develop the drawing. At this stage the artist concentrates on the outlines, producing a sensitive variety of marks. Firm, heavy lines are contrasted with fine, broken ones.

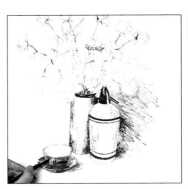

5 Bold, continuous HATCHING is added, without lifting the pen, not only to develop the form of the objects but also to establish a dark background behind the pale image of the soda syphon.

2 This loose pencil drawing is now almost completely erased, leaving behind just the faintest hint of the former outlines. The eraser needs to be used very gently so that the surface of the paper is not damaged.

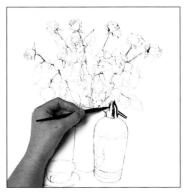

4 The density of the pen strokes is increased to block in areas of solid black TONE.

6 Newspaper is cut to shape and taped over the whole drawing, masking out everything except the vase. A toothbrush is carefully dipped in ink and the thumb is drawn across the bristles to spatter ink over the mask. The finished drawing (opposite) shows how the spattered texture of the vase is perfectly integrated into the composition.

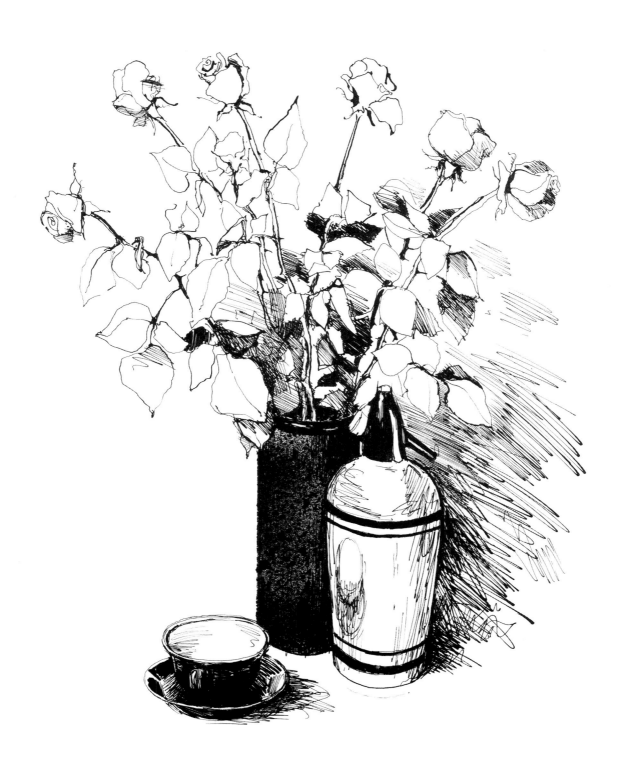

ANIMALS

The earliest drawings in existence are drawings of animals. The cave drawings in France and Spain made 15,000 years ago or so are more than mere visual records. They may have had some kind of religious significance for the hunters, and furthermore they are stunning drawings, made from memory and giving an impression not only of the animal's appearance but also its power in movement.

Animals have appeared in drawings and paintings throughout history, often as incidental elements, such as the dog in Jan van Eyck's *The Betrothal of the Arnolfini*, painted in 1434, or that in the Velázquez (1599–1660) painting *Las Meninas* painted more than 200 years later. Both these dogs are in the foreground, nearer to the viewer than the figures, and although relatively small, they play an important part in the composition of each picture and are beautifully painted in exquisite detail.

By 1775, Reynolds (1723–92) was painting portraits such as *Miss Bowles with her Dog* where the dog being caressed by the girl is almost her equal in importance in the painting, with its head turned pointedly to look at the artist.

There are famous drawings of animals by countless artists, Dürer, Pisanello (1395–1455/6) and Rembrandt (1606–69) for example. In the present century the bulls and doves of Picasso (1881–1973) and the racecourse scenes by Dufy (1877–1953) are examples of artists not merely featuring animals in their pictures, but making them the complete subject of the painting.

Stubbs and anatomy

One artist whose reputation is based almost entirely on animals as a subject is George Stubbs (1724–1806), usually regarded as a horse painter, although he studied the anatomy of many animals. He produced some of the greatest animal drawings that have ever been made; but even he found problems in recording animals in movement, and it was not until the invention of photography towards the end of the nineteenth century that it was more completely understood how horses moved, allowing the position of their legs in movement to be accurately depicted.

The fact that animals will not usually pose for us and that we, in any case, want to depict them in movement makes them extremely difficult to draw. It is not necessary when making a drawing to emulate Stubbs and have detailed knowledge of the anatomy of animals. Accurate observation and an analysis of the form and structure of the animal are sufficient. Photographs in magazines or taken by yourself can be helpful, albeit of only limited use. They may assist in getting the general picturing of the animal's legs correct, for example, but beware: photographs tend to understate the three-dimensional forms of animals and they do not have the detail you might expect them to have. There is no substitute for drawings made from direct observation.

Animals in motion

Although animals move most of the time, they tend to repeat characteristic movements. Cows in the corner of a field will, after moving, come back to the same position and eat in the same way as previously. A pet can often be drawn while it is eating; and birds in cages, or animals in the confines of a zoo often have a sequence of movements that they make around the cage, which enables the artist to depict them in certain characteristic positions. It is a good idea to work on several studies of a moving animal simultaneously, so that as it changes its position you can move to another drawing.

Drawing animals can be frustrating but with practice you should become increasingly better at spotting what is important, and much quicker at recording it. Making studies from stuffed birds and animals can be useful only to a certain extent. The anatomical structure and the accuracy of the animal's pose are entirely dependent on the knowledge of the taxidermist. You can get experience of drawing the texture and the particular markings of an animal in this way, but the drawing will inevitably be stiff and dead in the way that a drawing made from life seldom is, whatever its other faults.

Blending into the background

One of the most frequent defects of animal drawings is the inability of the artist to make the drawing anything more than a 'study'. To overcome this problem, the

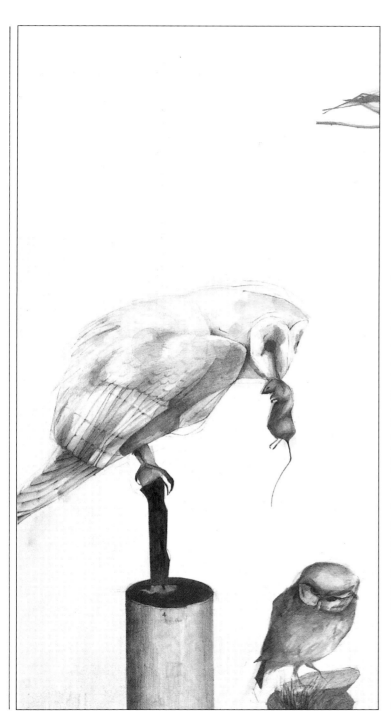

animal or bird needs to be drawn in some kind of environment, however simply this is indicated, so that the subject is not isolated and detached from its background. Unless the actual background in which the animal has been drawn is used, much practice is needed in drawing typical examples of the kinds of landscape in which the animal might naturally be found and then integrating the animals into these settings. Undue attention to detail in the drawing of the animal and too much emphasis on the silhouette can work against the unified appearance of animal and environment. The edges of the animal need to be softened and lost in the background and the treatment of the background should enhance rather than detract from or compete with the drawing of the animal itself.

Texture and form
One of the main concerns in animal drawing is the texture of fur or feathers. The secret in drawing these textures is to make them not only express the quality of the animal's protective cover but also describe the form of the animal. In the famous drawing of a hare by Dürer, the highly detailed drawing of the fur is used to indicate the fall of light on the animal and describes perfectly the form of its head, the long ears, the front paws and the back legs tucked under the body. The highlight on the eye gives a contrast between its smooth, shiny surface and the matt texture of the fur. The sharp contrast of soft texture and hard sharp features can do much to give animal drawings life and vitality. Textures can be produced by smudging chalk or charcoal. Softness can be achieved by a blurred, almost totally absent outline. Alternatively, textures may be achieved much more directly by pen and ink or a fine brush with diluted ink or wash. There are also many excellent examples of scraperboard animal and bird drawings.

Pencil, watercolour and ink were gracefully combined to produce these beautifully structured drawings.

STUDIES

Drawing, throughout history, has had different purposes. For centuries it has been used by artists as a means of studying and recreating their environment. Even the discovery of photography failed to provide a real substitute for drawing, and in areas such as medical and scientific illustration, the artist's drawing is preferred to the photograph, as it is capable of a much greater degree of analysis and a much higher quality of information.

Animal studies are made by zoologists recording information, in the same way as a botanist will make a study of plants. The studies may be of particular aspects of animals – their skeleton or muscular structure, for example. All the examples of a particular breed of animals look slightly different, and an animal artist may wish to observe these distinguishing characteristics and record them in portrait drawings.

The close study of a particular feature of an animal can provide the artist with a store of useful information. A soft pencil was used here to record the carefully observed details of a rabbit's head. Individual hairs are represented and used as contour lines to describe the bumps and hollows of the underlying form. This is just one of a sequence of drawings studying the head from all angles. A sound knowledge of the animal's bone structure is useful for this type of drawing.

Pen and ink is ideally suited to rapid studies. This sheet of sketches analyzes different aspects of an elephant hawk moth caterpillar. The creature is studied in detail including form and markings. The artist has also noted its habitat.

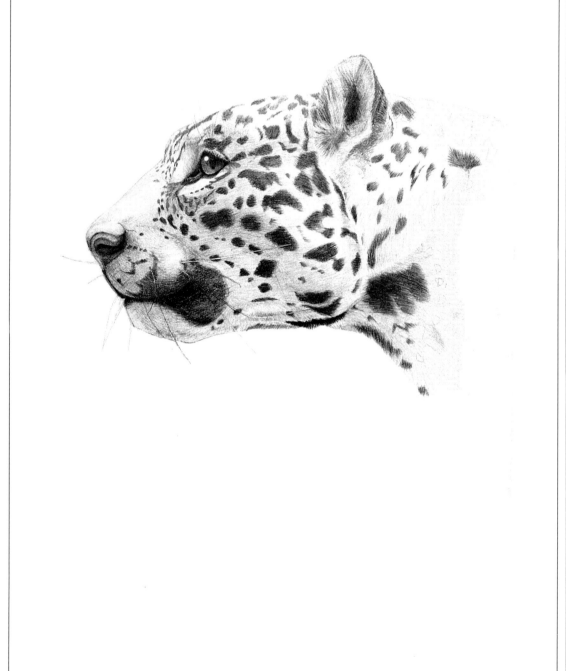

This sketchbook study of a jaguar's head displays a controlled use of pencil SHADING. An animal with a strongly patterned coat can be difficult to draw, as the form can be dominated by the pattern. The artist here has studied the dark spots carefully, noting how their tonal value changes depending on the light and their position on the form.

The flexibility of a soft pencil line has been utilized to make a simple yet revealing study of a bull's head. It is not exactly an anatomical study; in fact, it is more like a portrait – a study of facial expression and character. Through carefully controlled variation, the outline creates a sense of the bulky form it encompasses.

Not all studies are concerned with minute details or with unravelling complex structures. This vigorous charcoal drawing of a gorilla is a study of an animal's individual character. Heavy GESTURAL lines and bold LIFTING OUT with an eraser created the massive form. Our attention is focused on the face by the detailed study of the gorilla's facial expression, especially the look in its eyes.

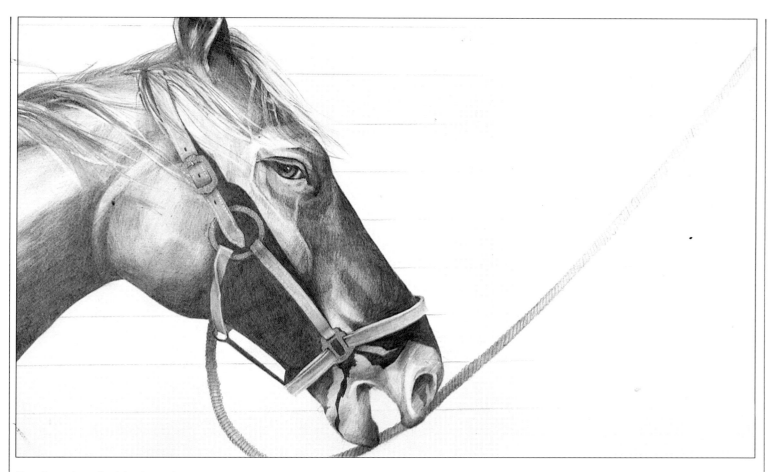

Pencil, touches of gold paint and pale washes of diluted ink were incorporated into this study of a horse's head. The SHADING was tightly controlled, while the artist studied the sculptural qualities and smooth textures of the subject.

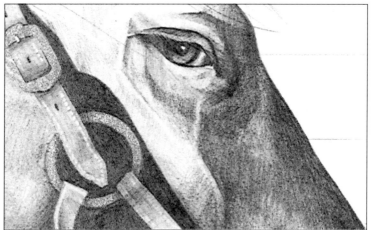

The extensive range of tones possible in a pencil drawing is illustrated by the detail (left). Different densities of HATCHING and careful control of applied pressure will produce both delicate pale tones and rich dark ones.

Dürer's famous study of a hare was the model for this SILVERPOINT drawing. The hare was actually drawn on prepared paper with a small silver spoon! The artist used individual hairs in the fur as contour lines, to describe the bumps and hollows of the animal's form.

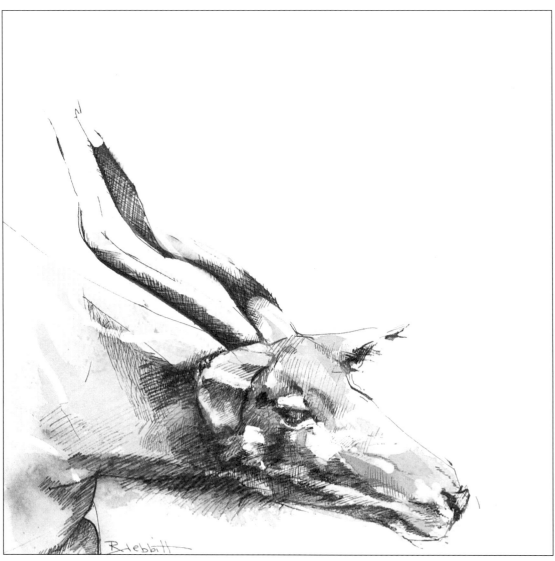

The artist studied the muscular tension of the stretching animal with great care before he commenced drawing. Then the basic conformation of the animal was blocked in with pale watercolour washes, used in conjunction with masking fluid. With a nib-pen and black ink, the artist added SHADING to strengthen the form and add details such as the eyes and horns. A mixture of linework, HATCHING and CROSSHATCHING can be seen.

In this study we are presented with a close-up of a zebra. The animal is dramatically cropped by the edges of the paper, filling our field of vision. Only the strong vertical bars separate us from it. Dense pencil SHADING was used to draw the pattern of stripes. These also act as contour lines, modelling the zebra's form. Pale watercolour washes were painted over the entire drawing to create an overall unifying tone. Finally, opaque white 'flashes' were added to reintroduce highlights. Some ink spatter work can be seen at the lower edge of the drawing.

ENVIRONMENT

Unless an artist is making a study rather than a drawing, animals need to be represented in an environment. This may be indicated only by a few lines or marks, merely to provide a hint of a background and give the drawing depth. Alternatively, it might be a feature of the drawing, showing the animal in relation to its human or natural environment.

With drawings of wild animals it is sometimes best to study the animals and the environment separately, bringing the two together in the completed drawing. The only problem here can be that the two do not relate. The scale of animal to landscape may be wrong, or it may look as though one has been superimposed on the other. Experience helps to overcome this problem, but it is important when drawing the animal, in particular, that you indicate the relative sizes of significant environmental features.

Animals in cages are easier. It is possible to draw the cage and then fit the animal inside, so long as care is taken to observe the scale and relationship of the bars to the animal or the animal to the background.

Often animals are drawn in isolation and their environment largely ignored. But to produce realistic drawings of animals, it is necessary to draw them in natural groups and in relation to a typical environment of landscape, zoo or farm.

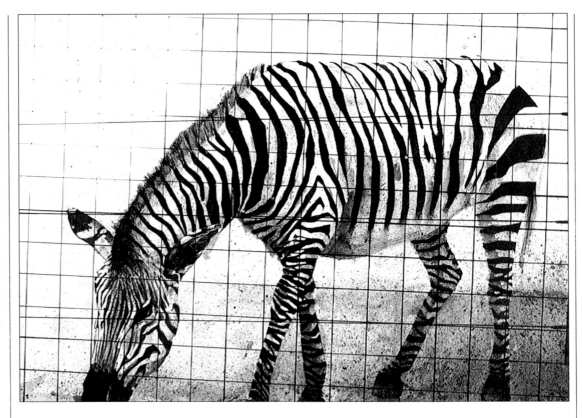

This animal was drawn in a zoo. The striking beauty of the zebra's natural markings contrasts strongly with the regular pattern of its man-made enclosure fence. The zebra's stripes were brushed in with black Indian ink. Ink HATCHING, washes and spatter techniques are exploited to develop the drawing.

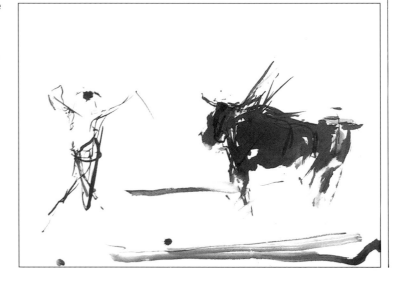

The dramatic encounter between bull and matador at a bullfight is captured here with GESTURAL brush drawing in black ink. A heavy, solid wash creates the tired form of the bull, contrasting, and therefore emphasizing, the dancing lines of the matador.

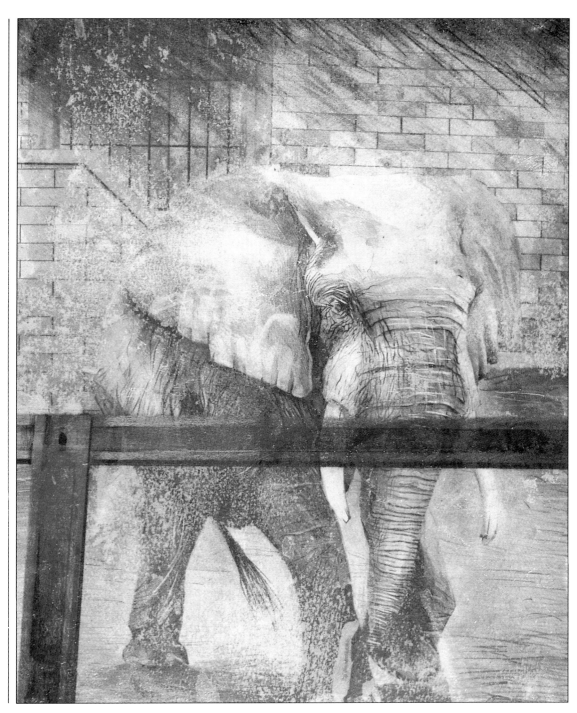

One important aspect of animal drawing is to convey the size and character of the subject. The elephant's massive bulk and potential power are expressed here by the mighty barrier needed to contain the animal. Pencils, crayons and coloured pencils all have been used in this drawing. The barrier was first drawn with crayon and pencil on a sheet of tracing paper. This was stuck in place, drawing side down, over the elephant drawing. The thinly transparent tracing paper acts as a veil, throwing the elephant back into the distance. At the same time, it has the effect of making the barrier appear very close to us.

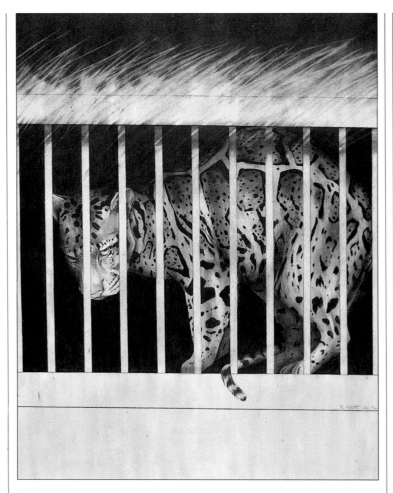

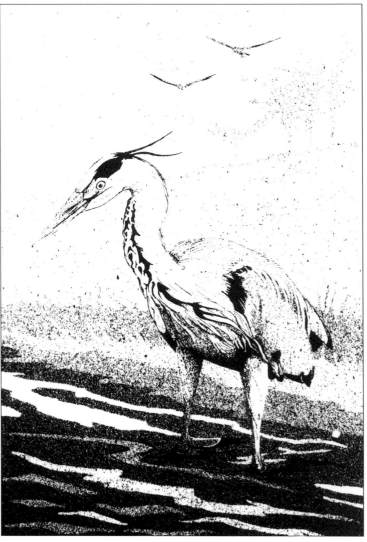

This poignant study of a big cat in a small, restricting cage was made with soft pencil on paper. The bars of the cage were masked out with tape before the dense tones of its shadowy interior were BUILT UP. Subtle SHADING was needed to portray the leopard's form and markings. An eraser was used to LIFT OUT the light across the top edge.

Guided by a faint outline, the artist covered areas that were to remain white with masking fluid. By blowing ink through a diffuser spray, he then covered the drawing with a pale STIPPLED tone. Again, parts of this pale tone were masked out and further stippled tone added. Once the darkest tones had been reached, the masking fluid was removed to reveal an image of delicate gradated tones. Fine pen and ink work was needed to modify tones and add details.

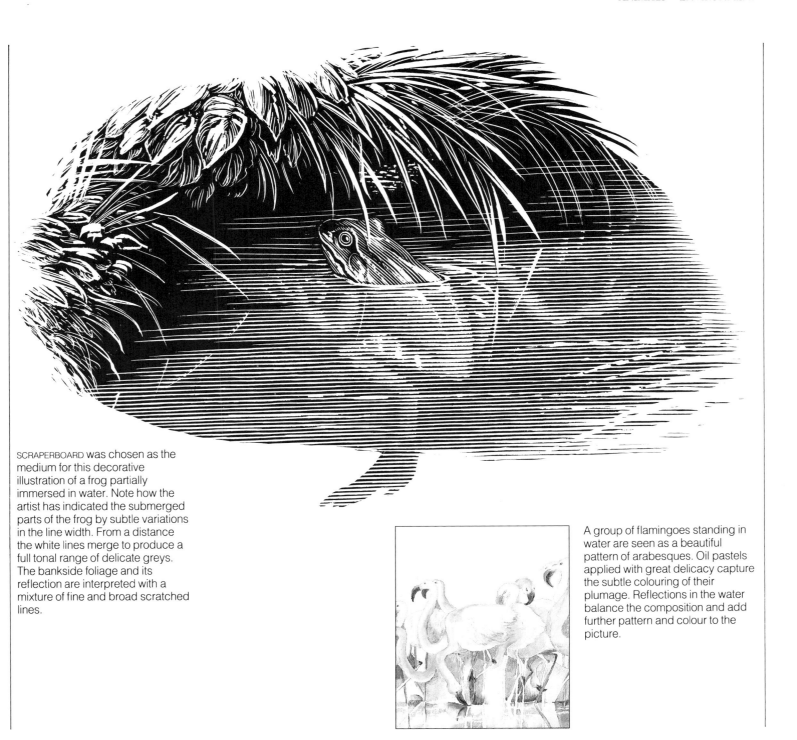

SCRAPERBOARD was chosen as the medium for this decorative illustration of a frog partially immersed in water. Note how the artist has indicated the submerged parts of the frog by subtle variations in the line width. From a distance the white lines merge to produce a full tonal range of delicate greys. The bankside foliage and its reflection are interpreted with a mixture of fine and broad scratched lines.

A group of flamingoes standing in water are seen as a beautiful pattern of arabesques. Oil pastels applied with great delicacy capture the subtle colouring of their plumage. Reflections in the water balance the composition and add further pattern and colour to the picture.

171

MOVEMENT

Animals are seldom still, and it is impossible to draw them posed as one can a human figure. So, unless you have an opportunity to draw a sleeping animal, it is an inescapable fact that you will have to contend with the difficult problem of drawing movement. Movement can be portrayed in many different ways. Sometimes artists make the drawing itself convey a feeling of movement. They do not fix the object on the paper but give it an indistinct outline, or perhaps several outlines, to show that it is not static. A sense of movement can also be achieved through the style of drawing employed. Long, sweeping lines, gestures made by recording the movement of animal or bird with great speed, can imply motion. Generally, however, movement is represented by a single position that best characterizes the animal in motion. Usually you will be trying to select this typical position as the animal moves around. The secret is to observe the animal intensely and then to memorize what you have seen.

Now you will need to draw it quickly as far as you can. Refer back to the subject, waiting for it to be in the chosen position again, and then return to developing your drawing. Drawing in this way requires much patience and great concentration. It also necessitates a rapid, sketchy drawing style. This is not only so that you forget as little as possible, but also to help you capture – through the speed with which you produce the lines and marks – the elusive quality of movement.

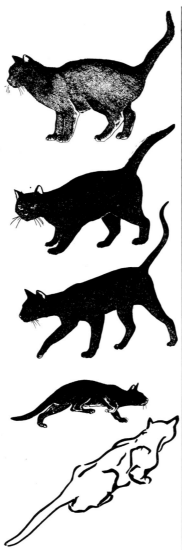

Among these five studies of a cat, two approaches are evident. In the lower sketches, brush and ink create rhythmical outlines that aptly describe the feline nature of the animal. The other sketches were executed in pen and ink and describe which parts of the cat were tense or relaxed.

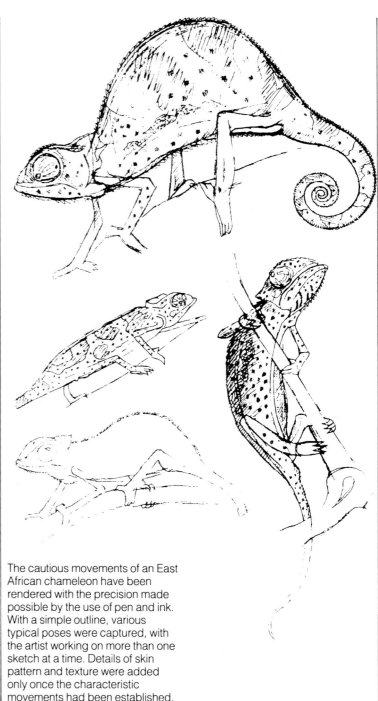

The cautious movements of an East African chameleon have been rendered with the precision made possible by the use of pen and ink. With a simple outline, various typical poses were captured, with the artist working on more than one sketch at a time. Details of skin pattern and texture were added only once the characteristic movements had been established.

Another approach to portraying movement is evident in this highly developed pencil drawing. Only certain parts of the bird were selected for attention by the artist in order to create small areas of focus. The wing-tip closest to us is clear, with the rest of the bird's form left indistinct so that it merges with the background. An eraser was used as a positive tool to LIFT OUT highlights and BLEND forms, creating ghost-like images.

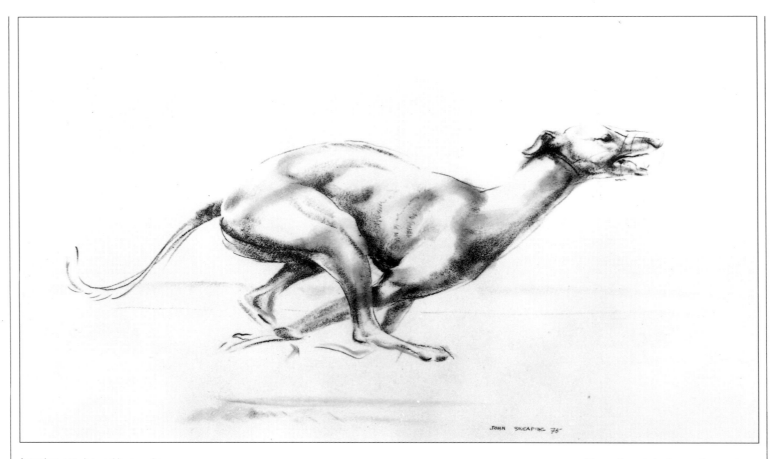

A racing greyhound is caught extended in mid-air. Yet (unlike many photographs) this pastel drawing does not appear static, even though the action is frozen. A sense of movement is created by the sensitive broken lines and dancing tones which animate the wave-like undulation along the muscular body, skilfully leading the eye from the dog's nose to the tip of his tail. The tail and paws are also slightly blurred as if moving fast.

Shown here is just one of a number of studies taken from life of an impressively agile snow leopard. By capturing the animal in mid-action, the artist has created a sense of movement, because the viewer's imagination naturally supplies details of what might have happened before and after this particular moment. The changing texture of the fur describes the contours of the form, adding to the impression of muscular exertion. Written notes have been added for later reference.

The energy displayed in a salmon's spectacular leap is effectively captured here by using a combination of superimposed layers of ink STIPPLE, carefully controlled through the application of masking fluid. First, masking fluid was applied to what eventually became the white areas of the drawing, after which stippled tones were formed by blowing black ink through a spray diffuser. More masking fluid was added to protect parts of this pale area from the next layer of stipple. This process was repeated until the superimposed layers of stippling formed the dense dark tone required for the deepest shadows. Only then was the accumulated area of masking fluid removed to reveal a sensitive TONAL DRAWING. Finishing touches were added with pen and ink.

TEXTURE

Not all drawings concentrate on the textural aspects of an object, yet the fur of an animal or the feathers of a bird are so much an integral part of their form and character that it is difficult to portray such a subject and ignore its textures. As well as describing the feel of the animal, texture can reveal its underlying form. Drawing the texture as it follows the form of the animal gives the drawing a feeling of solidity.

Texture can also help to create a sense of depth in a drawing. In the case of drawing a brick wall, receding away from you, the bricks will get smaller the farther away they are. In the same way, even if the animal is small, the marks made to represent the texture of its coat will reduce in size the farther into the picture space they are meant to be, even over the length of the animal's body.

Care has to be taken to choose a medium that will readily interpret the texture of the animal. Some media have inbuilt textural qualities. Chalk used on a coarse-grained paper will, for example, produce a broken, textured line naturally. Sometimes these ready-made textures can be adapted to suit a particular animal or bird.

A rule to observe when drawing animals or birds is to avoid trying to draw every hair or feather. Much can be suggested with very little. Make certain the outline shape of the animal expresses its texture, and look for distinctive marks or patterns that can be used to express the animal's underlying form.

The form of this fine leopard has been simplified because the artist's primary concern was the pattern created by the markings of its beautiful coat. Abrupt, HATCHED lines make up the spots, with finer hatching suggesting shadows. The smooth texture of the pencil drawing corresponds to the texture of the animal's short velvet-like coat.

The short, stiff lines that make up this dramatic drawing successfully convey the unyielding nature of a bird's feathers, while a varied pen and ink line makes the textural pattern very expressive. The result is a highly inventive interpretation of a vulture-like bird, drawn to illustrate a poem.

An unusual background texture was introduced into this drawing by smoking the sheet of paper, an ACCIDENTAL DRAWING method. The eagle's head was then sketched in with pencil, and wax crayon added to take advantage of WAX RESIST techniques. Next masking fluid and watercolour washes were used in combination to develop the texture of the feathers. Finally, the extremes of the tonal range were BUILT UP, with opaque white gouache forming the highlights – as can be seen on the tips of the feathers – and ink strengthening the darkest lines and tones.

BIRDS

Birds present the artist with an opportunity to test his or her drawing skill in recording a wide variety of sizes, shapes and colours. Fortunately, there are many different places where birds can be studied. Many people have small birds in cages, and zoos usually have a selection of large and exotic birds on view. But, of course, wild birds can readily be coaxed down to your level if you have a bird table and some food to attract them or a vantage point which allows you to observe them unnoticed.

Birds are particularly popular subjects, and drawings of them are frequently converted into decorative designs. Often textiles use bird motifs, as their many different shapes and plumage patterns can be adapted to all manner of decorative treatments. Often drawings are made from stuffed birds. Such an exercise can be a very useful way of gaining experience in drawing feather textures and discovering the main features of a particular bird; but it is only by studying a bird moving in its natural habitat that one can succeed in capturing its true character.

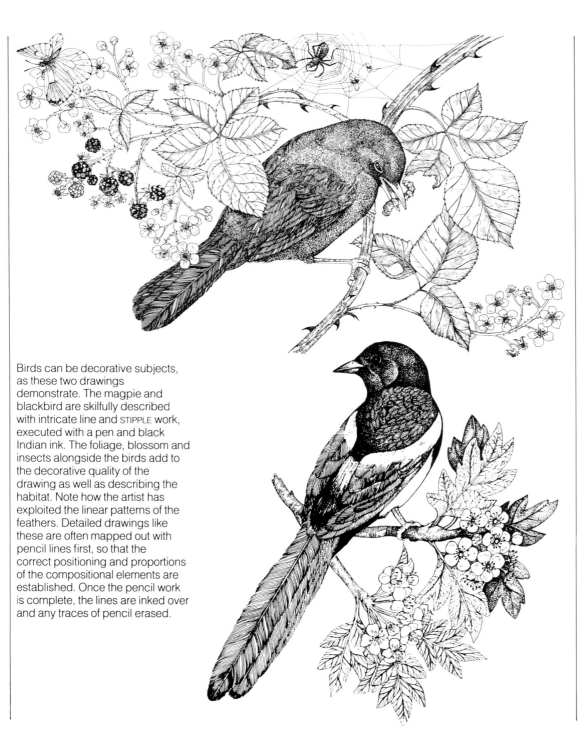

Birds can be decorative subjects, as these two drawings demonstrate. The magpie and blackbird are skilfully described with intricate line and STIPPLE work, executed with a pen and black Indian ink. The foliage, blossom and insects alongside the birds add to the decorative quality of the drawing as well as describing the habitat. Note how the artist has exploited the linear patterns of the feathers. Detailed drawings like these are often mapped out with pencil lines first, so that the correct positioning and proportions of the compositional elements are established. Once the pencil work is complete, the lines are inked over and any traces of pencil erased.

There is certainly nothing decorative about this portrait of a bird, in which the artist has responded to the savage beauty of an eagle devouring its prey. The bird was conceived with GESTURAL strokes, relying heavily on ACCIDENTAL DRAWING. Black and coloured inks were applied with pen and brush, then acrylic paint was spattered onto the paper. There is a strong contrast between the detailed execution of the bird's foot and the looser, more expressive, textural rendering of the feathers.

This running scarlet ibis was
created with a combination of MIXED
MEDIA. First, the pastel sketch of the
bird was photocopied. The
photocopied image was then cut
out and glued onto a fresh sheet of
paper. Next, the bird was reworked
with felt-tipped pens to add the
colour. Finally, the background was
indicated with pastels and coloured
pencils.

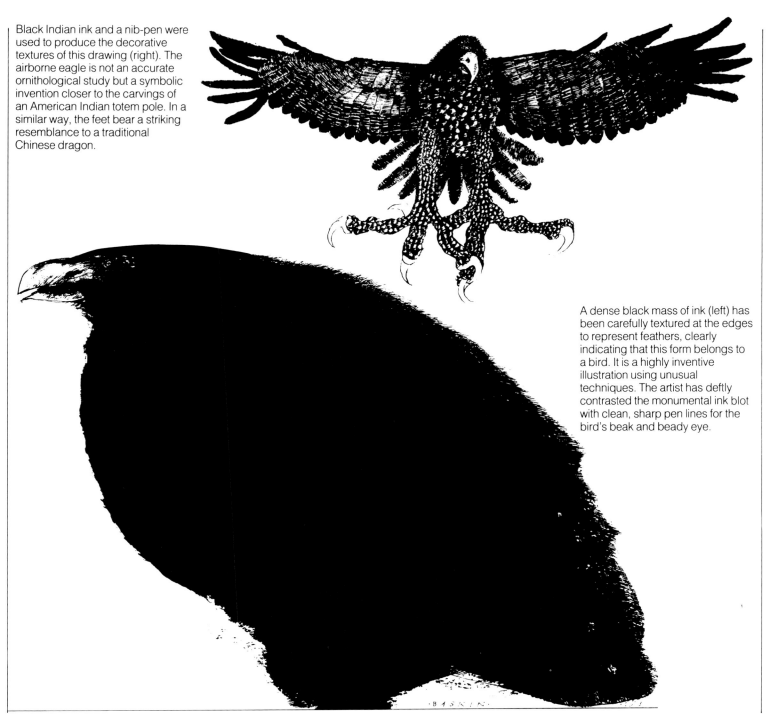

Black Indian ink and a nib-pen were used to produce the decorative textures of this drawing (right). The airborne eagle is not an accurate ornithological study but a symbolic invention closer to the carvings of an American Indian totem pole. In a similar way, the feet bear a striking resemblance to a traditional Chinese dragon.

A dense black mass of ink (left) has been carefully textured at the edges to represent feathers, clearly indicating that this form belongs to a bird. It is a highly inventive illustration using unusual techniques. The artist has deftly contrasted the monumental ink blot with clean, sharp pen lines for the bird's beak and beady eye.

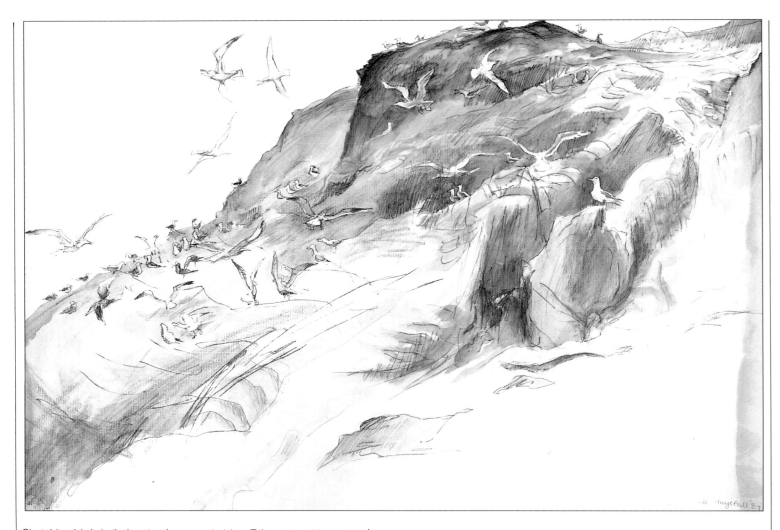

Sketching birds in their natural environment requires the ability to make a quick visual assessment combined with a rapid drawing technique. These Lesser Black-backed gulls were captured with a few quick strokes of a pen, paying little attention to detail but mastering the essential shape and movement of these graceful birds. The artist tried to recreate the noisy, action-packed atmosphere. Washes were added to develop the tonal qualities of the birds and their cliff-top habitat. Take care not to overwork such drawings, for a lively, sketchy quality is considered the essence of the LINE AND WASH technique.

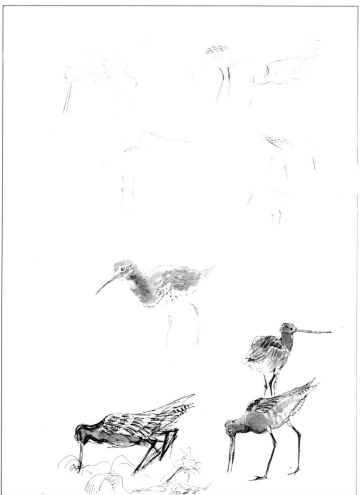

Sunbathing sparrows and a pigeon are captivating subjects for a sheet of rapid pencil sketches. Simple HATCHING was considered the most economical way of SHADING the strong shadows. The sensitive line and clearly established planes of light and shadow combine to produce sketches of tangible form and action.

Every wildlife artist should consider keeping a sketchbook handy at all times. Over the years they develop into a vast store of information, there to be plundered for inspiration on days when it is lacking. In addition, a sketchbook is a good place to explore different media and techniques. On one page of this book the artist has sketched a wader using three different techniques: pencil, pencil and watercolour, and ink and watercolour.

Bird Study ● Line and Wash

Drawing a living bird is certainly stimulating, yet there are, as you might expect, problems too. For a start, the bird is unlikely to keep still, so you must be prepared to draw quickly and at times AUTOMATICALLY. In this demonstration, we watch the artist producing sheets of rapid sketches as she closely observes her subject. She tries to record not only the bird's form but its personality as well. There is a natural progression through the sequence as one drawing inspires the next, or as a line of sketches tracks a series of related movements. The final drawing represents a virtuoso performance of the LINE AND WASH technique. In the final drawing the artist encapsulates the bird's personality with great delicacy and freedom, a direct result of the work put into the preparatory studies.

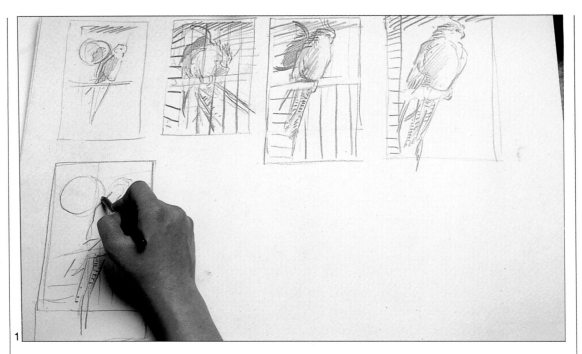

1, 2 and **3** Pencil is used to produce a sheet of rapid SKETCHES exploring the position of the perched bird in its cage. As the artist becomes familiar with the form and character of the subject, she quickly moves on to another sheet of paper. Here she develops the composition, basing it on the exploratory work of her first sketches. A graphite stick produces the soft broad strokes required, yet extensive adjustments are made continually with an eraser. Washes of grey watercolour are added to develop the effect of the lighting and to refine the bird's form. Note how the forked tail has been brought out with this technique. The details are kept to a minimum in a drawing which capitalizes on a style that is loose and airy and full of movement.

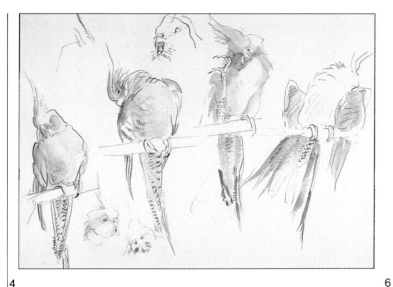

4

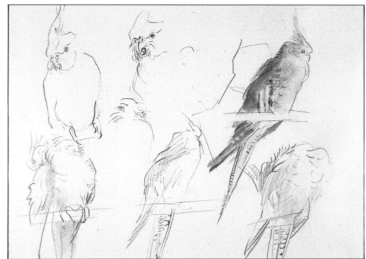

6

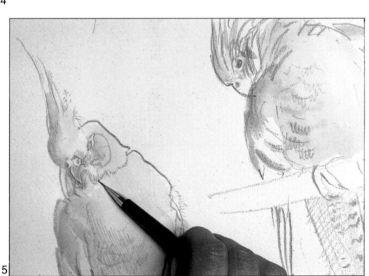

5

7

4 and **5** There is seldom any point in labouring on a single drawing when SKETCHING a living animal. Take a lesson from this artist, who has produced sheet after sheet of animated studies in her search for the characteristic perches and movements of her subject. In picture **4** she concentrates on the changing position of the head.

Two small 'portraits' can be seen here, executed in some detail with a fine pencil. On this sheet colour notes are introduced. Small POINTILLIST flecks and washes glow on the tinted paper. In picture **5** a propelling pencil is seen in action. A range of pencils will ensure variety in the marks made.

6 and **7** In the top sheet of drawings, the movement of the bird is recorded. On the left, the artist starts to draw the bird from the front, but, unkindly, it shifts along the perch and turns away. Quickly another SKETCH is initiated, this time concentrating on the subject's profile. Picture **7** shows an intermediate stage of this

drawing, where a pale blue-grey wash is being added to the breast. Touches of colour and Chinese white were added later. Although a worksheet such as this one may be scattered with individual images, there is a certain unity: a natural progression can be perceived as one sketch evolves from another.

8, **9** and **10** The artist is now on the lookout for more unusual movements or positions which characterize the bird. At one point the bird drops down onto its seed-tray, bending its tail feathers on the floor. The artist must respond rapidly to such an opportunity. So, immediately, a fresh sheet of drawings is started. It is important to have all materials close at hand, especially a good supply of paper. Inexpensive tinted paper was used for these SKETCHES. The detail shows the relationship between LINE AND WASH.

8

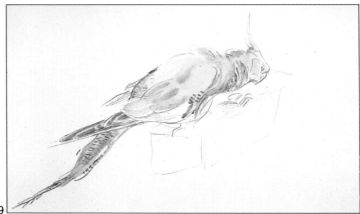

9

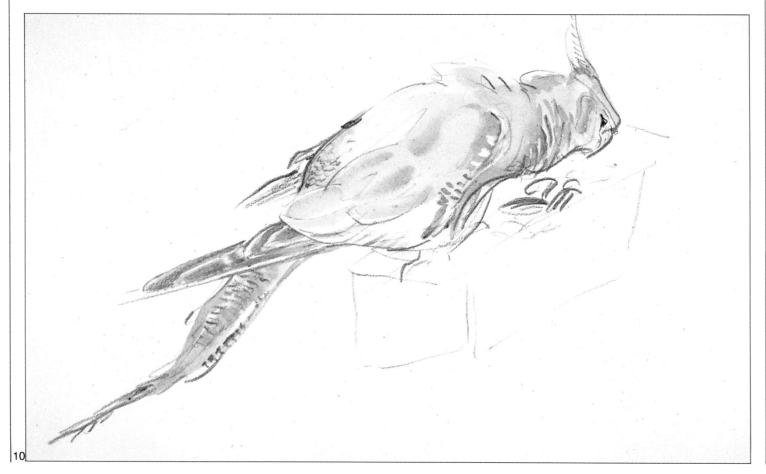

10

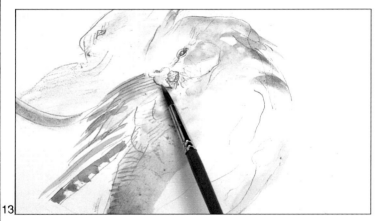

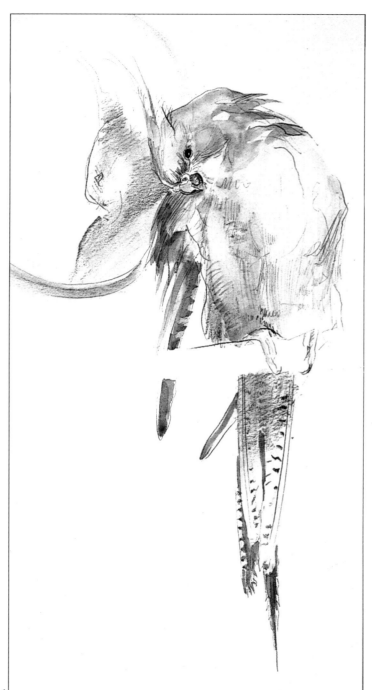

11, **12**, **13** and **14** As a result of this profusion of studies, the artist feels that she has 'got to know' her subject. She is acquainted not only with its shape and movements but also with the bird's temperament and character. So, taking a propelling pencil and a sheet of white paper, she starts a more 'in-depth' drawing using the information gathered. Line now suggests both form and movement and also records the patterns of the plumage. Graphite stick and watercolour lay in the tone and colours. Pale violet-grey and ochre washes are carefully overlaid to capture exact tints in the feathers. More intricate LINE AND WASH work develop the facial features. The final touch is the eye, carefully filled in with black watercolour except for the bright highlight of white paper, which shows through to give it life.

FLOWERS

Flowers are found in illuminated manuscripts and in medieval painting. They are often used emblematically – the white lily as a symbol of purity, for example, but they are usually only incidental to the more important elements in the painting. By 1440, when Lochner (d. 1451) painted *The Virgin in the Rose Bower*, flowers had become more important and could even be a possible main subject in a picture. The development of still-life painting, particularly by the Dutch artists of the eighteenth century such as van Huysum (1682–1749), saw the introduction of elaborate flower paintings in which the artist used his skill to paint the most intricate detail – even to the extent of painting drops of water and insects on the flowers. The Impressionists were fond of flowers as subjects for drawings and paintings, with Monet's paintings of waterlilies in the garden he had specially constructed for himself being one of the outstanding achievements of the Impressionist movement and now claimed by some as the true starting-point of abstract art. Perhaps the most famous flower paintings of all, however, are the seven paintings of sunflowers painted by van Gogh just before his death in 1890, one of which was sold for more than £27 million in 1987.

There are basically two kinds of flower drawings. Botanical drawings are primarily intended to explain the construction of the flower and to show, almost diagrammatically, its botanical features. The flower drawings described earlier are drawings in which the pictorial possibilities of the flowers are explored and exploited. Some botanical drawings are beautiful by any standards and flower drawings can be botanically accurate, but the two kinds of drawings have distinctly different primary aims.

An obedient subject

The most significant thing about drawing flowers, as with making any still-life drawing, is that the artist is almost entirely in control. The subject can be arranged in any way the artist wishes. There is no problem in working from direct observation or spending periods working from memory or from sketches and then returning to the flowers for later reference.

Flowers for drawing should be arranged to look natural and informal. The symmetry and balance of formal flower arrangements are not usually good subjects for drawing or painting. Rather, the flowers should be haphazardly placed but nevertheless arranged so that you have a variety of views of the flower heads. Some flowers should overlap others, with the heads turned in different directions. If possible, the flowers should be at different stages of development with some in bud and others in full bloom.

Lighting is also important. Light from the side usually gives a strong contrast of light and dark and assists in providing information that will help to create solid forms in the drawing. Whether this light is natural or artificial is immaterial, but remember that whereas artificial light can be controlled and provide sharper or softer shadows according to preference, it distorts the colour of the flowers.

The time factor

However, flowers do not stay absolutely still. They continue to change if placed in a vase, in water, just as they would do if still on the plant. During the course of a day they will open, move or close depending on the light and the stalks may bend, altering the position of the flowers and changing the organization of the group.

These things need to be borne in mind if a drawing is to be developed over a long period of time. Most drawings, even highly detailed, carefully considered ones, should not take so long that there will be enormous changes in the group, but it is nevertheless important that the position of the main features of the group are established early in the drawing and then left unchanged as the drawing is developed and the flowers change.

Subduing the detail

Possibly more than with any other subject, the danger in making drawings of flowers is that of being seduced by the detail. Flowers are intricate and incredibly beautiful but even so it is easy to make very boring drawings of them. Attention to detail has to be resisted until the drawing is firmly constructed and developed; even

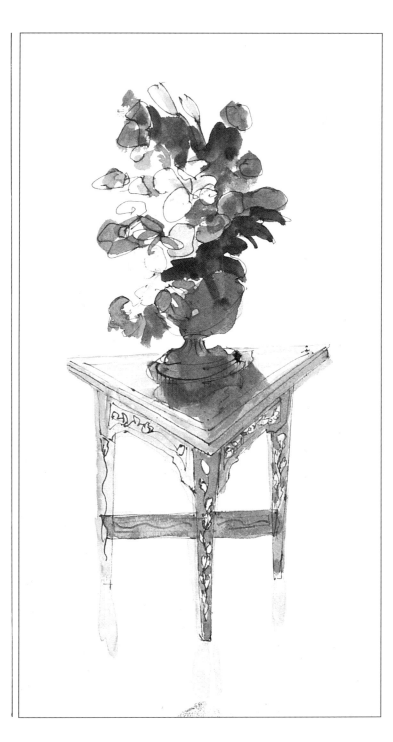

then it may be necessary only to select two or three flowers for explanation in great detail. The individual flower must not be seen in isolation but as a unit in the complex form of the whole arrangement. Once this form has been established against its background, the individual flowers can be drawn emerging from it. The flowers need to be drawn connected to their stems and the stems and foliage need to be drawn fitting into whatever kind of container is used.

Most importantly, the whole arrangement of flowers must look round and three-dimensional and whatever attention is paid to an individual flower, it must not be at the expense of the flowers as a whole. Undue attention to detail and to flowers in isolation from the whole arrangement will almost inevitably lead to the production of a disappointing flat pattern, with little of the character that animated the original subject.

What to use
Obviously, the most important aspect of any flower is its colour, and watercolour drawings of flowers can produce the intense, luminous colour that characterizes many flowers. Pastels and crayons are also popular and drawings in monochrome can represent the dramatic shapes of some flowers or illustrate the complex construction of others.

A large vase of flowers on a small, ornate table provided a highly decorative motif. It was quickly sketched with ink and watercolour.

BOTANICAL DRAWINGS

The finest botanical drawings are works of art by any standard; nevertheless the aim of the botanical artist differs from that of the artist who draws flowers for their pictorial qualities. The latter is not concerned with a precise, literal description. The flowers may only be suggested in the drawing, or they may appear as a few indistinct patches of vivid colour against a neutral background. In botanical drawing what matters is that the flower or plant be explained in all its detail. This sometimes involves the inclusion of written notes alongside the drawing or accompanying close-ups of distinctive petals, for example, or leaf formations.

To position flowers for botanical drawing, you should pay attention to shape and construction. Generally only one species is selected as an individual study, but depending on the type of flower, a stem with two flower heads or blooms at different stages of development may be needed, so that two different characteristic views of the flower can be represented. It is difficult to prevent botanical drawings from appearing flat and lifeless because the artist conceives his or her work primarily as a scientific study of the object with all its features shown and explained so that it can be used for identification purposes. It must remain, therefore, uncluttered by unnecessary background information.

This is one area of drawing in which detailed knowledge of the object is a great advantage, and a sound knowledge of botany, along with painstaking observation and attention to detail, will produce the best results.

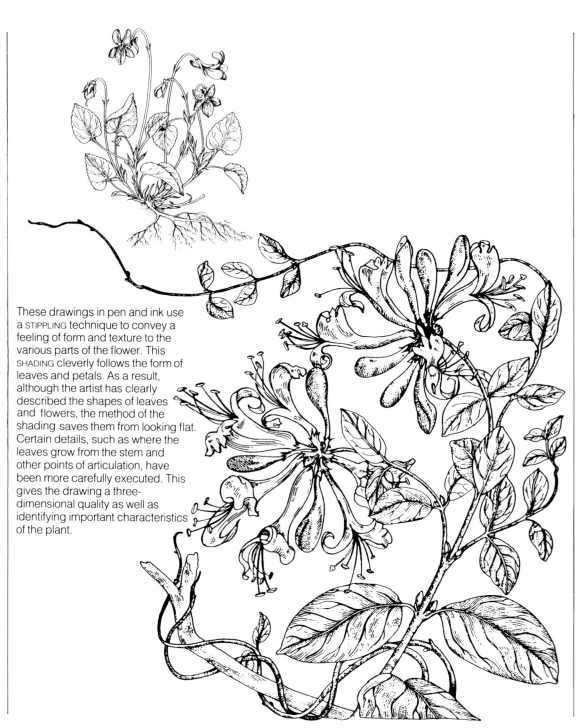

These drawings in pen and ink use a STIPPLING technique to convey a feeling of form and texture to the various parts of the flower. This SHADING cleverly follows the form of leaves and petals. As a result, although the artist has clearly described the shapes of leaves and flowers, the method of the shading saves them from looking flat. Certain details, such as where the leaves grow from the stem and other points of articulation, have been more carefully executed. This gives the drawing a three-dimensional quality as well as identifying important characteristics of the plant.

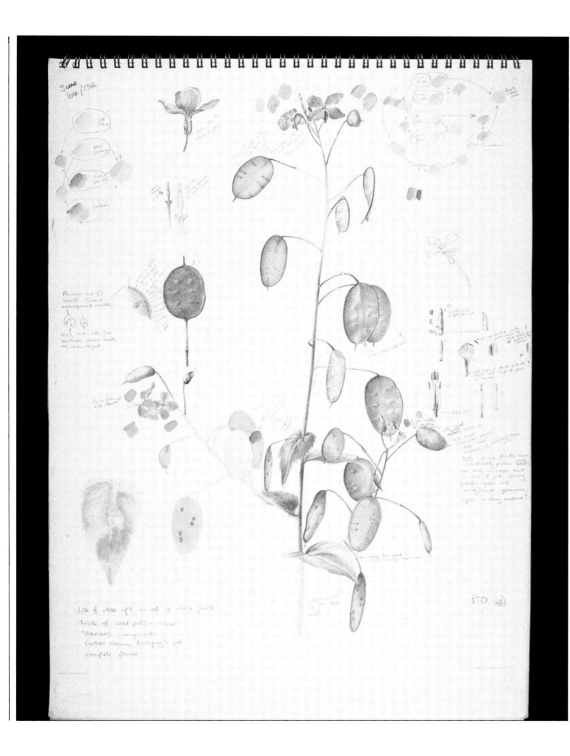

This inspired worksheet of drawings was the result of close scrutiny of the individual parts of the plant. Pencil is ideal for this type of botanical study, as it can be erased and corrected with ease. The colour information was added to the drawing with a small sable brush and watercolour. Many artists make written notes as they go along in order to help them remember not only the peculiar characteristics of the plant, but also the colours and quantities used to mix the exact tints and shades. Although this sketchbook page is a worksheet – a store of information rather than a presentation piece – the arrangement of the pictorial elements is still very important. The drawings need to be aesthetically appealing in order to be a source of pleasure and inspiration.

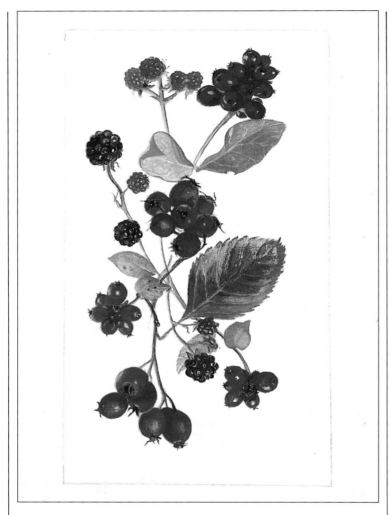

A detailed pencil outline was the first stage of this small drawing. Once satisfied with this, the artist blocked in the main colours and areas of SHADING with aquarelle pencils. Then, taking a small sable brush and clean water, she dissolved the applied colour and BLENDED carefully. By repeating the same procedure a number of times, the artist BUILT UP layers of strong colour. HIGHLIGHTS, in addition to those created by leaving the white paper to show through the BROKEN COLOUR, were dotted onto the drawing with a small brush and opaque white gouache. Aquarelle pencil used in this way makes it possible to build up beautifully subtle transitions of tone and colour, as can be seen where green turns to brown on the large leaf.

The delicate green tendrils of this plant appear as hairline cracks in the paper's surface. The drawing was made with very sharp aquarelle pencils. These pencils tend to be softer than graphite ones and therefore lose their point very quickly, especially when used wet. Clean water was needed to blend the pencil marks into washes for the flower and bud. Note how one flower is unopened, whereas the other can be seen in all its glory. Botanical drawings often illustrate the different stages of a plant's development in the same drawing.

This pen and ink drawing expertly describes the details of the plant, yet the result is somewhat stylized. This makes the drawing more than merely an accurate botanical representation of the plant; it has the qualities of a decorative motif. Different strengths of line and directional HATCHING describe the beautiful forms and impart a sense of movement. The detail bears witness to the careful observation that has gone into rendering the intricate shapes at the dark centre of the large flower. The solid patches of black ink help to punctuate and enrich the line drawing.

WILD FLOWERS AND POTTED PLANTS

It is always an inspiring exercise to search out and draw a living plant, whether indoors or outdoors. Flowers are at their best in their own surroundings, and seeking out wild flowers is a pleasurable occupation in itself. Indeed, it is often surprising where they crop up. Urban wastelands are scattered with the delicate colours of wildflowers. You can either make a quick sketch with colour notes on the spot or take a photograph and work from this at home. Do not ignore the weeds; to the artist a humble dandelion is as intricate and beautiful as any cultivated bloom.

Potted plants provide easy access to plant life and come in all shapes, sizes and colours. Drawing a plant indoors allows you to control the conditions, such as the source of light. Different effects will result if a plant is positioned near a window in natural light or if it is illuminated with a lamp or spotlight. Potted plants also combine readily with other household objects for still-life arrangements.

Limiting himself to a thin black ink line, the artist has carefully mapped out the complex shapes of these foxgloves and the background foliage (above). To make an interesting drawing with such limited means the artist must observe subtle changes in shape from one flower or leaf to another. This drawing started out on one sheet of paper, but as it developed the artist simply added another sheet on which he could continue working.

A combination of two techniques, line drawing and STIPPLING, executed with pen and black ink, skilfully describe these wild flowers. Not satisfied with depicting only the plants, the artist has suggested their natural environment by including two large power station cooling towers in the background.

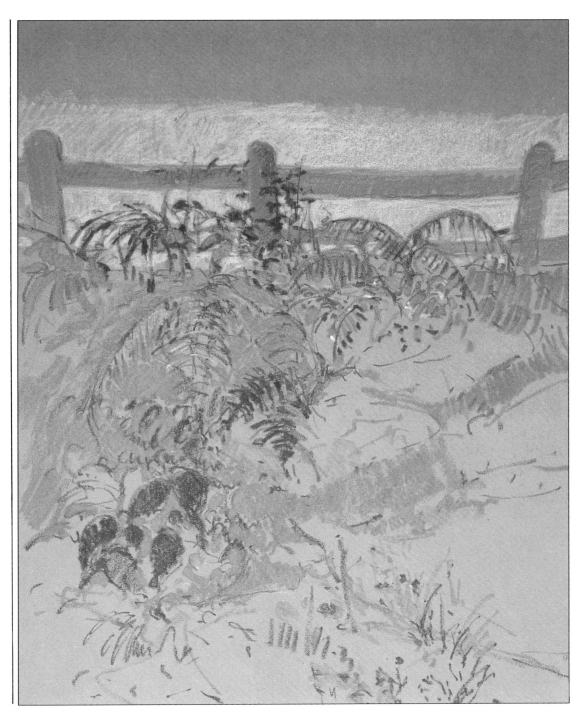

Oil pastels can be very effective when used in combination with a fine sandpaper support. The detail shows some of the varied textures that can be produced. A broken, grainy texture results when the pastel is dragged lightly over the abrasive surface. Firmer pressure causes the tooth of the paper to clog so that a more solid patch of strong colour develops. The potential of this combination seemed to the artist ideal for exploring the profusion of ferns, flowers and foliage of a summer hedgerow. But it is very easy to overwork an oil pastel drawing so that the whole image becomes too clogged and dull. It is better to aim for an unfinished, fresh appearance, as achieved in this example. This approach successfully creates a sense of immediacy, which is more likely to elicit an imaginative response from the viewer.

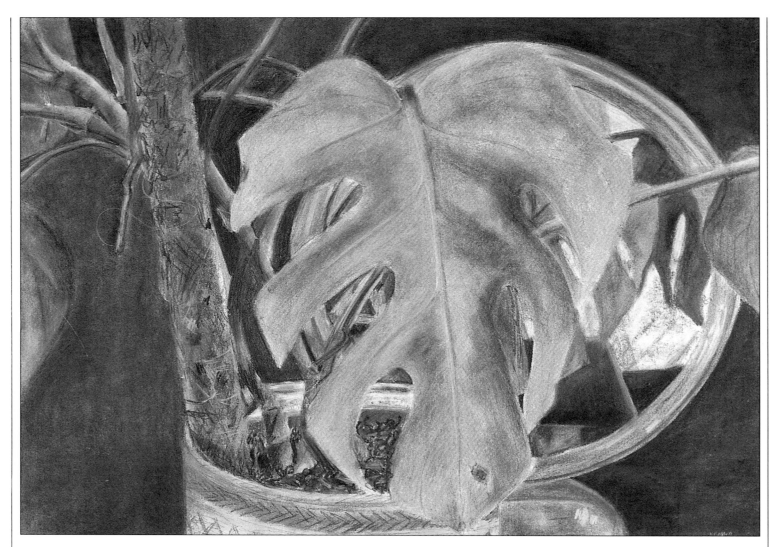

Potted plants, often accessible when other plants are not, can provide some stimulating compositional ideas. With a large plant such as this, a single leaf can form the basis of a drawing. The strong greens were BUILT UP with pastel, rubbed firmly into the paper, one layer superimposed over another. The circular mirror in the background adds an unusual and interesting background of reflections and light. Detail has been kept to a minimum, so that the arrangement of large simple shapes, boldly blocked in with colour pastels, is not compromised.

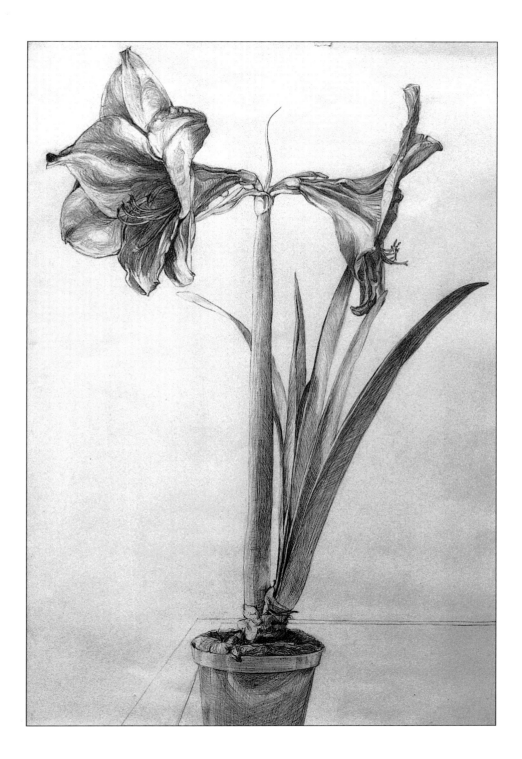

A common difficulty in flower drawing is how to describe the three-dimensional form of the petals clearly and yet ensure that their unique texture is retained. To solve the problem the artist has differentiated, in this pencil drawing, between the textures of the stem and leaves and that of the flower petals by using a different SHADING technique and by varying the quality of the line. The stem and leaves are shaded with short CROSSHATCHED strokes, capturing the firmness of their form. By contrast, the flower petals are shaded with longer, curving, more gentle lines. In this way the contours are clearly described, yet the soft pencil line also expresses the delicate texture.

CUT FLOWERS

Flowers arranged in a vase can make an intriguing subject in themselves, or they might constitute an important feature in an interior view or still life group. If the vase is to be included in the drawing, it is important that it be of a shape and colour that complements the flowers. Sometimes it is possible to find just the right colour and design of vase, but, if in doubt, use a plain glass jar, which will be insignificant and yet will allow the stalks of the flowers to be seen.

One of the pitfalls of drawing flowers is that their mesmeric attraction sometimes leads to an obsession with detail at the expense of seeing the total effect. If you are drawing a bunch of flowers displayed in a vase, the first thing you need to observe is the overall shape of the arrangement. The relative scale of one flower to another and their position in the defined space needs to be established long before any attempt is made to add detail. A drawing that concentrates on every petal, leaf and bud will often make the plant appear not soft and delicate but hard and metallic. With flowers, more than any other subject, it is important to avoid unnecessary laboured detail and try to capture the essential characteristic of the subject with a lightness of touch.

It is worthwhile remembering that one or two prominent flowers, drawn crisply in sharp focus, will allow the other flowers to be merely indicated as indistinct forms fading into the background. When arranging flowers for drawing, try to make them appear natural; formal flower arrangements should be avoided in favour of simple, perhaps even haphazard arrangements.

Penstemmon (firbird).

The simple glass jar used to hold this natural arrangement of flowers makes little comment, but it allows the stems to be seen in the water, providing an additional area of interest. The choice of pen and ink as a medium and the linear technique employed allow the artist to concentrate on the shapes and construction of the flowers. The treatment is economical; the stamens, for example, are simply indicated with a few dots.

In this drawing attention is focused on the flower in the foreground, with less detail invested in the flowers behind it. Although nothing is executed in great detail, the drawing expresses well the character of the flowers and has a lively feeling of space. A sensitive broken pen line has been used with HATCHING to describe the flowers, conveying a lively impression of their texture. The dark centres of the flowers are expressed with intense hatching. Tiny flecks of white paper showing through this dense tone, and the soft edge to these areas created by the hatching technique, rescue them from becoming overpowering and from looking merely like heavy black patches.

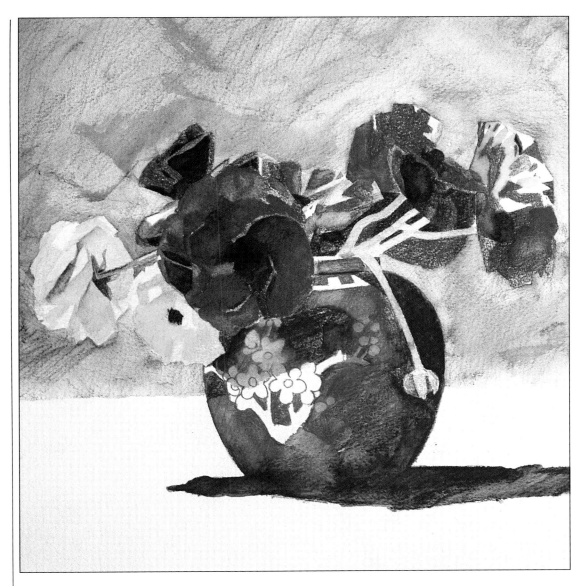

The artist here has chosen a vase with a floral decoration which relates in a positive way to the flowers it contains. Water-soluble pencils on textured watercolour paper have captured the image well. The artist does not differentiate between the treatment of the flowers and that of the decoration on the vase. So the stems, represented as simple light shapes, appear to link these two similar areas. Initially, the drawing was mapped out with bold strokes of the pencils, emphasizing the general shapes of the flowers with the patterns of light and shade seen in sharp contrast. Clean water was then applied with a brush to blend and soften some of these areas. However the artist had to be careful to preserve something of the original sharp contrasts, while using the washes produced by the brush and water to unify the fragmented elements of the drawing.

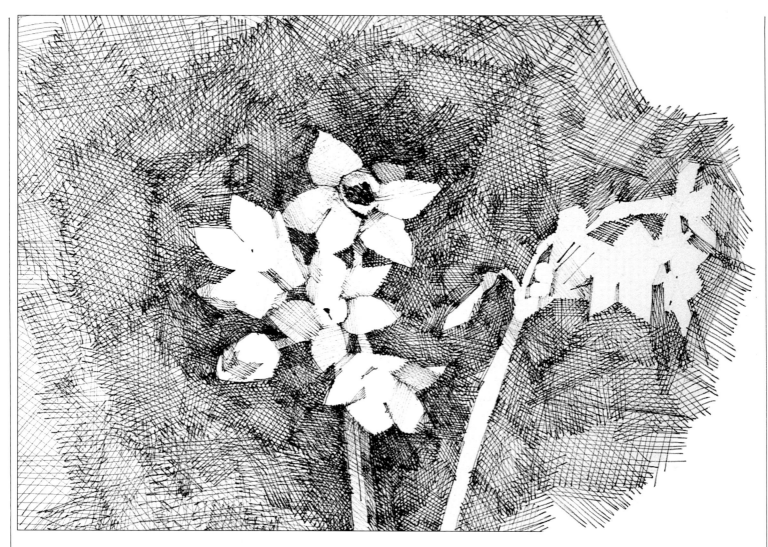

To make this drawing the artist chose a Rapidograph (reservoir) pen with a medium nib. The stylo nibs of this type of pen produce a line of constant width which is little affected by different pressure or rotation. Working on white cartridge paper, using the specially formulated black ink available for these pens, the artist BUILT UP the drawing gradually. CROSSHATCHING formed the background, with clean white shapes left for the Narcissi flowers. The artist emphasized the shadows of the petals and the flower centres, but left the flowers as light and delicate as possible.

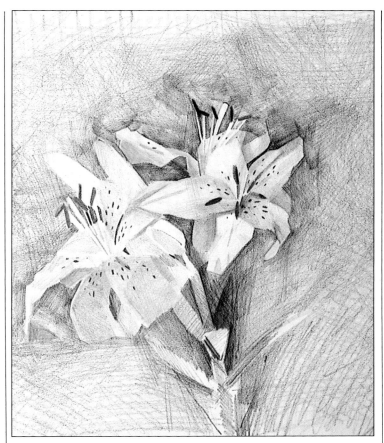

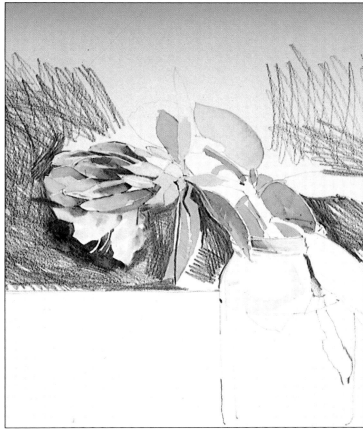

The first marks made on the paper in this coloured pencil drawing were very faint, but they were sufficient to establish the basic shapes in their correct positions and proportions. After filling in the background with carefully graded HATCHING, the artist developed the petal shapes with brighter colours and stronger tones. By controlling the direction of the pencil strokes, the artist has indicated the curving and folding form of the petals. Eight colours produced this vibrant image, with the warm colours describing the illuminated areas and cooler ones the shadows.

Soluble watercolour pencils are particularly suited to flower drawing. They provide a good range of colours which can be used to make LINEAR MARKS or blended with clean water to create interesting washes. In this example, the outline of the rhododendron was first sketched in with its local colour. Then other colours were carefully added with a sable brush and blended with water to develop the drawing. Note how the leaf shapes and the jar are described in less detail than the flower itself, so that the drawing is not overloaded with superfluous information; our attention is guided instead to the lyrical treatment of the bloom.

Flower Study ● Coloured Pencil

Among a bunch of mixed flowers, the artist found this freshly-cut golden-yellow lily. The perfection of the large supple flower head seemed to warrant individual study. Placing the flower on a white surface, the artist set to work immediately with coloured pencils. To make the most of the pattern created by the beautifully coloured petals and ornate anthers, the artist decided to fill the paper with a close-up of the flower head. The choice of a high viewpoint means that the leaves, stems and accompanying single bud combine to create an arresting and decorative linear design.

1 Pale contours and outlines of the flower, leaves and stem are sketched in with corresponding local colours. The artist studies negative and positive shapes, keeping the drawing fairly loose to allow for adjustments as the image develops.

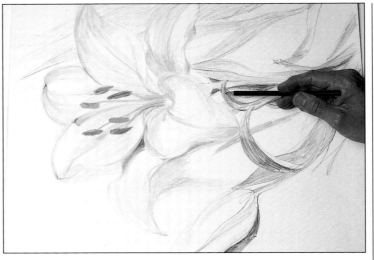

3 The artist begins to BUILD UP the rest of the drawing. The composition focuses on the flower head, which consequently is represented in brighter detail, but the leaves and stem play an important decorative role. The dark, linear patterns of the leaves and their shadows set off the delicate mass of yellow petals. Colder colours and deeper tones strengthen the shadows.

2 The mid-tones are now added and more colours introduced. Two different yellows and oranges are mixed to describe the subtle nuances of the petal colour. Capturing the soft texture of the petals is of paramount importance and this is successfully achieved with languid strokes. These contrast with firmer HATCHING on the leaves.

4 Finally, a black pencil is used to pinpoint dark areas, which provide necessary contrast to enliven the drawing. Note the shadows cast onto some petals from the anthers. This well-observed detail adds an important sense of space (opposite)

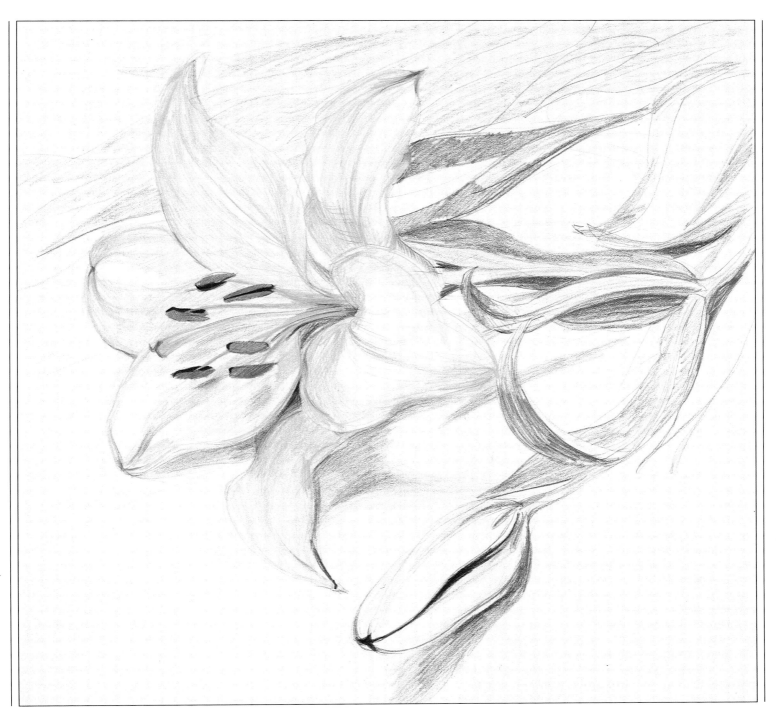

INDEX

CREDITS

pp10-11 Ian Simpson. **p12** Lawrence Wood. **p13** (left) Lawrence Wood; (center) Ian Ribbons; (right) Lawrence Wood. **p14** (left) Ian Simpson; (right) Simon Bill. **p15** (left) Ian Simpson; (right) Lawrence Wood. **p16** (left) Ian Ribbons; (right) Lawrence Wood. **pp17-18** Lawrence Wood. **p19** Ian Ribbons. **p20** Lawrence Wood. **p21** Ian Ribbons. **p22** Simon Bill. **p23** Ian Ribbons. **p24** Quarto. **pp25-26** Lawrence Wood. **p27** Ian Sidaway. **p28** (left) Lawrence Wood; (right) Ian Ribbons. **p29** Ian Simpson. **p30** (left) Lawrence Wood; (right) Quarto. **p31** (top) Ian Ribbons; (bottom) Simon Bill. **p32** Simon Bill. **p33** (left) Simon Bill; (right) Ian Ribbons. **p34** (left) Lawrence Wood; (right) Ian Ribbons. **p35** Quarto. **p36** (top) Ian Ribbons; (bottom) Lawrence Wood. **p37** (top left) Lawrence Wood; (bottom left) Neville Graham; (right) Canaletto, reproduced by gracious permission of H.M. The Queen. **p38** (left and center) Lawrence Wood; (right) Simon Bill. **p39** Lawrence Wood. **p40** (top) Lawrence Wood; (bottom) Simon Bill. **p41** (top) Lawrence Wood; (bottom) Ian Simpson. **p42** Ian Ribbons. **p43** (left) Ian Ribbons; (right) Gill Elsbury. **p44** (top left) Lawrence Wood; (others) Ian Ribbons. **p45** Ian Ribbons. **pp46-47** Lawrence Wood. **p48** (left) Ian Sidaway; (right) Ian Ribbons. **pp49-50** Lawrence Wood. **p51** (top) S. Garfi; (bottom) Andrew Farmer. **p52** Ian Simpson. **pp53-54** Lawrence Wood. **p55** (left) Lawrence Wood; (right) Ian Ribbons. **p56** Lawrence Wood. **p57** Ian Ribbons. **p58** Moira Clinch. **p59** (top) Moira Clinch; (bottom) Lawrence Wood. **p60** Lawrence Wood. **p61** Ian Simpson. **pp62-63** Simon Bill. **p64** (left) Vana Haggerty; (right) Gill Elsbury. **p65** (left) Moira Clinch; (right) Ian Simpson. **p66** Lawrence Wood. **p67** Ian Simpson. **p73** Tom Coates. **p74** (left) Ian Ribbons; (right) Jean Woodcraft. **p75** Claire Belfield. **p76** (left) Lawrence Wood; (right) Raymond Spurrier. **p77** James Horton. **p78** Tom Coates. **p79** (top) John Raynes; (bottom) Moira Clinch. **p80** Tom Coates. **p81** (top) Tim Wylie; (bottom) Josef Herman, courtesy of New Grafton Gallery, London. **p82** Student of the Roehampton Institute, London. **p83** Keith Grant. **p84** (top) Jean Woodcraft; (bottom) Ian Ribbons. **p85** Catherine Denvir, courtesy of Penguin Books. **p86** James Horton. **p87** (top) Ian Ribbons; (bottom) Donald Hamilton Fraser. **p88** Edward Ardizzone. **p89** (left) Raymond Spurrier; (right) Margaret Cowern. **p90** Ian Ribbons. **p91** Catherine Denvir, courtesy of Penguin Books. **p92** Ian Ribbons. **p93** Ian Ribbons. **p94** (left) Ken Howard; (right) Ian Ribbons. **p95** Lawrence Wood. **p96** Student of the Roehampton Institute, London. **p97** (left) Keith Grant; (right) Clara Vuillamy. **pp98-99** Clara Vuillamy. **p101** Alfred Daniels. **pp102-103** Moira Clinch. **p104** (top) Julia Hope; (bottom) Sue Emsley. **p105** Keith Grant. **p106** (top) Raymond Spurrier; (bottom) Brian Yale. **p107** Sue Emsley. **p108** Student of the Roehampton Institute, London. **p109** (top) Julia Hope; (bottom) David Hutter. **p110** Sue Emsley. **p111** (top) Student of the Roehampton Institute, London; (bottom) Sue Emsley. **p112** (left) Keith Grant; (right) Student of the Roehampton Institute, London. **p113** Student of the Roehampton Institute, London. **p114** (top) Ian Ribbons; (bottom) Brian Yale. **p115** Student of the Roehampton Institute, London. **p116** (top) Moira Clinch; (bottom) Raymond Spurrier. **p117** Andrew Hemmingway, courtesy of the Royal Academy, London. **p118** (top) Brian Yale; (bottom) Margaret Cowern. **p119** Keith Grant. **pp120-123** Lawrence Wood. **p125** Alfred Daniels. **p126** (top) Brian Yale; (bottom) Raymond Spurrier. **p127** Brian Yale. **p128** Ken Howard. **p129** (top) Raymond Spurrier; (bottom) Claire Wright. **p130** (top) Raymond Spurrier; (bottom) Ian Ribbons. **p131** Margaret Cowern. **p132** Ian Ribbons. **p133** (top) Raymond Spurrier; (bottom) David Hutter. **p134** (left) Ian Carmichael; (right) Tom Coates. **p135** Ben Johnson. **p136** (top) Raymond Spurrier; (bottom) Betty Swanswick. **p137** Moira Clinch. **p138** (top left) Nick Cudworth; (bottom left) Sylvia Wright; (right) Sarah Bratby. **p139** Ben Johnson. **p140** Susan Alcantarilla. **P141** Neil Gower. **pp142-143** Susan Alcantarilla. **p145** Andrew Farmer. **p146** (left) Sarah Adams; (right) Anita Taylor. **p147** Nick Cudworth. **pp148-150** Students of the Roehampton Institute, London. **p151** Shona Cameron. **p152** (top) Lawrence Wood; (bottom) Vana Haggerty. **p153** Sarah Adams. **p154** S. Garfi. **p155** Claire Belfield. **p156** (top) Claire Belfield; (bottom) Diana Armfield. **p157** D. Chatto. **pp158-159** Clara Vuillamy. **p161** Richard Jebbitt. **p162** Vana Haggerty. **p163** (left) John Norris-Wood; (right) Gill Elsbury. **p164** (left) Sue Fowler; (right) Jason Bowyer. **p165** Richard Jebbitt. **p166** (left) Lawrence Wood; (right) Richard Jebbitt. **p167** Richard Jebbitt. **p168** (top) Richard Jebbitt; (bottom) Jason Bowyer. **p169** Richard Jebbitt. **p170** (left) Richard Jebbitt; (right) Michael Wood. **p171** (top) Bill Sanders; (bottom) Moira Clinch. **p172** (left) Vana Haggerty; (right) John Norris-Wood. **p173** Richard Jebbitt. **p174** (top) John Skeaping, courtesy of D. Fuller Ackermann; (bottom) Gill Elsbury. **p175** Michael Wood. **p176** (top) Claire Belfield; (bottom) Leonard Baskin. **p177** Richard Jebbitt. **p178** Vana Haggerty. **p179** Richard Jebbitt. **p180** Shona Cameron. **p181** Leonard Baskin. **p182** Kim Atkinson. **p183** (left) Mick Manning; (right) Kim Atkinson. **pp184-187** Kim Atkinson. **p189** Lawrence Wood. **p190** Vana Haggerty. **p191** Gill Elsbury. **p192** Student of the Roehampton Institute, London. **p193** John Nash, courtesy of the New Grafton Gallery. **p194** (top) Trevor Allen; (bottom) Vana Haggerty. **p195** Susan Alcantarilla. **p196** Student of the Roehampton Institute. **p197** C. Ives. **p198** (top) Trevor Allen; (bottom) John Norris-Wood. **p199** Nicky Kemball. **p200** Ian Sidaway. **p201** Ian Sidaway. **pp202-203** Lawrence Wood.